Colors

Andrew Berardini

Not a Cult
Los Angeles, CA

Copyright © Andrew Berardini

First edition

All rights reserved. No part of this book may be used or reproduced in any manner whatsoever without written permission from the publisher except in the case of brief quotations embodied in critical articles, reviews, or academic projects.

The views, thoughts, opinions, fictions, truths, declarations, interpretations, and outright lies in this text belong solely to the author.

For information, contact books@notacult.media.

ISBN: 978-4-945649-67-7

Edited by Lauren Mackler
Proofread by Rhiannon McGavin
Cover Design by Shaun Roberts

Not a Cult
Los Angeles, CA

Printed in Canada

This, and everything else, for Stella

Table Of Contents

Blue
- Peacock — 3
- Sky — 12
- Cyan — 15
- Electric — 18
- Cobalt — 21
- Swimming Pool — 25
- Robin's Egg — 27
- Denim — 29
- Baby — 32
- Ultramarine — 35
- Navy — 37
- Sapphire — 40
- Pale — 43
- Powder — 45
- Midnight — 48

Black
- Ink — 53
- Pitch — 58
- Licorice — 61
- Obsidian — 64
- Asphalt — 67
- Ebony — 69
- Jet — 73
- Raven — 75
- Matte — 77

Gray
- Smoke — 87
- Charcoal — 90
- Ash — 93
- Haze — 96
- Iron — 98
- Slate — 101
- Silver — 104
- Taupe — 107

White
- Alabaster — 111
- Cream — 115
- Linen — 117
- Ivory — 123
- Ghost — 125
- Pearl — 126
- Lily — 128
- Cloud — 130
- Bone — 135
- Snow — 137

Pink
- Blush — 143
- Hot — 149
- Puce — 151
- Bubblegum — 153
- Amaranth — 156
- Coral — 158
- Cherry Blossom — 161
- Salmon — 163
- Flamingo — 167
- Rose — 169

Purple

Royal	177
Lavender	180
Plum	183
Orchid	185
Mauve	187
Amethyst	190
Lilac	192
Magenta	195
Violet	197
Wine	199

Red

Scarlet	205
Raspberry	208
Crimson	209
Ruby	212
Vermilion	215
Oxblood	219
Burgundy	222
Maroon	224
Auburn	226

Yellow

Lemon	231
Goldenrod	233
Blonde	235
Canary	238
Gold	239
Butter	242
Citrine	245
Piss	247

Orange
- Peach 253
- Poppy 256
- Carrot 258
- Tangerine 260
- Melon 263
- Honey 267
- Tiger 269
- Amber 271
- Pumpkin 274
- Harvest Gold 277
- Rust 280

Brown
- Beige 285
- Chocolate 287
- Sand 290
- Russet 292
- Dirt 294
- Copper 300
- Ochre 302
- Golden 305
- Bronze 306
- Cinnamon 310

Green
- Jungle 315
- Seafoam 318
- Mint 320
- Turquoise 323
- Teal 325
- Grass 328
- Avocado 331
- Chartreuse 334

Emerald	337
Poison	339
Sage	345
Jade	348

A kind in glass and a cousin, a spectacle and nothing strange a single hurt color and an arrangement in a system to pointing. All this and not ordinary, not unordered in not resembling. The difference is spreading.

—Gertrude Stein

*In this world
love has no color,
yet how deeply
my body
is stained by yours.*

—Izumi Shikibu

Blue

Peacock
Sky
Cyan
Electric
Cobalt
Swimming Pool
Robin's Egg
Denim
Baby
Ultramarine
Navy
Sapphire
Pale
Powder
Midnight

Peacock

Scratching paper is such a somber battle. There are no witnesses, no one else in your corner, no passion. And all the while, waiting outside, there are your blue spring, the very cries of your peacocks, and the fragrance of the air. It's very sad.

—Colette (1873)

The peacocks wander freely here.

Their bark is off-putting, otherworldly, unbirdlike. The peahens, naked of their lovers' iridescent tail feathers, moan with need throughout the long wet spring. Their aching calls fill the night air, already rank with night-blooming jasmine and exhaust, eucalyptus and smoke from the cheap cigarettes of the old Chinese men playing cards on milk crates under the streetlamps. In the mornings, incense breezes over the fence from my neighbor's shrine. In the afternoon, the traffic of two freeways distantly hums. The mating hens call throughout.

Perched on the faded bungalows and on the porch rails of anonymous apartment complexes, on the cruciform power lines and blooming jacarandas, these weird exotics with their sexual howls and pornographic tail feathers don't care at all that they are far from a jungle in India where they originated but instead, an ocean away, in the very center of a concrete cosmopolis of 15 million humans; or if they do, they make it work anyway.

The words wander freely here too.

They are ill-behaved, rebellious, unruly. They refuse containment. Always direct but never straight, they meander and arrive without schedule.

They hop the fence and sleep with their neighbors. They adulterate and miscegenate. These words switch genders with a turn of phrase. These words are swingers, unless they can't be bothered and then disappear as hermits and anchorites. They say whatever it is they want to say whenever they want to say it. They perform plays if moved by drama. They utter truth to power. They hide in fantasies. They lie through their teeth in fiction should that truth be a better lubricant. They criticize and report, they essay and they declaim. They enjoy a freedom on the margins of anything else, refusing to be nailed down.

This is a poem if they say it is. This is a prayer if they need it to be.

If the words decide it, as Henry Miller's did, this is a gob of spit in the face of art.

The windows shiver with the thump and boom of the rockets. Out my kitchen window, just over the lip of the hill past the half-built apartment building, its concrete skeleton lingering inchoate for years, I can see the fireworks bursting in air into ephemeral stars painted with light on the night clouds. With its vast parking lots and piercing lights and blue-capped army of fans, Dodger Stadium lies just on the other side and the fireworks make an after-game treat. Built over a demoed working-class neighborhood like mine, few

bother to remember. In the other direction a sickle moon smirks above the 101, the white headlamps kissing red tail lights as the traffic coughs its way through the downtown towers to Hollywood and beyond.

Those skyscrapers are so close you can almost touch them. A wallpaper of power, each bearing the name of our overlords, mostly bankers. When the fog rolls in, the glass and steel appear and disappear like ghosts in the mist.

—

I once thought being a writer meant writing conventional novels. Characters moving along an E. M. Forster plot line from exposition to denouement in the linear rise and fall of a bell curve. In 1759 Laurence Sterne began publishing the fictional autobiography *The Life and Opinions of Tristram Shandy, Gentleman*. The invented author of the book, Tristram, outlines in its pages a plot line for the first four volumes of his memoir:

Linearity and realism and the Forster curve place a false shape and unnecessary rules on an existence that is neither linear nor realist. Past and future, distant events and quotidian concerns, memories and lacunae, imaginary threats and visions, hormones and desires and drugs thwart the straight line, the superficial sightlines of a faux-objective reality.

In his autobiography, Tristram does not even make it to his own birth until Volume III.

—

There are no roads to the Stadium over the hill to the North from my neighborhood, though you can bushwhack over the chain-link fences and scrubby grass down the steep decline to the Gate if you wanted. To the west, Sunset Boulevard, ribboned from the beach 22 miles away finally dissolves just past my house into Cesar Chavez Blvd. and east into the East. Just beyond it is the 101 and its endless stream of lights. To the south is the 110 Freeway underpassing a few WPA bridges and down steep hills beyond lies Chinatown. Neon dragons and paper lanterns beckon tourists to buy pop snaps and flimsy fans, greasy noodles and plastic anythings. "A Bestseller Movie by Jackie Chan *RUSH HOUR* Was Shot Here!"

—

When I see the peacocks perched on the powerlines, on the roof of my house, dragging their tail feathers down the concrete walkway past my bungalow, that radiant blue ringing their necks and gleaming from their feathers, it always feels like a blessing. As they shift and move, so does their color.

—

Is Chris Kraus writing fiction or theory or essay? Is Moyra Davey an artist or a writer? When Anne Carson responds to Roni Horn in a work of literature so beautifully amorphous you might as well call it a poem, do I need to even call it a poem or art criticism or that Greek oddity, an ekphrasis?

I read *Against Nature* (1884) by Joris-Karl Huysmans to be

reminded how art can have a body that makes you tremble and ache with every word. It's less a novel for me and more a handbook for how to destroy oneself in the most delicious ways possible.

I read Sheila Heti's *How Should a Person Be?* (2010) because for all its loose navel-gazing, it is real. Or as real as many of us are able to manage, surrounded as we are with illusions (not that illusions can't also reveal truth to be sure).

The gentleman scholars of the Enlightenment can vivisect and classify, I do not need to murder the bird to admire its flight.

—

I move up and down Sunset everyday. My neighborhood lies near Echo Park, ruled once by street gangs and crooked cops. The corrupt police division has been dismantled and scrubbed. The street gangs still scrawl their names and claim their turf in loopy letters with old-fashioned angles, but they don't run the neighborhood anymore either.

Few of the empty storefronts stay empty for long, each dreamer takes her chance. The eco-bridal store appears to open everyday. The restaurants with subtle signs and modern menus look crowded. But the shoe repairman in his Astrovan still parks next to the burrito truck even if the once abandoned grocery store they neighbor now tenants a health food market.

But this is all just adjacent, a nearby place I can always visit but don't actually live.

—

"A Hunger Artist" by Franz Kafka published in 1922 is the

greatest piece of art criticism ever written, should we want to call it art criticism. It does not call itself anything at all but its own name.

The artist starves himself for wildly popular public display in the circus. Interest wanes, he continues to practice anyway. Forgotten almost entirely until his death, even then he is mostly misunderstood and unappreciated.

"I always wanted you to admire my fasting," said the hunger artist. "But we do admire it," said the supervisor obligingly. "But you shouldn't admire it," said the hunger artist. "Well then, we don't admire it," said the supervisor, "but why shouldn't we admire it?" "Because I had to fast. I can't do anything else," said the hunger artist.

The artist can be nothing but what he is. He isn't any different than the jaguar that takes over the cage after his demise.

> *This noble body, equipped with everything necessary, almost to the point of bursting, even appeared to carry freedom around with it. That seems to be located somewhere or other in its teeth, and its joy in living came with such strong passion from its throat that it was not easy for spectators to keep watching. But they controlled themselves, kept pressing around the cage, and had no desire at all to move on.*

The Hunger Artist did not practice for fame, the tameless panther will never flaunt its freedom for accolades. The jaguar's freedom, undaunted by the bars, gives us hope in our cages.

Our attention is a kind of tether, but we need their freedom. When we escape, we will return with songs and poems, paintings and dance, each a rope back into the prison. Maybe somebody else will grab it and escape too.

But if you free a panther do not expect gratitude, she might eat you. It is only nature.

—

My neighborhood got the name "The Forgotten Edge" because it exists between so many larger neighborhoods and doesn't really belong to any of them: geographically, ethnically, linguistically, spiritually. No through-traffic either and the city in the past often confused which police precinct served it, and so for years criminals had a hilltop fiefdom. This has all been sorted out now, but I still feel like I'm hiding in the middle of it all, with the closest most intense view of downtown. One of the few spots where a quasi-suburban Los Angeles really feels like a city.

I am in the center of everything and belong to nothing.

—

And where can the artist or his audience escape to? The walls are not always tangible: those laws and rules defined by governments and corporations, the options imposed on us by economics and opportunities (or their lack). These walls buzz with binary through digital webs. They shape each action and choice inside your head. How do you hop over a wall you can't see and perhaps don't even know exists?

I think about this all the time.

The only answer I've ever found is in Italo Calvino's *Invisible Cities* (1972):

> *And Polo said:*
> *The inferno of the living is not something that will be; if there is one, it is what is already here, the inferno where we live every day, that we form by being together. There*

> *are two ways to escape suffering it. The first is easy for many: accept the inferno and become such a part of it that you can no longer see it. The second is risky and demands constant vigilance and apprehension: seek and learn to recognize who and what, in the midst of the inferno, are not inferno, then make them endure, give them space.*

I repeat these words like a prayer.

The space I find amidst inferno is not inferno. It is here in this city of changes. It is a forgotten neighborhood where the peacocks roam wild. It is a house on a hill, a table in the kitchen, and a white page for me to fill with whatever I desire.

—

Unlike most color, the blue in a peacock's tail is not a pigment but a structure and one that shifts with how light hits it. Their feathers contain microscopic ridges that bounce light just so. Some colors are cancelled out, while others are amplified. Peacock blue in the tailfeather of this exquisitely impractical bird is created by a crystalline lattice of nine to twelve rods containing melanin, a color pigment. Spaced approximately 140 nanometers apart, these rods have such a distance that allows light to reflect back in a certain way at the viewer in wavelengths of blue. The feathers do not contain color, but reflect it. Grind up the peacock's feathers and you won't find a single glimmer of blue.

—

My landlord is the grandson of my grandfather's landlord. Though it's mostly Chinese and Mexican and the weird ethnic brew of young aspirants, my neighborhood was once working-class Italians. I am almost the last in the neighborhood who can trace his lineage to those early immigrants.

There is another though. He runs the Eastside Market, a deli beloved by cops and firefighters. I read somewhere he's from the same village as my family but I've never met him.

None of this matters, except that it makes me feel a stillness that roots me into the past while the loose drift of a transient civilization washes around me. The house where my grandfather and grandmother raised my father was torn down fifty years ago for a parking lot that has since been abandoned. I am from somewhere, and this gives me some comfort, but it doesn't mean anything. I easily trade tradition for freedom.

But this is Los Angeles and so am I.

Moving with a peacock's strut, in the shimmer, we both make ourselves up as we go along.

Sky

Blue skies
Smiling at me
Nothing but blue skies
Do I see
　　　　　　　—Irving Berlin, "Blue Skies" (1926)

Today the sky is so blue it burns.
　　　　　　　—Joe Brainard, "30 One-Liners" (1973)

A bright and bitter blue, an everyday infinity. There is nothing but the blaze of brightest sun through a noisy atmosphere (though its vastness seen from the surface seems so terribly silent). Why is the sky blue? The light catches on particulates, oscillating and scattering, the choppy waves get stripped to give the daybright sky a color. Our revolving planet spins around the sun. And when our star speeds, its dust we eat is a blue beyond blue, a color unbreakable from the sky.

A dry and touchless ocean of air, the sky is everything that the earth and sea are not. Painters can whirl the latter two together, and vaporous water loves to swim in all that air. The elements hazing together in a disappeared horizon. And what are clouds but water's envy of the sky?

And certainly sky blue's best when a few sheepy clouds wander across its Elysian Fields, though this determined condensation can blot out the blue for months in long

northern winters. Sky blue needs something floating across its color, a war plane, a hungry hawk, towering cumulus, wispy cirrus, a long-tailed kite. Without anything the color dulls to matte, depthless, an oppressive vacuum, its purity and hardness reward the earthbound only with a dizzying smallness, overwhelming in its spatial intensity. The airiness of sky blue is too much of everything and nothing.

Songsters always chime a blue sky when they need a cliché for hope, the promise of respite after the stormy deluge. I don't grudge any poet, no matter how lowly, a dream of forgiveness and redemption, but the desert nomads know better. The noonday sky has no mercy until the darkness comes and the distant stars tell a thousand and one stories of their own burn and sear, ancient and cold as it is when it kisses the night, their patterns instructing wanderers of the way in milky swirls.

Some get birthed a shard of it in their eyes, a genetic mutation from the north where the sky for long winters clouds with slate gray and this lack bred its denizens to cultivate the color on their own.

The color of the sky before we had a pigment for it was simply *sky*.

Edward Gibson, a cognitive scientist at the Massachusetts Institute of Technology in Cambridge wanted to study language and culture around color perception, so he hauled a car battery–powered light box and 80 standardized color chips down the Amazon River to talk with the Tsimane, a hunter-gather tribe. In an interview with *Science* in 2017, Gibson said, "We have a word for a color when we have two things that are identical except for color. Yes, the sky is blue, but there aren't two skies." He went on to add, "We see the same colors as hunter-gatherers, but they don't need to label those colors."

We can only truly name colors once we control them.

(Stare too long at the blue sky and it ripples and dances with wavy patterns of psychedelic light.)

The reachless heavens, that forever blue is where so many gods hide from humans, deciding our fates and hiding from our prying eyes. Is this blue divine? Sky blue grants a thoughtless permission, if only for a moment and perhaps a season, mercifully released from snow and rain, sleet and ice. At its brightest turn, we shed our clothes, forgetting edenic curses and winter's deadening cold, sunkissed and naked. Clad only in light, we can be free, if just for a time, under the soft forever of this boundless blue.

Cyan

Just mix cyan with suicide and you'll get the picture.

Cyanotypography is a limited technology for printing images, only ever giving you that bluesy wash. In addition to naming seven moons of Saturn and four of Uranus (the latter after characters in Pope and Shakespeare), fathering twelve children, and inspiring Charles Darwin to find the origin of species, Sir John Herschel, 1st Baronet, invented the cyanotype as a one of the early forms of photography then emerging. He showed it to Anna Atkins, who became, and these qualifications seem weirdly specific, the first person ever to make a book illustrated by photographic images. She was a botanist and used cyanotypes to capture the small subtleties of plants. The title of her first book is as limited and curiously compelling as the cyanotype: *Photographs of British Algae* (1843).

Like cyan, the cyanotype takes its name from the same place as cyanide and uses cyanide in its processes.

Cyanide plays a different song than cyanotype.

Cyan comes from an ancient Greek word meaning something like "deep blue," and cyanide is so named because of its origins as a constituent in the paint Prussian blue. The twist of the tail on cyanide, that chemical suffix, smells like bitter almonds.

Cyanide takes only minutes to kill a person.

The preferred instant escape carried by revolutionaries and secret agents, hydrogen cyanide took the form of Zyklon B in the hands of the Nazis for mass murder. Californians used it to execute their prisoners, for which some insanely argue that such murder is neither cruel nor unusual. Cyanide, in the form of pure liquid prussic acid (a historical name), was the favored suicide of the twilighting Third Reich. Erwin Rommel, Eva Braun, Heinrich Himmler, Martin Bormann, Hermann Göring. Adolf Hitler himself bit a cyanide capsule while simultaneously firing a pistol into his right temple, just in case. Mathematician Alan Turing, after receiving a guilty verdict of being a homosexual, injected cyanide into an apple and ate it rather than go through the hormonal castration mandated by the English court. On November 18, 1978, 907 people died in Jonestown, Guyana, from drinking fruit punch with cyanide at the behest of their spiritual leader, Jim Jones.

Though it wasn't the brand of fruit punch they drank, even so the massacre birthed a cautionary phrase to true believers: *Don't drink the Kool-Aid.* The bright, sweet color may entice but don't drink just anything the guru, the policeman, the advertisement tells you to. A spoonful of sugar helps the cyanide go down.

Does the cyanotype hide in its singular color any of the deadly potential of the poison?

Cyan as a color name is even younger than the cyanotype, only used since 1879. The color of shallow ocean water over white sandy beaches, cyan is worn by surgeons because it's said to be calming.

The color of my time is cyan. In a dark room, a screenlight flickers from a phone onto a face and the color is cyan. It is the singular glow of billions alone with their screens, linking to the internet, a connector and divider, the alpha and the

omega, the repository for all human knowledge, all abstractions coded into 1s and 0s, awash in cyan.

If we die in a hospital room, one of the last colors we'll witness is the soothing color of cyan worn by our healers. Screens are another way we are pacified, waiting for death. Cyan is the color of a soothing death. The hue of all those that go gently into that good night.

Darkness isn't always death of course. Not everything thrives in the light. One of the curious qualities of the cyanotype, I'm told, is that when the color fades, it can be put away and the darkness restores the picture almost entirely to its former glory.

Electric

Blue blue electric blue that's the color of my room, where I will live–blue blue.
—David Bowie, "Sound & Vision" (1977)

All colors can lead to lovers. Or childhood. If we let them.

With fully blossomed faces untrespassed, children seeing the world for the first time hold these original impressions deeply. Adults tend to miss the vibrancy of colors except when heartstruck and ecstatic, caught in the blush of new love and in the thrall of spiritual revival.

Color can reveal its depths when compelled by charisma. The essence of attractiveness, charisma comes from the ancient Greek for grace, favored by the gods. To me, charisma is certainly electric blue in color.

So it is with children first encountering the world or with the eyes of the ecstatic seeing the world renewed, both are touched by grace and all colors seen in those moments are electric in our memories.

Electric blue, like humanity's control over electricity, is a modern invention. It is the spectral emission of excited ionized atoms of air settling down into an abundance of light, electric blue in color. It is the color of argon sparked in neon signs, of the welder's hottest sparks cutting long gooey gashes into the hardest metal, of lightning breaking

the darkness with gigajoules of electrostatic balance that can turn rough sand into fine, spidery glass. Electric blue is the color of tights stretched taut over long legs and soft eyeshadow blushed up and fading into faint eyebrows.

Possessing powerful verve, electric blue lacks both radiance and depth, but even then, it can attract wanderers to tender a caress and undergo an electrocution.

> *Here she comes. You better watch your step. She's going to break your heart in two, it's true....*
> *'Cause everybody knows—She's a femme fatale.*
> —The Velvet Underground (1967)

Fatal beauties are beyond gender. And what makes them fatal is our reactions more than who they actually are or their actions towards us.

Outside of their specific pigment or wavelength of light, so many colors to me become people. And to me, electric blue will always be Anya.

On mixed CDs slipped into handmade sleeves, Anya tested my tastes with her selections, communicating to me through music or perhaps simply trying to delight me with song. Lee Hazlewood's "Trouble is a Lonesome Town." Shirley Collins "Rambleaway." Cluster & Eno, the Manson Family.

It ends with "Can't Seem to Make You Mine" by The Seeds.

A musician, I can still hear her thin fingers pressing down on the ivory keys of her synthesizer, a glossy mouth closing in on the black netting of a mic, her breathy voice thin and otherworldly, a plaintive song rocketed and whipped through a haunted house, as *free and vacant as the wind*. Her words are unhearable but even if you could they are layered with a surreal poetry, more for each word to be felt in an

onslaught rather than understood in any commonplace, linear meaning. All of Anya's angled beauty released into pure electricity.

Electric blue is the color of charisma like a lightning bolt as it shivers through your body, all that power all too dangerous.

It was the color of my heartbreak: the kind that holds you and that you cannot let go of while locked in your room, burned by its force and licking your wounds.

David Bowie, who understood so much, understood this too...

> *Pale blinds drawn all day. Nothing to do, nothing to say. Blue, blue.*

Cobalt

Some distant wedding gift. My family ate its meals in antagonistic silence on Delftware china finely lined with pastoral scenes painted in the spidery lines and deep wash of cobalt.

Dad hoovered his meal with nary an upward glance, Mom's interrogations born of love jabbed with passive mockery and corporal threats, the changing cast of children dreamed, with every choked mouthful of thawed vegetables, of missed TV shows, interrupted novels hurriedly dog-eared, and the lost gossip over the rarely unoccupied phone-line. Too typical, another nuclear family playing out unhappy roles and handed-down expectations sadly lacking the soft filler of a laugh track.

Shifting mashed potatoes into snowdrifts around the Dutch villages, limp carrot coins fashioned into wagon wheels, a slip of salad a sail for a boat along a distant canal, I peered down into cobalt blue scenes coloring a dream of somewhere else when circumstance subdued all other escapes.

Stuck under the bell jar of our suburban home, we dreamt of other places.

—

Beneath the sea, just flipper deep enough and look up.

Swirling shoals of painted fish circle and part around the belled and tentacled bodies of ethereal medusae. Oxygen tanked, each breath bubbles skyward through cool water. A

flippered and wetsuited body sloshes and billows with each movement, the sound undulating through the vast fathoms, distantly mingling with the songs of whales and the sonar of battleships. A still ocean of color tides beneath the froth and churn of wind-kissed waves, the hue shifting as sunlight pierces and diminishes into the abyss.

Cobalt blue skirts these atmospheres.

"Cobalt — is a divine color, and there's nothing so fine as that for putting space around things...." wrote Vincent to Theo on 28 December, 1885.

The watercolorist and astrologer John Varley remarked cobalt could replace ultramarine for sky, but this is from a man for whom the sky felt intimate, a readable chart rather than its true infinity. "Capable, by its superior brilliancy and contrast," he wrote on his *List of Colours* in 1818, "to subdue the brightness of other blues." When Atlas is forced to bear the dome of the sky on his shoulders, its color was surely cobalt. The defeated Titan's task a punishment for him and the primordial mother and father, forbidding the sky from ever again embracing the earth. Cobalt softly enclosed him.

—

Cobalt's name falls from the German word *kobold* or goblin. Hungover after Christianity's triumph over Teutonic spirituality, these supernatural tricksters beleaguered ancient miners with cave-ins and landslides, cut ropes and tipped ladders, releasing toxic gases and cursing ore. Veins of cobalt often occurred with fatal arsenic, gassing its deadly poison upon smelting. But kobold, these mythological creatures of earth, can perhaps be commanded.

According to Goethe's *Faust*, a wizard can never master the spirits without including the goblins.

Salamander shall kindle, Writhe nymph of the wave, In air sylph shall dwindle, And Kobold shall slave. Who doth ignore, the primal Four, nor knows aright their use and might, o'er spirits will he, Ne'er master be. (1808)

The color comes from elemental cobalt in alumina salts. Used in glass for ages, mostly from the misunderstood smalt, it's true identity remained a mystery until the 18th century. Used after with purer hue for pigments and plates, cobalt's still a subtle poison even without arsenic.

Between the world of spirits and things, earth and air, sea and sky, in that thick haze between frontiers, there hovers the brightest band of purest cobalt, a poisonous color confounding in its beauty.

—

Escaping my house as a child took everything I had and I was certainly poisoned in the passage. I left many times as a runaway. One time for months, finding a job and a sofa to sleep amongst a gang of vampiric tweakers in the beach city next to mine. I came back by choice, knowing that my parents' spirits wouldn't survive intact if I didn't return to them, so I went back under the bell jar. Things were different after I returned that last time. This final escape had subdued them, though my mother would still have outbreaks of madness from time to time. And up until I left properly as an adult to college and after when I would return for visits, we ate our thawed and microwaved meals from those cobalt blue plates.

Both of my parents are gone now and I have inherited what's left of their collection of these plates. I snorted lines of ketamine off their color recently. However childish this act of rebellion may have felt, it was no less healing.

We can escape from the poisonous places in our lives, break

out from under their glass, but we will never truly be cured of their color.

Swimming Pool

An inflatable lounge drifts in the cool, chemical blue. Precious parts chastely swimsuited, a curve of naked skin slowly tans, and manicured fingernails dip thoughtlessly into the surface of the water. Chlorine lends its clarity but subtle impurities capture a swathe of light's spectrum, and the water beams back the wettest of chemical blues. In the sky above, weary air travelers fingering barf bags bend against the oval windows as the plane banks for descent, their dazed eyes counting the kidney-curved blues that punctuate the tract houses under the swaying palm trees. Midnight teenagers hop padlocked chain link fences, a redhead with a black eye, a thin boy with nipple piercings, a tautly vinyled gothette, a bitter blond with glittery lipgloss, passing storebrand vodka and skinny-dipping in the shadowy waters, its color muted but still a rippling blue under the distant streetlights.

Swimming pool blue is cool with just the slightest tinge of green, always a little sun-bleached (or pigmented just so to look that way). It shimmers with emotional release and relief. It breathes with vacation, worn to accent your holiday or coloring the brochure to a farflung resort, a place where this color is a relief from the sumptuous heat. For me it was always a status, never rich enough to own a pool. I eyed those pools from economy class. I watched them flicker on a hundred screens for movies shot an hour from my house. I hopped that midnight fence careful not to drop the frosty bottle of vodka. I birthdayed at the water park.

A summer child, I dreamt of its wet play, my eyes open

underwater to a hushed world beneath this one that we can visit but never live. Following the long half-hour after lunch, parentally imposed, the two-tone call of "Marco" is met with a quiet splash and the reluctant return of "Polo." In a water park wonderland, the endless slides, tubed and slick, empty with a splash into frothy pools, bare feet slap on the hot concrete running from ride to ride, and the scent of sunscreen drips off all the shivering, half-naked adolescents. Stretch-marked and beer-bellied, gym-fit and tattooed, mothers and fathers lackadaisically watch over their sopping children. With bodies beyond the firm joys of youth, they still shudder with the first bracing chill and thrill of each stroke and gasp, goose-fleshed and glistening when it's their turn to swim. In those cool waters sloshes the promise of pleasure palaces and leisure classes, desert oases and movie stars, numb languor and empty excess.

Off *Sunset Blvd.* (1950), Joe Gillis floats facedown in the pool he always wanted, though the black-and-white film can't show the hue of the water in his lungs. A California dream, David Hockney's naked boys make a silent splash into its depthless color, the perfect sunlight casting rippling shadows made permanent with paint. A wastrel Benjamin in *The Graduate* (1967) basks in the directionless drift of post-coital bliss and suburban ennui, an earned rest from Mrs. Robinson's mature charms. In Ed Ruscha's 1976 book, the blank stare of *Nine Swimming Pools* are matched with empty pages and concluded with a broken glass.

Wait long enough and the sunstroked drift ends. A twilight chill, your mom's voice calling for supper, the homicide squad's sirens, a perfect moment passed, purchased on credit, interest paid with more than a sunburn.

Robin's Egg

Robin's Egg Blue is tender, but not soft. Fragile, the charm of its hue invites protection and here, a fairy tale.

—

He was a keeper of unkeepable birds. Each one fetched from foreign locales far and wide from odd brokers with improbable names, fezes and monocles, burned off tattoos and flowery cheroots that dangled ever unlit from brownish, mossy teeth gilded in precious metals. He tempted them himself into his aviary with whispers and promises, guiles and traps, baited and unbaited, and they came, winged or walking, bagged or boxed, sleeping and awake.

He kept them in cages like fractals and castles, jeweled caverns lit with a single lasering shaft of sunlight, rooms of ice and rooms of fire, chambers like deserts and coastlines, forests tropical and montane, broadleaf and needleleaf, evergreen and deciduous, sparse and parkland, freshwater swamp and mangrove thicket. He kept birds in illusory savannahs and plains, in vast wind tunnels and boxes flooded to appear as oceans, upon naked cliffs and in the cars of trains kept in almost perpetual movement, on concrete ledges towering above colossal cities, in dirt tunnels and narrow chasms, in domed cosmos with a Milky Way of stars and lightless stone boxes like deep caverns. He kept them in long corridors lined with flowers plump with nectar and fruits hard and soft, long and short, round and oval and squared, wide and plump as fresh sausages and shriveled and desiccated like

the dead fingers of an ancient hermit, with and without seeds, each to the pleasure of each bird. Some birds need the threat of a predator to motivate and he would give them predators. Some needed cyclones and hurricanes, wildfires and volcanoes, earthquakes and tsunamis, blizzards and heatwaves, droughts and hailstorms, drizzle and tornados, he gave what others had found impossible to give, a real taste of disaster without the disaster defeating the animals.

He kept each as a sculpture, a painting, a rarity, many creatures unknown to science or thought extinct, uncapturable and if captured thrashed into death or wilted quickly with the stress of captivity. The birds, feathered and scaled, flighty and flightless, understood the keeper, his kindness, but they also understood their imprisonment with a quiver of anxiety, a clipped lifespan, a sadness. An imprisonment that was never locked as the keeper had understood locks to be gaudy and useless, a cheap, literal boundary to those who understood nothing but cruelty. There were always stronger bonds than bars and shackles.

Each stayed long for reasons only ever understood by the keeper and his kept.

Denim

Worn and faded, denim wraps the asses of miners and cowboys, searchers and bikers, programmers and CEOs, blue jean baby queens and jukebox jezabels, factory floorers and telephone linemen. The agrarian sons of soil and toil gave way to a democratic durability, a denim for all. Rugged individualists and Yankee imperialists and would-be bohemians and corporate schills and folksy politicians and moony troubadours. Denim by color is a derivative of indigo but only just. Part of the warp and weft of pants loomed and riveted by Levi Strauss and worn down by the labor of life, though the word itself according to most is a corruption of 'serge de Nîmes'. *Serge* shorthanded for sturdy wool worsted or twilled, *de Nîmes* misspoken to the simple denim, even though now we weave almost all denims from cotton.

Denim blue is the least pretentious of blues, wearing its color with sturdy simplicity, a rare color whose fade increases its hue. Indigo's royalty becomes in denim the laborer's endurance, the teenager's easy rebellion, the corporate get-up for casual Fridays. It was the cheapest natural dye that best hid grime at the time of jeans' invention.

Bootcut and bell-bottomed, carpenter and classic, flared and relaxed, easy and loose, high and low, skinny and wide, slim and straightlegged. Belted, blasted, corded, and crosshatched. Frayed, baked, laced, slubbed, stretched, tinted, stonewashed, and raw. Dyed all the colors but ever always truly blue and nothing else.

My father was denim.

Made soft by years at the plant, ever sturdy, smoothed over with wear, held up with a brown belt, leather, adorned with a metal key holder for the jangle of keys on a coiled ring. Paired with wide Wolverine work boots and cotton Tartan shirts worn over graying white undershirts, v-necked and hieroglyphed with spaghetti stains, always peeking from his chest a thin gold chain and a simple crucifix.

It had been years since he was the moon. But even if it had been years, the moon had been poked out of the sky.

A funeral in a windswept mausoleum with a crowd clustered around the metal coffin and the handsome Filipino priest with the long unbroken mustache, my hand rubbing against my mother's black velour jacket as I kneeled black polyestered knees on the stone behind her, head bent down, eyes closed, whispering amen along with the rest. A bell tolling on cue.

A wake with aunts and uncles with thin skins and spidery faces knowing they have not much time either, with children snaking through in somber dresses and smirking faces selling soda to all comers for a dollar a cup, and one drunk cousin, doing toast after toast with cheap red wine for my dad, turning mid-toast to tell me stories of the bar my grandfather owned next to the whorehouse his grandfather owned along the plaza with the spluttering fountain across the street from Union Station. A wake where I'd stumble in and out of conversations, trying to act cheerful and feeling like some songbird had crawled into my ribcage and died.

Threading it together. This thing, these days, how much I yearn for the stillness of work (like him, always), the warmth of the sun, the cool whisper of the breeze, but the hours today are filled with the memory of my father's hand and

his legs as he walked. The hand a sheer size, giant, thick and lined, nails cracked, and my hand inside his hand, a boy's, small and delicate. I don't know where we're going, but I look up at him and I look at my hand in his and I forgot whatever worries, filled with a profound and total trust I'm too trespassed to ever know again. Blissfully, I went along toward wherever it was he was plodding, each step a shift of denim.

Baby

You must leave, now take what you need
You think will last
But whatever you wish to keep
You better grab it fast
Yonder stands your orphan with his gun
Crying like a fire in the Sun
Look out baby, the saints are comin' through
And it's all over now, Baby Blue.
—Bob Dylan (1965)

Consider this chapter an ill-considered party, a coven of drunken painters, a portfolio about picture-makers, the prancing of their brushstrokes, the cut of their jibs, the jibe of their colors, soaring along a highway painted black for all the gamblers. Perhaps weirdly obvious, perhaps not, plunked against each other in a stand-off; laughter and snorts, flirtations and snubs slither out of all the layers and armatures, stripes and marks, actions spilling out of stillness, a kaleidoscopic whammy of paint.

This is a group show of abstract paintings that never happened for a museum that never existed. Or that exists in every city and happens all the time.

The space of painting, particularly what we call abstract painting, is only ever spoken of in terms of its material and action, the way the combinations and colors make us feel.

Baby blue is a color usually reserved for newborns with the kind of parents that throw gender reveal parties. It is the color of eyes that seem innocent, safe, inviting. It is the Bob Dylan song "It's All Over Now, Baby Blue." All tangled up in symbolist poetry, Dylan's song invites a hundred associations but no clear meaning. Perhaps it's about letting go of being children and childish things, letting go of the birth of an art form that's finally matured, letting go of one way of seeing the world and allowing all the others to fold over you. And his line about the painter inspired these:

> *The empty-handed painter from your streets is drawing crazy patterns on your sheets.*

In this group show that doesn't exist, the paintings window into other rooms and out back at each other. They make me want to write "smeary" over and over. I imagine different parts of each like characters in anachronistic costume dramas: Constable Oxblood odd-bodying in the cellar with the Colonel and a half bottle of off-year pinot gris. Wet and slathery, tangible reality pokes out of composed fantasies, a swath of unadorned canvas there, the warp and weft of materials here, the four corners of a few jutting out like sharp elbows across unadorned walls.

The abstraction of color, after all, isn't a veer away from reality, only from one way our eyes see it. Burnt orange clouds frost skies bruising from pink to purple. Squiggles drop shadows. That dangle and bend cracks a tart, off-color joke. New colors: neon and fluorescent shimmer with an alien and electric light, excellent for abductions and dance parties. Close your eyes and rub your fingers over them: is that vision abstract or actual? Remove your glasses or squint: is the blur false?

"Representation" and "abstraction" are weak words flailing to summarize strange continents of art, particularly when we

talk about painting. Alone, our eyes are a feeble instrument for seeing. Heart and mind, fingertip and hip-crease, tongue and toe-tickle, cocks and cunts all see where eyes fail. Not to mention that third-eye with which yogis and new agers espy dharmic truth: the Ajna opens and the Sahasrara chakra petals open, a blooming lotus above the corporeal mud bath of our bodies.

Across the summer skies waves of strange light ripple across the blue: colors collide, wobble, shimmy in patterns so protean and unpredictable they are untraceable. I still attempt to trace their patterns with language, painting's linear cousin, a method of mark-making with its own expansive spaces and hard boundaries.

Hallucinations are just another kind of real, patterns repeat out of nature, interior visions wrestle with materials into surfaces daubed and decorated, stabbed and stroked, whorled and colored, here perhaps with words.

How to explain to someone that the most important parts of visual art are not visual at all?

A history of humans making marks gives us only conditions, not directions. When it comes to tradition, we have to paint our way out of that corner on our own. *Don't worry, the dead won't follow you.* A softened sadness, paled but undefeated, this *sky too, is falling in over you.*

And it's all over now, Baby Blue.

Ultramarine

Beyond the sea.

somewhere i have never travelled,gladly beyond
 —Cummings (1931)

From another place past the oceans. A color that goes beyond the swirl and power of water. Ultraviolet contains colors unseen. The mantis shrimp can see five shades past it, with twelve photoreceptors in total as we humble humans are merely trichromats, or most of us are anyhow. Ultramarine we can see, but only just, a color that gladly goes beyond color. It bends space, reshapes the eye. Ultramarine is otherworldly, a minor ambassador from another dimension. The science fiction writer Douglas Adams invented a sentient being from a faraway galaxy simply known as a hyper-intelligent shade of blue, an obvious relative of ultramarine.

In May 1960, the French artist Yves Klein submitted the Souleau envelope (a kind of copyrighting in France at the time) for his own color that he called International Klein Blue. It was really mostly ultramarine suspended in a resin that would help keep its vivacity.

Found naturally in lapis lazuli, synthetic ultramarine goes far past lapis in the uniformity of grain and the diffusion of light, a brightness that requires its own color.

Ultramarine. A magic spell, humans again stealing the sacred fire, no other color is quite so super.

Even lapis lazuli's not entirely of this world. Mined for 6,000 years, *lapis* is the Latin word for "stone" and *lazuli* is a corruption of the mine it came from in West Asia (in Turkestan according to Marco Polo). The mineral that makes the blue we call lazurite, and from these origins also falls azure.

A favorite stone of Egyptian amulets, Cleopatra used it for eyeshadow. Ishtar gives a chariot to Gilgamesh wrought from the gem and the epic ends with the tales of the king being carved in a tablet of lapis.

In paintings and manuscripts from China to England, brushed by Zoroastrians and Normans, lapis lazuli makes for a fugitive pigment and degrades easily under the acid of fingers.

Very dear, too expensive to be used idly, the color came to be employed only for that which was most important and beautiful. When in 1665 Vermeer gives that tint to the headdress of the girl with the pearl earring, he has crowned her with a color to match the mystery and power of her glance.

Beyond the sea, ultramarine is merely a way through, an open door, a portal.

We can only ever reach heaven by passing beyond the power of its hue.

Navy

Consider the subtleness of the sea...
—Herman Melville (1851)

The sea calls me home.

I dream of sailors clinging to ships blown across the ocean from bank to bank, port to port, coast to coast. Seaspit and endless winds. All the blues of the ocean blend and settle into navy blue. A color that calls me to escape on water, a song as erotic and dangerous as the sirens.

The time and distance, above and below, an ebb interrupted only by weather, a slow prow lolling through landless infinities, flattened horizons. Crank and creak. Stars die off the starboard, the deck wet with their tears.

Querelle of Brest waits on the docks for a mark, a trick, a lover. "The man who wears the uniform of a sailor is in no way pledged or bound to obey the rules of prudence..." says his maker Jean Genet.

All those beautiful boys
Pimps and queens and criminal queers
All those beautiful boys
Tattoos of ships and tattoos of tears
—CocoRosie with Anohni (2005)

But their fists are faraway, the mercy of lust, a miserable and lonesome blanket, a wet slip and rough handling across an ocean. (Sometime below decks, a dark closet, such desperate coupling.) And here the writhing gray and green and brown and red and blue, a palette that makes painters wet, a possibility of freedom in its color, but the sailors wear navy, a blue made black by the captains to fight the sea's perpetual decay. Navy blue possesses uniform depth, martial trappings, and with it a submission to a tidal force.

> *Full fathom five thy father lies.*
> *Of his bones are coral made.*
> *Those are pearls that were his eyes*
> *Nothing of him that doth fade*
> *But doth suffer a seachange*
> *Into something rich and strange*
> —Ariel in Shakespeare's *The Tempest* (1611)

The hard currents and jet stream of clouds have a rhythm—though studied, no one knows for sure when and where they'll churn as they churn. Currents and tides carry some illusion of purpose, meaning, pattern but remain perpetually mysterious. Priests worship, but water obeys no prayers. Scientists take a temperature, gauge a current, but they'll drown in an unforeseen tempest. The ways of water can be intuited, guessed, though all assurance remains elusive. Sailors pledge their allegiance to the waves, and if they die on land they cheat the sea, their brother, father, mother, lover. Unfathomable despite intimacy, the sea moves relentlessly. However mortally present, the ocean's vast secrets can never truly be known: the monsters and mermaids, dolphins and jellyfish, kraken and whales. Sometimes captured, this does not mean we understand what we can kill. Captain and quartermaster, boatswain and gunner's mate, master-at-arms and lowliest seaman.

Weathered, yearning, sunburnt and sea-polished, navy blue sailors accept water's powers without succumbing to its depths.

> *The ocean doesn't want me today, but I'll be back tomorrow to play.*
> —Tom Waits (1992)

The sea calls me home, but not yet.

Sapphire

Sapphire, precious gem, a bright star in an ocean of blue, radiant woman I never knew.

A summer sunset, Sandy came home and told me you died. We sat on her front porch and smoked cigarettes. The sky was raw and tired. Sandy drained her tall boy. Still panting from her bike ride up the hill, beads of sweat trickling down the black feathers tattooed on her neck. She told me your story.

Your parents named you Lazarus. At fourteen, you told your conservative Catholic family you were a girl. They were from the countryside in Mexico, these things they could not understand. And Lazarus died to them and this new woman, Sapphire, was not their child. Sandy met you while working with homeless, HIV-positive transgender teens, helping them to transition at the children's hospital and you were one of her clients.

Sandy and I on her sunset porch, we did not mention our own daughter, but thought of her and you at the same time.

Penniless, homeless, fourteen, you turned to sex work. There you were a woman. And the other women who worked the streets with you, gathered their stories to yours. Ariel and Chanel, Desiree and Jessica. On Santa Monica, you'd get condoms from the needle exchange truck. It's there you found out about the virus.

Every donut at the corner shop made you worry about your

figure, but they were so cheap and so filling. A reward for a hard night. And there you could talk, the hard bench seats bearing weary women. Your nails perfectly shaped, glittering blue, tapped the hard formica table top, one finger at a time dropping in a slow deliberate rhythm. The ladies gathered in the sanctuary for a brief respite, waiting to see what blew in. And all the power of your body summoned to a single glimmer in your eyes when you spotted the men that came and went.

How old were you when you caught HIV? What man gave you the disease with his desire?

Sandy would help you with the doctors for your meds to transition and your meds for the disease. She told me how beautiful and funny you were, how completely kind and gentle. She never said that she did, but I know that she loved you. A wandering sister. And there were rules of how she could help, what she could do, but she loved you as she could. To your appointments, you came with sweet smiles and sashays, you came with strange bruises and a methamphetamine stutter. Sometimes you never came at all but stayed back in Steve McQueen Square, strutting and pausing near the art gallery, near the drug store with all those who walk along the boulevard trying to find warmth and safety, earning what you could with your feminine wiles. Did you sing? A glorious chanteuse on shadowy stages, ballads in Spanish crooning from the speakers, your lips and body moving with the mournful rhythms.

Desiree came in and told Sandy you died. You were not yet nineteen, but how many lifetimes disappeared with your eyes?

Do the ladies miss you at the laundromat? Do they miss you at the Y? Do they still sing your songs on Mondays at the Silverlake Lounge? Do your clients at the Royal Hawaiian

and the Grand Motel ask after you? Do the streets themselves, the concrete sidewalks and asphalt thoroughfares, miss the clack of your high heels and the sound of your laughter? Maybe the wind cries Mary, but the rustling palm trees along Santa Monica whisper Sapphire.

I mourn you. Regularly. In ways that I do not mourn those I knew better, those I knew at all.

Every year, the city buries all the unclaimed bodies, ashed by crematoria, into a single grave. The most important memorial in all Los Angeles, the monument to the dreamers and drifters, the lonesome and the orphaned, the lost and forgotten, the unclaimed. Sapphire, were you buried there? Did your family claim you? Did they bury you with their name or yours?

I know your name, Sapphire. It is a prayer, a ballad, a poem. I wish you kept only one thing from the name your parents gave you: resurrection. I wish that you were still alive. That Desiree was wrong, that whatever tale of death only presaged your new life, somewhere else. A home, safety, warmth, food, love. That you returned from the dead and found this new life. But when Lazarus died, Sapphire was born. Maybe we are only granted so many resurrections.

"Dying / Is an art, like everything else," says Sylvia Plath in *Lady Lazarus* (1965) and your death carries more than any art I know.

Ms. Sapphire, perfect star in deepest blue stone. Sandy left working with clients not long after you died.

Sapphire, the woman I never knew. A stranger misses you tonight.

Pale

And I looked, and behold, a pale horse! And its rider's name was Death, and Hades followed him. And they were given authority over a fourth of the earth, to kill with sword and with famine and with pestilence and by wild beasts of the earth.

—Revelation 6:8

The coat on the horse of apocalypse might very well be shadows but here that pale horse and pale rider scatter the light and take form in the color of an eternity of unbroken love. Does the pale rider bring mercy? Does he bring only death?

Thought of you as everything,
I've had but couldn't keep.
I've had but couldn't keep.
Linger on, your pale blue eyes.

—Lou Reed (1969)

If ultramarine is a color beyond the water, pale blue hovers in the haze beyond it. The distant mist on a cold bright morning, the clouds a softest tincture. Beyond the beyond, a Raphaelite saint's holiest hue, the color of ether, the wallpaper of heaven with the floors planked by beams of light. Pale blue. A higher luminance and lower chrominance, bright and unsaturated. Is it truly brighter or just a fade off into yonder that color can't contain?

Nothing can be kept, when we dissolve into the swirl of dust and light, we leave all behind and dissolve into the pale blue of never and forever, a shade always out of reach.

Powder

Ah, the last time we saw you you looked so much older
Your famous blue raincoat was torn at the shoulder
 —Leonard Cohen (1971)

I have not visited my father's grave since his funeral. A cool stone mausoleum flanked by strip malls along a highway. I keep his watch on my bedside table. His work coat, voluminous and patched with union logos, hangs empty in my closet.

At the Hammer Museum in Los Angeles in 2015 hung an exhibition called *Apparitions*, about the medium of frottages and rubbings with many beautiful works by Ernst, Michaux, Breton alongside anonymous rubbings of ancient monsters from carved stone and on through the present. Leaves and hands, floors and manhole covers, books and street signs, a shrouded skeleton being eaten by worms and the gravestone rubbings every gothy romantic collects from autumnal boneyards. Documents like photographs but lightless and so much more physical, a snapshot of skin and contour rather than shadow and chemistry. A cool mist of a medium, rubbings wraith though the museum with colored shadows and textured reveals, the wisp of a bony finger up a naked spine.

In the middle of the show hang two powdery blue rubbings by Jennifer Bornstein, the larger one reveals the folds and contours of a trenchcoat. The thing itself is striking and

almost silly, a loose and wrinkled joy, open and exclamatory, a coat caught by surprise. An empty blue imprint in a papery field, its shapely creases white in relief against the waxy hue of the rubbing. It is one of many things owned by her father mysteriously purchased and sorted through by the artist, according to a wall text, from an Internet site auctioning his scattered possessions after his death.

My dad died not long before Jennifer's. We ran into each other in a gallery parking lot and talked about it. She was back in town only briefly. We were never casual friends but would have odd, meaningful, emotional encounters. Like this one. The California sun beamed hot and unshadowed. We stood on the gravelly asphalt, cars coming and going, the traffic on Wilshire coughing past palm trees and the festive colors of a 99-Cent Only Store just across the boulevard. We gave each other a big hug and I have not seen her since.

Picking through the possessions of the dead wrankles your guts with the petty preciousness of life. The incomprehensible irreplaceability of every moment and the empty trappings and rigamarole of owning a body. How little objects matter in comparison to their absent owner, how heavy with meaning they become because of that absence. Just after the funeral, I handled my dad's rusty razor blades and fish oil pills, his stained, faded V-neck t-shirts and his worn brown Wolverine work boots, all donated. I kept only a jacket, a watch, an old ID. In my head I've kept many more of his possessions, but only as loose pictures and memorized poems, as if by assembling them as words, I might summon his spirit. I miss him.

These things and the art we make are imprints of mortals, specters that live outside of us and give voice to our lives whether we are alive or not to speak. That whatever merchants may make out of estates, this need to express and communi-

cate, in this case grief and memory, is more important than any literal value that could be placed on it. Despite the shared inevitability of our deaths, we can still make something meaningful out of our struggles and share that with others. The ghost of a man in a mass-produced trenchcoat, one of identical thousands, might be only an aide-memoire but without its silhouette rubbed into paper, I would not have had this moment, with all the rhetoric of art sliced through to an actual feeling. The rubbing of this lonesome blue coat, splayed out as if caught by surprise, has all the pathos I need. I feel something and am reminded why I was alive, which is all I could ever want any artwork to do.

The man is not his coat. The artist is not their artwork. Both are only shadows, but as Dante writes in *Purgatorio* (c.1308-1320), "Now you can understand the depth of love that warms me towards you, when I forget our nothingness, and treat shadows as solid things."

Midnight

Night eats color....
Fingers stained with tar from cigarettes
Caress the writhing darkness.
And then the people move forward.
—Chika Sagawa (1936)

Tonight do you look from the porch into the darkest blue for succor from the loneliness, nervous cigarettes and scorched cocktails, old medicines for poisonous worries? Tonight do you feel a hot hand fingering your naked heart, rising and falling desire with each wet second in your crumpling sheets? Tonight do you feel the weary day wear away, each hour shed with a shred of clothing, until disrobed, you feel the pull of sleep cover your limbs with sweet relief?

Tonight do you pass from club to club, party to party, rum to whiskey, molly to coke, elated and free and knowing with abandon that you will never ever in your life be this young again? Midnight here opens the night rather than closes it. Into the sweaty sway and jerk and glide, the swerve and shudder, the dancers have never been more beautiful and you've never felt more beautiful amongst them, subliming into the crowd, the music, the deep shadows and flickering lights. "In the evening there is feeling" says Gertrude Stein and never more than after midnight. And the broken hangover and the emptied accounts and the clenched obligations and unchoice choices are tomorrow again and tomorrow, despite the chime has never felt more mercifully

further away than now.

> *Let the Midnight Special shine her light on me.*
> *Oh let the Midnight Special shine her ever-lovin' light on me.*
>
> —19th century prison song

Tonight and tonight and tonight. Midnight blue is a blanket that shrouds should we need shrouding. It covers our covert actions should we need its cover. Midnight blue gifts us intimacy, with ourselves, with others, with the darkness.

> *This is thy hour O Soul, thy free flight into the wordless,*
> *Away from books, away from art, the day erased, the lesson done,*
> *Thee fully forth emerging, silent, gazing, pondering the themes thou lovest best,*
> *Night, sleep, death and the stars.*
>
> —Walt Whitman, "Clear Midnight" (1881)

Almost black, midnight blue colors the sky of the long night, the witching hour, the tip of time from day to day, tomorrow lurching forward to tomorrow. Often unwitnessed, the daylight workers under duvets and coverlets, readying for the alarms' shrieks and sober commutes, beigest walls and whitest copy papers, mechanic grays and safety oranges.

But that is tomorrow and there is no "what was" or "what will have been", there is only "what is" as there is only the night, right now, at its fullest. And here we let the dreamers dream and here we let the dancers dance and here we let the lovers love and here we let the sleepers sleep and even if here the lonely are at their loneliest, the fullness of their loneliness is richest, deepest, thickest. And yes, the night belongs to lovers, and yes the night hankers for other nights, the nights before and the nights after, and yes it is awful lonesome and

awful exciting and not yet dead, and yes the rustle of trees in the midnight breeze feels like a kiss and a shiver, and yes our beds beg for sleep, but not yet. I'll have one more. To midnight, the bluest hour, the last of the blues before eyes close and there are only the depths and mercies in the finales of black.

Black

Ink
Pitch
Licorice
Obsidian
Asphalt
Ebony
Raven
Jet
Matte

Ink

Ink black is a stain that won't wash out.

By the time you read this, I will have a drawing by Raymond Pettibon tattooed on my body. With the sparest of lines and simplest of words, he made me unashamed to love odd beauty, to pass through struggle and embrace my own weird affections and subtle intuitions without self-consciousness. His work haunts me.

Asked by Ed Schad guest-editing for *The Brooklyn Rail* to write about an artwork that I couldn't forget, I sent him a half dozen choices and he asked me to write about a drawing by Raymond Pettibon. I started to write and couldn't finish the piece. So I went to the tattoo parlor.

I think the working class, like my family, gets tattoos because it's something that can't be taken away, a struggle we wear in our skin. My brother has our last name between his shoulder blades. My sister has one of her photographs, the shadowy torso of a mannequin, inked into her flank. I have a poem scarred into the top of my right foot that says "Once again as ever free."

I grew up like Pettibon, lower middle class in a SoCal beach suburb, barely enduring its sunstroked crypto-fascism. Nazi skinheads proudly prowled along on Main St. The local police were too often just another gang enforcing their own racist violence. Slick sunglasses and deep tans hid many a bitter white authoritarian, evangelical in their bigotry. When he was fourteen, my friend Kevin was shot in the head by a cop

for the crime of being Black. The bullet bounced off his skull and he miraculously survived. He wasn't ever the same after. The local ultra-rightist congressman sent my house regular postcards of himself surfing. The Richard Nixon Library was a half-hour drive away. The old, idealistic hippies we knew drank themselves to death under bridges.

The whole time I was reading Artaud and Kerouac, Plath and Céline, Djuna Barnes and Bukowski, Joseph Campbell's myths and Aldous Huxley's acid trips, Jean Genet's journals and Anne Rice's lush, vamp porn, secretly listening to The Velvet Underground and Bessie Smith alongside the gangster rap my friends and I would blast whilst watching worn VHS pornos, playing Mario Kart, and smoking spliffs. I hid all of it, all the high and low culture. Every poem composed, every novel read, every picture clipped out of old art history textbooks and studied tucked out of sight. My mother would often steal my books if I left them out, read my poems and stories for incriminating knowledge later to be lobbed at me with punishing force and on occasion handed over to the authorities as evidence.

It all fell apart when my brother went to jail with half his gang. I wasn't there when they took a bat to the head of Tony Leadbetter. Stubby soft pencil on thin paper, my brother's prison letters outlined the prolix politics of racial division (peckerwoods, brothers, the Mexican Mafia), elaborate diagrams (shot-callers, hierarchies, attack formations), and delicate drawings of their tattoos, the words and pictures scratched like tags across the ghostly translucence of each sheet.

I ran away and survived on the streets for a time, becoming a loner long enough to learn that the cold passion for truth hunts in no pack, that the battle was no longer physical but spiritual. I understood that to throw my body on the

machine like I was doing was just suicide. Spiritual rebellion could cause one crack to blossom through songs, pictures, words into a multitude. A single punch with a thousand blows.

This all happened before I was 13.

I first saw Pettibon's work like most punks, in the blunt force anger and defiant humor of a Black Flag record cover. Later, though still barely a teenager, I stood in a room devoted to his work in a London museum tracing the spidery weave of India ink, reading each line over and over like prayers. Pettibon loved all that he loved, high and low, with bitter abandon. He documented the crushing force of subtle and unsubtle fascism in everyday life in these American states, and he did so with an intelligence and grace that exceeded the simple revolutionary knee-jerk of punk and evolved into something tender and strange, nuanced and intellectual, into art, without ever forgetting the authoritarianism and intolerance of his origins, a regime that killed more than a few sensitive souls, murders and suicides and early graves of beloveds too sad to list here.

No Title (When I see a train...) (1986), I first saw on a t-shirt. A birthday present from my girlfriend, I wore it to ghostly thinness. It disappeared in one of the constant moves normal for a certain transient varietal of poverty.

The clank and boom of greasy black iron punching the air with a thousand tons of punishing force, the lost dream of a Hank Williams tune and the hobo fantasy of a thousand searching crust punks. I feel a surge of unalloyed joy every time I see a train. Is it a false nostalgia for some 19th-century Americana fantasy of Depression-era rambling? A boyish affection for some Freudian symbol of virility or maybe just a dream of escape? It doesn't matter. The feeling is real and immediate, electric and beautiful and earnest, a

poem. I don't care what it means or reveals. It gives me joy. Perhaps this feeling of a free affection is born out of all the struggle against the casually cruel forces that put a price tag and a brand on every noble impulse, place a prison guard at every spiritual passage: a painfully earned joy, perhaps, but true and unfettered.

I don't care that the myth of Raymond Pettibon has become some symbol of picked-over underground cred, a hipster signifier. That he's cool or successful for being a fucked-up weirdo who's friends with rock stars, a punk with a fortune, that it might make me look subterranean cool for liking him or his drawings. I write this out of wholly uncommodifiable affection. The one time I curated a show with Raymond (a collaboration with Yoshua Okón), I did it unpaid and spent hundreds of my own precious few dollars to make it happen, something I don't think I ever told Ray or Yoshua.

Besides, this one drawing might be the least hip of all his drawings. No surfers muttering noir koans or burn-out hippies arguing about Manson over bathtub acid. No acerbic critique of George W. Bush or Ronald Reagan. This isn't the anger and dream of a punk youth now retreaded by a corporate stooge. It doesn't hang above my desk at the record company.

Every time I see a train, I want to take it in my arms.

Late at night where I live now, I hear the long lonesome whistle of the freights tracking a steel path through the eastside slums, pounding with lethal force through a sleeping city bathed in the sickly glow of streetlights. The sound deep and ancient, a dynamo in the heavenly night, a song that fills me with an almost tearful exultation.

I lived a youth afraid of ever showing who I really was lest something horrible happen to me, as it often did. The quiet

tyranny of life in America strips you down to nothing. They will take away everything and suddenly. The nuns and teachers and parents and bullies and cops could break or steal anything that was precious.

We wear our spirits on our flesh and when the repo man comes, he can't skin us. At least not yet. As Susan Sontag wrote, "consciousness is harnessed to flesh." The rebellion is more spiritual than physical now, but our bodies are the first and last site of our individual and collective fight for deliverance, for freedom. This naked and unembarrassed joy I will now wear with lumpen pride on my flesh without judgment or fear, with a simple and defiant affection, until the end.

Pitch

Paint it black.

Sink into pitch black and you won't come back. Light disappears with the slow descent into its sticky squelch and gulping ooze.

The accumulated biomass of ancient life, however lightless pitch black may be, it holds in its depths millions of years of stored sunshine. Humans have been burning up this treasure trove of ancient light for over a century now, blackening the sky and greenhousing the atmosphere fueled with the destructively distilled dead of another epoch with gluttonous ease. Poetically, pitch black falls off the edge of darkness, but technically there are other pigments that can eat almost every beam of light with a single swallow.

Developed by some clever scientists, Vantablack absorbs almost all light. Painted over an object, it flattens and disappears all details and edges, curves and captures 99.96% of light. First commercially available in 2014, Vantablack's name derives from the acronym Vertically Aligned NanoTube Arrays. Though it was designed mostly for scientific and military purposes, the artist Anish Kapoor acquired a license for its exclusive artistic use. Not the first artist to find a door and close it behind him, trolling this pigment he didn't invent. In 2019 however, engineers at MIT invented an even blacker black also with vertically aligned carbon nanotubes (CNT) grown on chlorine-etched aluminium foil that captures 99.995% of visual light. No word yet on its exclusive artistic licensing.

Pitch 59

Whenever a paperback detective or a romance novel heroine opens a window and looks out and sees only pitch black, they're doomed. Pitch black, a color without meaning. A cliché. Said over and over again, it's lost its magic. When the radio announcer says, a million barrels of oil a day, can you picture the ocean of petroleum bubbling deep in the earth, the ooze of a billion years? The viscous black pumped and fed into trucks and jets, extruded into the plastics that vortex into trash continents in the oceans. In the La Brea Tar Pits in Los Angeles, statues of wooly mammoths stand forever in distress, babies watching their tusked mother sinking deeper beneath the water into that black, sticky goo. Stick a finger into tar and your skin will likely come off before the black does.

I used to read about the pitch black at the bottom of certain Christian Hells in Chick tracts. These flimsy, oblong religious comic books penned by Jack Chick would be left at phonebooths, stacked at laundromats, and handed out by true believers by the millions across North America. After committing the mortal sins of Halloween and Dungeons & Dragons (or being Mormon, Muslim, Catholic, Buddhist, Hindu, or gay), the beleaguered main character of these twenty-page cartoons would sink ever deeper into sin and iniquity. After dying some excruciating death, the sinner would awake wailing in agony, sunk waist-deep into the burning black pitch of perpetual suffering. "If only I believed," the damned scream while a horny devil with a goaty chin beard, laughingly speared the writhing bodies deeper into the fiery tar. After distributing about 800 million of these booklets, the publisher has been listed as a hate group by the Southern Poverty Law Center. Launch your enemies into pitch black (or even have enemies just because they're different than you) and you may just be a hater, sinking into the hopeless darkness of your own loathing.

Pitch black. A night without end, a complete darkness, a

black that absorbs all that's thrown at it. A black so black you get stuck in it, each yank and pull only sinks you deeper. Succumbing to the black, feeling its sticky forever seep around your body. Does it feel like a mercy or a curse? The gooey black pitch covers your eyes, the last color of the damned.

Licorice

My eyes can taste the bittersweet of licorice black. Soft and chewy, tough but pliable, readily twisted, bitten into and pulled so its skin stretches and snaps, I see it all in the dubious hue made originally with gelatin and molasses and root extract. I can almost feel licorice wriggle and squirm with sugar-rush in my hands. A glistening black, a color coated with beeswax to add to its gleam, I can taste licorice when I see it, through the glass of the candy shop display, past the crinkling plastic window, nestled in cardboard, winking its flavor at me.

We kiddies strawed licorice into movie sodas, biting off the ends and sucking in the cola. A potent sugar amalgam, a close children's equivalent to nitrous and cocaine.

In the darkness of the preteen movie theatre, I felt free. Unwatched, we would giggle and eat forbidden candy to our hearts' content. It is where I first felt brave enough to sweatily reach for another's hand. Their name, very tellingly, was Chastity. We were watching a movie about singing nuns. And my hand, gently taken for only a moment, was too slippery to be held for long.

Licorice black pushes and pulls at the same time. The soft luster adds glamor at the cost of comfort. It gives as much as it takes, the lash back of licorice black can sting. It is truly the molasses that gives licorice its color, but its dark subtlety comes from its herbal stain with a whisper of magenta and yellow shading it just so. Succulently sweet, you can taste its cavities with every bite.

Licorice is and isn't candy after all. The ancient herb is distant enough from the story that its history need not be enunciated here, though its name was uttered by Dioscorides in his treatise *De Materia Medica* written between 50–70 CE and means simply "sweet root," the tastiest parts hidden from sunlight, buried beneath the rich darkness of soil. Excepting perhaps ouzo, few other licorice herbals, fresh or processed, have a flicker of the black.

But the black of licorice finds other forms after all. Licorice whips always had a shiver of S&M. "Kiss the boots of shiny, shiny leather, whiplash girlchild in the dark," sang Lou Reed of The Velvet Underground in 1967's "Venus in Furs." When he says in his heroin drawl, "Taste the whip, a love not given lightly. Taste the whip, now bleed for me," you know its flavor is licorice.

The sugar of licorice is a tease, but we all love a good tease. Pleasures too easily satiated lead to spiritual indolence and intellectual lethargy, eventual corpulence and dissatisfaction. The too-easily-pleased in time find gratification only in suffering. Byzantine passions skitter down dark hallways, labyrinths of unspoken desire, each avenue filigreed with fingernails and deckled with bite marks, each corner reveals a begged for torment, new places easy to get lost in, to lose the wish to ever return.

The comfortable beg for affliction.

More devious devices allow for more exacting perversions, subtler excitements. A whip is hardly the most sophisticated lineament of gratified desire in the libertine's arsenal, but lovingly hued with licorice its pain might be a sweeter one.

How many of us begin with mouths full of candy, watching nuns in movie theaters with Chastity, end up curiously eyeing the shiny black whips in a dungeon?

A thousand dreams that would wake me, different colors made of tears

Obsidian

Surely black, but so lively one cannot catch its true hue. Volcanic glass cooled too fast to crystallize, scientists never can quite call it a mineral or capture its color too closely. Depending on the angle of shimmer however, approximates exist.

The Aztecs called Obsidian *itzli*, a force that found form in the macuahuitl, a sword brandished by imperial warriors. Set with prismatic blades laid into a finely carved wood shaft, according to Bernal Díaz del Castillo, the macuahuitl could chop the head off a horse with a single blow. Many drawings exist, but the only surviving macuahuitl burned in a fire in Spain in 1884, a last obliterating kiss from the conquistadors to a cruelly annihilated people.

Wielded like a club but sharp and when pulled back, serrated. Handy for preparing sacrificial victims, the blunt side could knock them unconscious while the blade could do the rest. The highest level of Aztec heaven was reserved for warriors and sacrifices, either side of the black stone sword.

Some scholars think obsidian kept pre-Contact Americans from learning advanced metallurgy. It was not this but surprise, bad timing, and disease that destroyed the wielders of obsidian blades, which gleamed even in the moonlight as they marched in loose formation, animal-skinned, and armed.

Though often black in your hand, if shaved right, the slivers of obsidian shine clear. The stone is too liquid to catch a

perfect color, but in the low spectrum, a few shades from pure black exists a flicker of its fire, far enough to glow with the softening impurities of other colors.

Obsidian is the color of soothsayers. Polished to perfection, the Aztecs also peered into them as portals to other worlds, sacred caves, reading prophesy through its starless gleam with darkling perfection. Obsidian is "the Smoking Mirror," the English translation and symbol of the fearsome deity Tezcatlipoca, god of the night sky, the north, the earth, enmity, dark winds, hurricanes, discord, divination, temptation, beauty, war, strife, and most fully, the divine embodiment of obsidian. At the founding of the world, he traded his right foot for an obsidian mirror. The deity of rulers and sorcerers, the personification of change through conflict, he is the lord of the night and its creatures—above all, the jaguar, capable of crossing between the earthly realm and the underworld.

Though wandering far from the Aztec dominion in the Yucatan, Robert Smithson came to that Mexican peninsula in 1969 trailing Heizer's dad and John Lloyd Stephens, both chasers of myths and monuments. In his rearview appeared Tezcatlipoca.

"All those guide books are of no use," said the god. "You must travel at random, like the first Mayans; you risk getting lost in the thickets, but that is the only way to make art," Smithson wrote in "Incidents of Mirror Travel in the Yucatan" in *Artforum* in September 1969.

Smithson placed mirrors around the peninsula, near Mayan ruins, in the jungle, and beside the sea; "mirror-travel" between his and the ancient world. He took photographs of his "Mirror Displacements," and carrying their glass back with him to New York, documented his visions for the magazine.

"It was in the black mirror of anarchism that surrealism first recognised itself," says Andre Breton in 1952.

Art is a poor reflection of life, its colors shine best only momentarily, the objects as lively as skeletons. There is a freedom to be found in art, as Breton and the surrealists found it, in the momentary liberation from illicit power we can sometimes find there. Beauty doesn't have to be only a short glimpse but a system of meaning we can produce, better than what we began with. Even so, a better future isn't found in obsidian or in the reflection we find in it, but in ourselves.

> *The reflected light has been erased. Remembrances are but numbers on a map, vacant memories constellating the intangible terrains in deleted vicinities. It is the dimension of absence that remains to be found. The expunged color that remains to be seen. The fictive voice of the totems have exhausted their arguments. Yucatan is elsewhere.*

Asphalt

I asked the painter why the roads are colored black. He said, 'Steve, it's because people leave and no highway will bring them back.'
—Silver Jews, "Random Rules" (1998)

Asphalt is the color of lost highways and running away, of America tying itself up into a snarl of perceived freedom through roads and oil. Sometimes raw and sometimes natural, asphalt usually dances with a dashed line streaking its color, choreography for cars and boundaries for games. Broken lines on your mind, a hyphenated thought stretching on, a scissory instruction hollering to the sky, "Cut here!" When it's double yellow, a dark black stripes the middle like a skunk mark.

Every road I ever played on as a kid. Every playground. I can hear the crunch and shift as sneakers grip its surface while basketballers dribble and fake and move with muscular grace to and fro across the court. The sound of the bounce punctuates the shiver of a metal net with each swish and brick.

A graying black ribbon that stretches in front of my house and flows uninterruptedly from the Arctic Circle to Patagonia, from Pacific Coast Highway to the New Jersey Turnpike. Black bituminous tar mixed with gravel and sand, baked by the sun, this black ooze fades a bit gray as it cracks and crumbles and makes for a color that colors modern life. Is asphalt the color of order? Of cars? Lacing

together civilization with petroleum and sand and gravel, asphalt makes the speed of modern life possible. Still viscous in heat, you can trace the scars of accidents and the imprint of kickstands for motorcycles in its skin. Asphalt's surpassed in rapidity by electricity in copper and information-fat light beaming through fiber-optics, but those two can't move our bodies. In the corpus of civilization, the veins and arteries run black.

In a thousand years, will extinct humans leave behind a spiderweb of faded asphalt cracked with weeds? Will we, with floating cars or teleporters, abandon all our asphalt roads, tearing them up and leaving only fields and gardens for those who still weirdly bother to walk? Will we abandon this ancient material for some road surface still yet to be combined, as soft as moss, needfully porous, that lets our wheels and feet move with necessary swiftness but without the punishing crash of metal and flesh across its surface?

I imagine in our future, asphalt kept around in New York like cobblestones in Vienna, a quaintness from the time of the great empire, a theme-park's period anachronism, the stink of hot tar cooking in the sun as our ancestors pad over it, trying to understand the world that made it.

Not that we ever did.

Ebony

Above all, magic seemed a form of ... insubordination, and an instrument of grassroots resistance to power.
—Silvia Federici

Let the witches gather.

The vulnerability of women in the nightless day, their ritual burns under an unsetting sun. Let these black words be a protective incantation for the ceremony, a dark, wet amulet against the bonfires of the patriarchs.

On this Midsummer's Eve, the longest day of the year, the villagers assemble near the water to get shitfaced and chant anthems and light fires to burn the witches. In the far north, the sun never sets on the solstice.

A gallery of portraits, a collection of female faces, a ceremony for the sun's zenith. On the night of *sankthans*, here we have a sabbath for ebony.

The wise crone, the dangerous beauty, the lonely widow. What was her trespass? Defiant, brave, free. A voice too loud, a wisdom too deep. Her body already a crime from birth, anything more is just a spark.

> *It must be noted that during the Inquisition, few, if any, real, verifiable, witches were ever discovered or tried.... Estimates of the death toll during the Inquisition worldwide range from 600,000 to as high as 9,000,000 (over*

> *its 250 year long course); either is a chilling number when one realizes that nearly all of the accused were women, and consisted primarily of outcasts and other suspicious persons. Old women. Midwives. Jews. Poets. Gypsies.*
>
> —Wicasta Lovelace (2002) introducing Kramer & Sprenger's *Malleus Maleficarum* (1486)

The ropes hug tightly. A torch kisses the kindling, the dry grass and wood crackle. The flames force screams until the silence of its color overcomes opposition, bitter red and hungry orange. The earth stained black, so not even rain can wash away the sin.

> *I'll fly through the candle's mouth like a singeless moth.*
> *Give me back my shape. I am ready to construe the days*
> *I coupled with dust in the shadow of a stone.*
> *My ankles brighten. Brightness ascends my thighs.*
> *I am lost, I am lost, in the robes of all this light.*
>
> —Sylvia Plath, "Witch Burning" (1966)

Time passes, and the gods change but the ritual doesn't. And then the witches become only effigies, but they still burn those.

Even in the land of the midnight sun, there's still hard shards of ebony shadow. The witches hold power in the darkness of bodies and the brightness of spirits. The moon might not light the night sky, but she's still near, a constant satellite. The dark waters still follow her call. Boil, boil, toil and trouble.

Here in the darkness of ebony, the witches gather. Here the spellcaster makes her body heave with the spiritual force of a pieta and the annunciated woman confides in her sister. Here the escaped bride of a forced marriage gives succor to the tortured. A hysterical angel flies from the pages of Georges Didi-Huberman's *The Invention of Hysteria* (1982) and a woman screams from Sylvia Federici's *Caliban and*

the Witch (2004). The proud emigrants return all looks with the necessary defiance of women. The anxious daughter lept from Gericault with a sneer on her lips. Here is Helen, having fought off all suitors, Greek kings and Trojan princes, instead becomes a warrior herself, spilling the blood of the fathers until it matches the tears of their daughters.

On this nightless night of *sankthans*, they congregate. Draped in silks and clad like soldiers in fitted ebonies, skirted and dressed, in tights and pants, in the hard glare of distant deserts and the shadowy liquid of a saffron sunset.

> *And to my holy sacrifice invite,*
> *the pow'r who reigns in deepest hell and night;*
> *I call Einodian Hecate, lovely dame,*
> *of earthly, wat'ry, and celestial frame,*
> *Sepulchral, in a saffron veil array'd,*
> *pleas'd with dark ghosts that wander thro' the shade;*
> —from *The Hymns of Orpheus* (300 BCE–200 CE),
> translated by Thomas Taylor (1792)

Eyebrows arched, their eyes can pierce flesh. There's a fearless sexuality in that wet stare, but not for you. Their naked colors cream and dance, the sky shudders with pigment. Summoned with paint, their magic is undeniable. With a palette light as a feather, they levitate off the glaring white walls. Goya imagined the sabbath and Dürer caught the eyes of a witch-mother's wisdom, but men, allies and sons at best, cannot match the power of women gathered though we can honor it. Margarita is bathed in their magic in the pages of Bulgakov. The softness of their powers comes from the hardest darkness, carved and cut by solar flames, their embrace is a sanctuary for sisters and void for their enemies. They stand often alone in their powers, but here together in force.

Ebony is originally a tropical hardwood, dark black in color, harvested from West Africa to South East Asia, prized for the depth of its dark color. Found statued in Egyptian tombs, ebony for thousands of years has been carved into everything from amulets to piano keys. The illegal overproduction threatens to annihilate the genus and the ecosystems they grow in. More broadly though, ebony is shorthand for both blackness and Blackness. It has been used by authors to condemn and celebrate the perception of this color, whether as the absence of visual light or a color of human skin. Shakespeare and Langston Hughes and a million poets in-between and after have employed ebony for skin (as did the affirmative Black lifestyle magazine of the same name launched in 1945).

In ebony, I see the toils and trials of women with power, often and easily called witches.

In ebony, I see real witches invoking tradition and nature and their ancestors, from Wiccans and pagans, to those that practice Hoodoo or invoke Yoruba Orishas.

In ebony, I see Tituba, the indiginous, enslaved woman who was the first to be accused of witchcraft in the Salem Witch Trials.

In ebony, I see "#BlackGirlMagic" and Black practitioners of witchcraft and Black scientists like Blanche J. Lawrence, photographed on the pages of *Ebony* magazine in 1949.

And I dedicate ebony specifically to them, our mothers, sisters, and daughters, my peers and elders.

The flames will still burn on distant beaches, but smoldering effigies and patriotic songs can never extinguish the fire of matriarchs. Not here, not now, not ever.

Jet

When Nina sings black is the color of my true love's hair, it's jet.

Jet black is fading as a color in everyday usage, but as a shorthand, most still recognize it as a shade of dark hair.

Jet is originally a stone, depthlessly black. Easy to carve, easy to break, and with a polish, it shines. Not a proper stone, jet was once wood from a tree like the monkey puzzle, decayed under extreme pressure over time. An organic material, a living thing, crushed but not destroyed. Burdened, it endures.

When Victorians mourned, they did so with jet, polished to perfection, arranged in arrays. Jet dangled on the breast of the Queen and strung the necks of her subjects. It fell out of fashion after the 1870s and the last master carvers of it in England disappeared before the Second World War.

Its name comes from a corruption from Greek *gagatēs*, meaning 'from Gagai', a small town in Asia Minor. According to one story in *The Princeton Encyclopedia of Classical Sites* (1976), certain Rhodian sailors arriving in Lycia called out "ga, ga," either as a request to the natives for land or upon sighting the shore in a storm; they then founded a city named after this yearning. The ruins of Gagai are not abundant, its only true remnant is jet. When some sailors tire of the struggle against the tireless seas, they yearn for the solace of jet.

Most jet is found washed up on the shore.

74 Black

But the color jet sounds like a jetplane too of course, and this ancient black gets a pilot's booming speed, beyond sound, engined into a new age, the promise of other, new places, and the speed to move there. The first issue of *Jet* magazine was published on November 1, 1951, John H. Johnson named his magazine so because he wanted it to symbolize both "Black and speed". Embedded in its name is a modern movement forward for African-American rights, traveling ever beyond, booming past the "go slows" as Nina (again) sang, less a song even than the exasperation and anger of the dignified shouting with all the force her forceful voice could carry "Mississippi goddam!"

Even if endurance is a virtue, none should be forced to do so.

> *My black face fades,*
> *hiding inside the black granite.*
> *I said I wouldn't*
> *dammit: No tears.*
> *I'm stone. I'm flesh.*
>
> —Yusef Komunyakaa (2001)

Jet black takes all color in softly and without judgment and spits back a shimmer of light. Out of the sanctuary of blacks, jet is its brightest and most enduring shadow.

Raven

Raven lover. Elegant stranger. In the long night, I will listen to your nevermores. Come tapping, rapping at my chamber door. The night is long and awful lonesome.

Silky, I can bury my face in your shade and feel the darkness as a caress and not a threat. We hide together in that shadow, the stars lending their shimmer to our sighs. I can only go gently into that good night with your color softening the mysteries.

Guide, prophet, spy, maker of the world, trickster, keep us company, waiting in the trees if only to clean our bones. The borders of the unknown are guarded by your glossy black sheen. Our births and deaths carried in your thick, black beak. Tempter sent and tempest tossed, ghastly grim and ancient bird wing out of the darkness into Poe's poetry. Byron's lady walks in beauty like the night, her tresses shimmer with the shade of softly disappearing evening: raven black.

> *Hello darkness, my old friend, I've come to talk with you again.*
> —Simon & Garfunkel (1964)

Darkness made manifest, the raven's feathers lend their color to this purgatorial shade, almost blue. The prophet of Apollo and the eyes and ears of Odin, you haunted the forests of northern peoples for epochs beyond memory. In Sweden, you are the ghosts of the murdered and in Germany the souls of the damned. To the Tsimishians, Haidas, Heiltsuks,

Tlingits, Kwakwa̱ka̱'wakw, Coast Salish, Koyukons, and Inuit of the American Northwest, curious raven creates the world out of play and ever after continues these tricks.

Ravens mate for life. When their lover goes missing, the raven mimics their lost mate's song. Beckoning, crying, praying.

Raven, when I get lost, will I hear your song? I am lost now and I listen to the wind but hear only its breath and not yours.

In the dark woods, the way misplaced, I see only crows. They caw to me. Their voice is not yours. I wander on, listening for your song.

Matte

One of the stories of American artist James Lee Byars, surely true, was a declaration by Guggenheim director Thomas Messer recounted to Thomas McEvilley. When Messer inquired if Byars was interested in a retrospective at his institution the artist insisted that the entire museum be painted matte black. "To give Byars a show would be to destroy my museum," Messer said. "I'll give him a show when he is dead."

A charmer, a dandy, a magician, a Zen Baudelaire, a cheap circus barker, an ebullient evangelist for the ethereal, a self-made exotic from some Michigan dullsville, a showman, a shaman, a gaudy charlatan, an inveterate writer of letters and a crafter of perfect, a true poet and (according to some) a real asshole, James Lee Byars is as close as Conceptual Art will get to have a low-end high priest, quietly kissing the air in gold lamé and black velvet suits. Between the virtues of professors and the vices of businessmen, these days we need a little of Byar's magic to carve a path between.

James Lee Byars is what in the 20th century came to be known as an artist.

> *A letter is a short story.*
> —James Lee Byars, letter to Toni Gerber (1975)

You can't ever look straight at James Lee Byars.

There's some trick he does, a shift of his eyes, a sweet

shimmer off his top hat, the light slippery on his black suits and gold lamé get-ups, the heavy glasses (eyes are too intimate says JLB), some combination where he's there and not there at the same time. Astral projection, perhaps stoned, or one of his goofy grinned performances under luxurious silks and gilded rooms, spaces and seats for contemplation and sanctuary and letter reading, always and ever a Perfect Death. In his *Autobiography*, the 1972 film shows only complete darkness until JLB clad all in white appears for a fraction of a second. For all his billowing spiritual power and flittering fame, he is only a momentary flicker in the black matte void. Or he's actually the void.

—

If James Lee Byars didn't exist, we would have to invent him.

McEvilley recounts an interview with JLB for his first big article on the artist for *Artforum*: "Evincing impatience with the prosaic, clerical approach, he exclaimed, 'Oh Thomas! Just make me up!'"

—

One of his "deaths" was a room gilded simply and totally in gold.

One of his last works, an arrangement of glass globes blown by a master glassmaker, each globe a single breath, arranged in the shape of an angel.

It seems wholly fitting that James Lee Byars the actual human died whilst being held hostage by creditors in a four-star hotel in Cairo, Egypt, the first capital of Eastern mysticism for Westerners seeking arcane knowledge and esoteric answers.

The artist was of course more interested in questions.

Though he staged his death many times, James Lee Byars's final performance resulted less in the death of the man and much more the demise of his imaginary.

—

One day in the 1960s, James Lee Byars released 100 pink helium-filled balloons to rise towards the moon. In 1967 in Los Angeles, JLB handed out ten thousand round sheets of white paper, each printed with the message: *A White Paper Will Blow Through the Streets*.

For these two acts alone, I love the work of James Lee Byars.

—

I also love JLB's work because he allows me to love the sensual and the ethereal simultaneously. Some sensualists can empty the object of their affections of all heart, head, and soul. While those that are committed to the cults of emotions, intellectuals, or spirits, drift out of reality, forgetting the pleasure of food or that sex breathes its own special magic.

Fingering marble and the thrush of silk on skin feels good. So does knowing that they are only stopovers on a much grander, abstract adventure.

Neither professors nor businessmen satisfy what I need art to satisfy, and the art world these last years has felt an either/or proposition. James Lee Byars is both and neither, brilliantly so.

—

A tamer of beauty, a crafter of perfect things, closed and inward, complete, somewhat silly perhaps, but always only

receptacles for a long and searching life.

James Lee Byars's grand and generous spirit frees you to physically love the things that he made. Finely crafted out of precious materials, he makes their sensual textures and glistening skins seem like they're pure material, their undeniable simple selves carved into spheres, folded carefully, gilded with gold, and spread loose and smooth, each and always was and is perfect. Is JLB an old Zen master, the kind to slap you in the face, giggle, fart, and prove with each rudeness the utter perfection of the universe? JLB was always after perfection and always found it. Though not offered with a question mark, the last book in the series of *100 One Page Stone Books* (1977/1978) declares "Do you think there could be two perfects."

In Theravāda Buddhism, there are ten "perfections" or qualities that lead to Buddhahood. Plato said ten was the perfect number. Pythagoras preferred six. Aristotle wrote in *Metaphysica* that something that is complete is perfect, nothing to be added or subtracted. And in *Physica*, the tutor of Alexander the Great declared that the circle was "the perfect, first, most beautiful form." In 1985, JLB answered his own questions, perhaps, in crafting *The Book of 100 Perfects*.

Perfect of course is more about intention than result, but JLB loved circles and spheres. He once wrote NASA asking them to take into space a flag for the planet to be permanently displayed on a satellite circling the earth, a perfect gold circle, twenty-feet in diameter. NASA declined. Though in 1982, JLB presented one to the former president of the Explorer's Club in New York. During the presentation, McEvilley played an eight-foot long brass Tibetan temple horn, its sound meant to represent the void.

This all got reported in the *The New Yorker*'s Talk of the Town column.

From JLB, March 1978:

statements

1. i'm a mystic
2. ask my best
3. i write the world's simplest poems
4. i think so
5. philosophy is news
6. thinking is my first quality
7. glimpse is enough
8. the only prerequisite is that you should be excited about something
9. you can say anything about anything
10. hypothesis doesn't exist

questions

1. which questions have disappeared?
2. i can repeat the question but am i bright enough to ask it?
3. if you ask for something that doesn't exist do you deserve it on the intelligence of the request?

—

JLB's perfect objects made of Thassos and blue African marble, labradorite granite, red lava, cut into spheres and crescents, enclosed in glass cabinets with scrawled gnomic messages are ancient relics from collapsed civilizations meant to inspire some sense of material and perfection, the meeting of reality and ideal in beauty, the realization of such making a life full of suffering more subtly endurable, the highest crafts of an inspired people.

They are also totally cheesy. Circle, sphere, column, marble,

silk, gold, red, pink, and black. Crescents and beauty and question and perfection. These are titles and images off a self-help rack at the local New Age bookstore, the gaudy flash of empty esoterica. They are crackpot dreams of a society broken by its own repressions, in a decadent age of mysteries and mystics holed up in small rooms to hear stories from speechless stars. A joker with a lunatic assurance in his own mystic quest. A holy fool. His objects are fake relics from an invented religion. JLB's stone books bear resemblance to the tablets Joseph Smith pulled out of a hill in upstate New York, quickly lost, that made for the basis of what some people call Mormonism, a made-up religion now millions strong.

All religions are made-up of course. So are their relics. Gilded in gold and left to age in grand halls, all things grow holy.

Carved from stone, JLB's objects will easily last so long. Imagine them in two thousand years in some great hallway of a museum devoted to the relics of the great, collapsed American civilization, what stories will anthropologists weave about them? What cult will they say these objects are relics of?

You could say maybe that the cult was Conceptual Art. JLB stood on the ethereal end of that spectrum, where dematerialization became more spirit even than pure idea, though some might say the two are indissoluble.

A cult of one led by a charismatic drifter and dreamer named James Lee Byars, perpetually caught between Question and Perfect.

-

The 97th of his *100 One Page Stone Books* reads: *I CANCEL ALL OF MY WORKS AT DEATH*

—

James Lee Byars deserves more colors than I can give him, but here he will be matte black. A hard impenetrable infinity of black, the color of the void he leapt into with death. The color of a perfect museum show, caught between Question and Perfect, cancels all works at death.

Gray

Smoke
Charcoal
Ash
Haze
Iron
Slate
Silver
Taupe

Smoke

Where there's smoke, there's fire.

In the warzone flares of 4th of July, after ten thousand fireworks explode the sky over the hills and valleys, tract homes and high rises, a stink of smoke settles over Los Angeles, dulling the streetlights and softening the stars, a whitening canvas that each rocket fires through and bursts against into a hot sparkle of briefest rainbows. Scratching throats with each inhale, the gunpowder burn noxious and delicious, hateful and nostalgic, just playacting battle. *The rocket's red glare, the bombs bursting in air.* Smoke is what's leftover when the last twinkle's snuffed and the last patriotic drunk stumbles home. It coats the cities for days, making more than one asthmatic curse pyrotechnic nationalism.

In the long summer, the rainless air smudges with the malodorous cough of a million cars and the diesel splurts of trucks and the chugging wheeze of factory chimneys into a smoke so thick it blankets the city. Smog mingles with the burnt-out black powder and the sky hazes gray the green palms and goldenrod houses and all you really see is smoke.

Recovering from the psychedelic blur, I have always lit a cigarette to observe the aftermath of smoke coating the city. Becoming one with the haze with each puff. As Oscar Wilde once wrote in *The Picture of Dorian Gray* (1890): "You must have a cigarette. A cigarette is the perfect type of a perfect pleasure. It is exquisite, and it leaves one unsatisfied. What more can one want?"

Smoke in, smoke out, smoke up.

When fire kisses matter, when the arson flicks his match, when a black-and-white starlet sucks a long, languid puff through two lipsticked lips, exhaling with a slow curl, a skeletal finger on a pretty face. A cleanser and a killer, an airless billow, a little taste of poison. Volcano's sulphuric sighs from hell and a forest's aromatic crackle, smoke's as close to the fire of creation you can get without the burn, but it'll kill you anyway.

> *Where do they go, the smoke rings I blow each night?*
> *What do they do*
> *Those circles of blue and white?*
> *Oh! why do they seem to picture a dream above?*
> *Then why do they fade my phantom parade of love?...*
> *Puff puff puff puff your cares away*
> *Puff puff puff night and day*
> *Blow blow them into air silky little rings*
> *Blow, blow them ev'ry where, give your troubles wings*
>
> —Gene Gifford and Ned Washington (1932)

Smoke 'em if you got 'em.

The smoldering remains, charred and black, still sing a song of smoke. Smoke is spirit, inhale a plant and its powers become yours for a breath. Cannabis's sticky green and tobacco's nicotine stab, don't soak their spirits too often or your two tarred lungs will birth more than a bad habit. A truly ghastly death awaits all those who can't kick. "You will cough. You will gasp for breath. You will suffocate at sea level, immersed in an ocean of air." says Dale Pendell in *Pharmako/Poeia* (1995). A poem enough to make even Freud quit, though he never really did. The longest he could manage was fourteen months, all of it agony: "the torture being beyond human power to bear." Just kiss another filter and learn to forget.

I began smoking tobacco and cannabis at around ten. Trapped in a prison that was childhood, the distinctly adult charms of both seemed like one of the ways out. Though I quit weed at fourteen, and have paused from tobacco from time to time, smoke still feels like my oldest and most trustworthy friend. However poisonous, when my anxiety gives me a taste of the fear I lived in as a child, the flavor of smoke again and again gives me an escape. However poisonous, smoke is an ally, a ritual, an escape.

> *When your heart's on fire*
> *You must realize*
> *Smoke gets in your eyes*
>
> —The Platters (1959)

Smoke and mirrors.

With a caping flourish, a comic book villain's escape plan. A swirling cloud of gray envelops and hides, caresses with toxic gusts, a mask made of smoke. Burn some incense and watch the aromatic bend and curl, a priest's swinging censer breathes a dragon's breath of prayer through a church heavy with faith and fear. Is the scent pleasing? Does it inspire the divine?

Smoke comes in a range of shades, from angry black plumes and pure white wisps, to chemical greens and yellows and reds; but smoke is truly ash made air, a light gray shade that colors the end of all fires. When all my flames burn out, all the courage of my colors disappear into a breath of dust, a wisp of a human, I become only smoke, a ghost clinging to life with just enough heat to keep a form that anyone can disappear with a single blow.

Charcoal

Beneath the cooling smoke, the wood and bone of a blackened forest smolders with the vanilla reek and hiss of a dying wildfire. Amongst the scorched trunks and seared flesh, cracked stone and singed fur, a naked ape gingerly foots through the cinders. A smudged finger grazes a stone, a face. A thought flickers, some synaptic spark, and the finger traces a pattern. And from this single mark, a civilization.

Before lead whites and cadmium reds, lamp blacks and burnt umbers, one of our first pigments was charcoal. Not a shimmering spectrum measured in nanometers, color is our interaction, traced in dyes and names, art and emotion, its light captured and stained into memory. Before leafy green there were only leaves, nature indissoluble from itself. The essential color not abstract from its thingness. Names still reflect nature, sapphire and ruby, rose and carrot, ivory and charcoal, but color is born with our power over it.

Coal formed from the settling of ancient life into peat and through epochal heat into fossil fuel, but charcoal is born of fire, the heat rapidly distilling that base element from the matrix of life that held them. Sucking all but carbon out, the burn preserves the shape of life in its residue. We measure oxygen and life on earth through the ancient charcoal of the first wildfires to sweep through earth.

The fire that made life when the sun kissed a settling earth is found in the fires, first wild then tamed, that danced over human faces. Controlled, that fire feeds hearths and stoves,

jet engines and reactors. In its residue of black dust, early and essential, there is also metalworking and black powder, guns and steel. Prometheus gifted us awareness with the sacred flames but also in the glowing embers, he gave us art. With the charred remains, we made our mark. Those conscious designs were the beginning of meaning beyond physical realities, the first yearnings and dreams made manifest.

In those oldest caves touched by people, we find charcoal, made mostly from bone char (ivory as opposed to carbon black for painters), mixed with spit or animal fat into pigment. Hands traced, pussies painted, herding deer and trotting auroch, still bison and proud horses, pictured hoofing it across smooth stone. Hungry prayers of our ancient mothers and fathers, transmissions to the gods, to each other, to us.

Just guesses. The drawn auroch hardly a decoration, but a literal summons of the beast and indivisible from it. (In Judaism, the name of G-d is inseparable from the deity, they are one and the same, the word that created the universe.) The pictures weren't symbols, they were prayers. To make something a symbol is, like in writing, to use a simile rather than a metaphor. Similes are always a hedge, a way to skirt a direct feeling with the softness of a *like* or *as*. "The rain is like a song" only shadows "the rain is song." Bone charcoal is and was always truly the dead animal, the hunter that killed and burned it, the artist that traces its picture, the eyes that light upon it, all united in a glance.

Many paintings still self-consciously represent and illustrate, but the actions and rituals of the best works are so connected to the materials of their making, the spirit of the artist, their vision of truth, the witness that receives it, that they become inseparable, a work that is freshly remade each time a new person sees it. I want these arbitrary letters to weave together into something neither symbolic nor representative but more

like those indissoluble prayer-actions, for the experience of reading it be indivisible from writing it, a work that isn't *about* anything but is singularly *the* thing itself.

In the scratched patterns of "charcoal" written are human fingers dragging the blackened bone in the first prayer, starvation moving their hand, hope and desire sketched into life.

Ash

Ashes to ashes and funk to funky,
we know Major Tom's a junkie,
Strung out in heaven's high,
Hitting an all-time low...

—David Bowie (1980)

What begins in fire ends in ashes.

Punched with digital gauges and flickering indicators, the glaring chrome façade opened into an oven lined with scarred and ancient brick. Wetly panting into the warehouse, the orange glow of the flames mixed with the cold fluorescents. Inside was a man.

Chris set down his beer and placed his cigarette into the side of his mouth. With a garden rake, seared and darkened, he poked into the furnace at the ashing shape. It dissolved. Some parts went easily, others he prodded hard, scraping back and forth with the metal teeth. A few stray ashes blew out of the oven with the heat of the fire and into the cool night air.

The crematorium stood in an industrial park, a dull legion of semi-anonymous buildings. A few stunted cypress trees and sharp, sticky hedges stuck out of stubby grass between parking spaces, all lit with the flacid, carrotty light of old streetlamps. Each building emptied through metal roll gates into long alleyways backed onto cinderblock walls,

occasionally patterned with some simple design to break the grayness of the crumbling concrete.

The crematorium's smokestacks were fitted with sophisticated capture technologies so that it would never puff ash into the air, though one assumed something must escape through the pipe. Those ovens were the only ones in the southern half of the state big enough to accommodate the morbidly obese. And they took so much longer to burn. Though the two side-by-side ovens ran twenty-four hours a day (which is how we ended up drinking and smoking speed with Chris at 3am that weekday night), the bodies piled up.

The crematorium ran out of room, so his bosses picked up a large refrigerator truck, the kind to rig beef across state lines. Inside, full to bursting with cardboarded corpses, one untopped box held the largest human I've ever seen in my life. Skin a bloated lavender with a white shock of hair, wild and uncombed. Months this body waited on ice to burn, so it looked, or longer. Backing out of the refrigerator and down the trucks rattling metal ramp, Sandy and I clicked the door shut behind us.

After one body had cooked its time, Chris took a push broom and brushed all the ashes and whatever else into a small receptacle in the back of the oven. After sweeping what could be swept (—*only about eighty percent of the ashes is you in the end*—said Chris), he chunked and shimmied out the contents onto a long metal table, the chrome smoked and scratched. Pacemakers get sliced out before they burn you, as they can blow-up in the oven, but everything else is sifted, run through with a magnet. The rough ash, chunks of bone, and chips of teeth are poured into a bone blender to dice whatever's left into a fine gray ash.

The ash retains a breath of moisture. At least in its hue. Everyone is a slightly different color.

Chris poured that into a clear plastic bag, knotted it shut, and marked it with the toe tag the body came in with.

—*Any more beers?*

Chris had a wide, ghoulish grin, a mouth too big for his face, glassy eyes flickering this way and that a little too quickly. We met at a David Bowie concert in high school. His mortuary school wasn't far from my college. He gave me my first hit of speed in a long glass vial, rounded tip glowing red hot while a wisp of cool, chemical smoke slithered down the stem.

After he hanged himself, the obituary did not note if it was a burial or cremation. There was no funeral, and I still do not know how to mourn him.

Haze

War is an area of uncertainty; three quarters of the things on which all action in War is based are lying in a fog of uncertainty to a greater or lesser extent. The first thing needed here is a fine, piercing mind, to feel out the truth with the measure of its judgment.

—Carl von Clausewitz, *Von Krieg* (1837)

Dazzle camouflage, called razzle dazzle by Americans, striped British and American merchant marine and warships through World War II. Geometric shapes of contrasting colors interlock and clash, a beautiful noise of stripes, a broken mirror of color. Floating paintings, skittered with bold lines and bright angular planes, however easily recognized, their disruptive patterns intend confusion and not subterfuge. Black and white, shades of gray, a tactic of mixed result, but intended to confuse periscopes and sights on position and direction, making it more difficult to hit. Radar now makes it harder to hide.

Picasso claimed it for himself. "We invented that," he told Gertrude Stein. Malevich might have too, if he, like Picasso, had seen a cannon dragged through the boulevard Raspail painted just so. Meant not to hide but to confuse.

These days, razzle still dazzles a few small ships meant to net smugglers, but for the big guys, the standard color of American warships brought down to a single shade is haze gray.

"Haze gray and underway" is a US Navy saying referring to hard duty for a surface ship at sea. Submarines enjoy a darker shade of gray. Hospital ships hide nothing with bright white. "If you cut me," says a sauced squid, "All you get is haze gray and salt water."

On a clear day you can see anything that needs to be seen, but the Navy bargains that mist and atmospheric dust is a more common condition. Like the name implies, the mixture of sky and sea in a distant horizon of thirty miles from sea level, the wisps of clouds, dissipate in a nebulous line of sight, a haze that settles into gray. The truest shade of the military-industrial complex, a Kafkaesque color, the hue of fog and bureaucracy.

Nebel des Krieges. The Fog of War. The uncertainty of knowledge about oneself and one's enemies. Their intent, their capability.

> *Reports that say there's—that something hasn't happened are always interesting to me, because as we know, there are known knowns; there are things that we know that we know. We also know there are known unknowns; that is to say we know there are some things we do not know. But there are also unknown unknowns, the ones we don't know we don't know.*
>
> —Donald Rumsfeld, United States Secretary of Defense, February 2002

In a haze of gray, we hide from ourselves as well as our enemies. Sometimes and maybe often, they are one and the same.

Iron

Gold is for the mistress—silver for the maid—
Copper for the craftsman cunning at his trade.
"Good!" said the Baron, sitting in his hall,
"But Iron —Cold Iron—is master of them all."
—Rudyard Kipling (1910)

You can taste iron at a glance. A bad filling, a slave's mouth piece, a pistol placed between your teeth, tongue gagging on the alloy barrel. Tough and dirty and poor. Iron is one of the colors of industry and power, violence and poverty. "You will hear people say that poverty is the best spur to the artist," writes Somerset Maugham, "They have never felt the iron of it in their flesh."

Grime and sparks, smoke and coke and ash, the gunk and schunk of metal scraping metal greased with oil. Iron-toothed cogs pull and churn a coil of chains, and the wheel turns, always some poor bastard's shoulder to it. Humans just operators and soft-tissue accidents, the most interchangeable of parts. The exploited proletariat puts his body and soul through the iron gears of the loveless factories, his flayed corpse just another byproduct. The holy metal colors the ancient churning dynamo, the creaking machine of perpetual inhuman labor. The iron men are always poor, their ends invariably hard.

Like most denim-clad workers, my father's bones were made of iron. A factory worker for half a century, he watched his

workforce slowly crumble as machines took most of his colleagues and so much of the rest was done elsewhere. A Union worker that voted again and again for the bosses to dismantle his way of life. He would not have understood how he helped to close his factory, crush his own union, export the engine of democracy, but he did.

American industry reached its peak and begun to sunset simultaneously.

The Minimalists, understanding the materials and potentials of modernity, began to make work out of what this new world is made of, plywood and iron and steel. Donald Judd in plywood boxes and galvanized iron, Carl Andre with metal plates, Richard Serra with hulking ribbons of Cor-Ten steel. Every object we touch is no longer made by hand but cast in factories, how could art perhaps reflect this? Female minimalists tended towards less industrial materials: Agnes Martin with paint and Nasreen Mohemedi with drawn lines, though Beverly Pepper also sculpted with steel. It makes sense that the men used such butch materials with ease, though when I look at the work of African-American and female artist Chakaia Booker, her understanding of eviscerated tires holds so much more understanding and grace of this rubber laced with metal than any other artists I've ever known.

The production of iron and its offspring like steel is dirty, and to keep the price low, Americans started letting others do it for them. China makes most of the world's steel now, the next ten countries and unions combined do not make as much. In the dirty furnaces of the People's Republic, much of modernity is cast. The artist Danh Vo wanted to remake the Statue of Liberty piece-by-piece and scatter it across the world. The original was made in France of course, but this is no longer possible. This potent symbol of democracy and liberty could

only now be made in China, a one-party dictatorship.

Iron Curtain and Iron Cross, Iron Horse and Iron Lung, Iron Man and Iron Maiden. Iron builds and bars, hardens and restricts, strengthens and secures, murders and preserves. Cast and wrought, pig and scrap, invariably alloyed, melted and smelted into prisoner's bars and serf's chains, blood-guttered swords and endless guns. Mostly steel, a colder hue, but iron all the same. Assault rifles and machine guns, revolvers and pistols, semis and automatics, bolt-actions and carbines, single and double barrelled, matchlocked and flintlocked, muskets and cannons. Numbered and named. The hunted soldier's last friend and worst enemy. A sheriff's peacemaker and the bandito's widowmaker. Each and every made from iron, the most abundant mineral on earth. The Age of Bronze gave way to Iron not because it was better but because it was cheaper, the easiest metal to outfit an army. It's no surprise that Mars, the Roman god of war is also and truly the god of iron.

Precious to modernity but plentiful in supply, it is the cheap hard bones of iron on top of which we flesh our civilization. Wet concrete sloshes and hardens around coarse rebar into stone, thus towers and prisons, cloverleafs and border walls rise from the plains. Iron is in our blood, left wet it rusts and crumbles, birthing this other hue of decay and neglect. No longer able to survive without this unprecious metal, by iron we have lived and by iron we will perish.

Whether we can see it or not, iron now colors everything.

Slate

Slate gray is a chalkboard. I recall the perfect white cylinders of chalk dusting fingers as they screech and scrape, their tips dancing over the slate, wearing down with each twist and turn, each sentence and algorithm, the simply sketched picture and the swirling cursive letters. The teacher, her back turned just so, a few wisps of hair escaping a tautly tied bun by mid-afternoon. The bent sun glares a wet orange light through louvered windows. Heads nod, eyes shudder slowly out of wakefulness to sitting slumber. The only thing to fight the drowse are daydreams and mischief, played out under the soft drone of teacherly instruction and song of chalk on slate. Daydream fantasies make pimpling boys throb against their zippers, hidden mercifully by the desktops in front of them. A few of the children dream of other places, adult places, filled with free movement and perfumes, far from the sweat stink and petty fascism of school.

Mischief invites punishment. Afternoon note passers, disco nap drowsers, and marginalia doodlers when caught often end their schoolday in detention, lingering after class to pound the erasers in the courtyard and methodically wash the chalky remnants of the day's lessons. Wiped clean, the surface returns to its unbroken, stony purity bordered by wood with a slim metal ledge to hold spare chalk and erasers. Upon slate's hard skin dance the long equations of calculus and the long march of history, snippets of literature and religious commandments, it bears the theory of relativity and the Lord's Prayer, a kangaroo court's death sentence and a quick game of hangman.

The swirling discursions of Cy Twombly over slate gray fields made for the apex of chalkboard doodles, elevating it to a spiritual apotheosis and into the permanence of an art historical canon. In *I Heart Huckabees* (2004), Dustin Hoffman's existential detective leans too far back behind his desk and when he turns Twombly's loops chalk his dark suit. A painting worth millions has the delicacy of school days blown away, maybe. Though anyone with enough money to buy one of Cy's masterpieces knows better than to lean into it, every chalky particle on that coat was a month's wages for a school teacher.

But art and learning and the hardness of slate has nothing to do with money. Money's just how the unimaginative measure desire and the masters dole out daily rations. But slate is not imaginative either, it's just a surface to draw your thoughts, and it will silently bear whatever you give and learn nothing.

Slate will take anything, but it gives nothing back. Certain poets stare at the sad ceiling of European winter and always mumble 'slate gray,' an unbreakably depressing color of sky. Even when it weeps rain or shivers snow, no stormy wetness can soften this unsparing shade. Named after the stone, this color is even harder.

Slate does not listen or speak, lacking in both empathy and enmity. Slate begs no one and grants no mercies. A grand old meister, thin-lipped, authoritative and silent, more than a bit grim, a passivity marked if only temporarily for instruction. Slate's refusal to absorb or luminesce is its value. A millennia of scholars and students found a clean surface to write and erase, over and over and over. The handheld writing slate has been in use since the 11th century in India (and probably is still used in more than a few villages) and the simplicity of its design inspired Silicon Valley rajas to craft slim slate-like computers. And for a few seasons, the impenetrably modern

"slate gray" clad these gadgets, a custom color option for a discerning consumer.

Slate's hardness is only in the eyes, it takes only a tender tap to break that stone sheet into shards. But despite its unyielding nature, slate gray does not break me either. Not in a long winter, not on a chalkboard, not yet.

Silver

Silver is of course the moon.

The finest conductor of heat and electricity, silver metal brings a spectral traveler across its color with frictionless grace but the unrhymable element is only moonshine made manifest, a pale luminance contained. Or it is at least to me.

Free of judgment and full of permission, the moon lit my teenage trawls through midnight parks looking for witchcraft in the shadows of the trees and finding the soft fingers and hard alcohol of punk girls and boys with safety pin piercings and chipped blue nail polish, smeary red lipstick and silvery bangles.

She lit my discovery beneath the long silver skirts of the merciful Bronwyn that first nervous sticky joy of sex and the moony mysteries of love.

She lit my desert dance, barefoot in sand dune labyrinths, finding in each feverish footstep the knowledge of no-knowledge in psychedelic blurs, exalting in the sweat of a thousand swaying bodies wet in the shiver of night, every heartbeat primed to primal drums, each of us lost together in ecstasy.

She lit my doleful steps and choked weeping on the white sands of a distant, tropical beach, the lunar queen lapping at my feet with a cool oceanic tongue, each sob containing the suffering of all people everywhere and the singular small tragedies of my own loves lost and grief found.

The luminous spaceship caught always in locked revolution against the earth, the moon's cool gray radiance reflects the sun's hot white heat. She measures that uncontrolled blaze of incandescent plasma with her rotational reveries. The tidal queen, the chaste mistress, the keeper of secrets and magic. An ancient, feminine force, the lustrous light of the moon shines with the ceaseless rhythm of ancient oceans, her glow ponderous, ruminative and unfathomable, a wisdom shaped from four billion years of circumgyrative contemplation.

We can sip her dewy moonjuice, dribbling down grateful chins, and we can see her naked and big-bellied in the sky, honeyed and rouged, sometimes just a smirking crescent like a sliver of thigh, but she will never be ours. Men can make mothers of daughters with a squirt and a sigh but lunar love cannot be consummated even by force. Her silvery light never generative but only reflective. Not our mother, but another woman we cannot live without. Never to bear children, still she controls the cycle that makes birth possible. Her powerful pull midwifes all living things.

It doesn't matter that a handful of astronauts set their boots on her surface. We can poke her with flags and rove her over and over, but we are powerless to possess her beauty, to diminish her celestial force. Half hidden from prying eyes, she keeps a darkness we can witness only as darkness, unborn but still new, a mystery telescoping scientists may inspect with lunar orbiters but her bright face, struck with meteors and settled by waterless seas, never truly turns its perpetually still glance.

The guardian of the night, her velvety glow illuminates our nocturnal rites. The sun is too bright, my skin too naked under its revelatory fire. The sizzle of raw creation, sunlight fathers life with its searing heat, but that brute burn hides no mysteries. The shadowed gaze of the moon however

grants us true intimacy. Even full-faced, her brightness is still loving, freeing, kind.

Sexual offerings made to strangers in the name of the moon goddess are more than forgiven but were once requisite. She pulls us from the solitude of our slumber to fuck with lunatic abandon, to light the late harvest lest our fruits rot on the vine, our wheat to seed, and we pay her tribute with feasts and orgies.

If day forces wakefulness, and night allows for sleeping; the full moon middles these two states, permitting passage between body and spirit, innocence and experience, consciousness and unconsciousness, being and non-being, death and life.

The cool consideration found in the moon's detachment contains the silvery separation from fear and mortality as one sublimes into its ceaseless waxing and waning.

Taupe

A brownish gray, taupe finds voice through sophisticated lips on autumnal afternoons, the long earthy twilights of heaving clouds and wet earth. A choir of moles sing hymns and anthems in the shade of taupe to earthworms and buried treasures, moldering coffins and ancient hoards, ruins and roots, loam and stone as they maze over secret rivers and oceans of oil, the heaviness of dirt and the gravitas of gravity causing the crust they scratch to core into the silky heat of molten lava, the fire of pure universal force, the maker of worlds.

Should you be alive in your grave, taupe is the shade of darkness your bloodied hands and dark infinities will claw should your strength allow for such a last, lost endeavor for air and light. Taupe is both alive and not. Beyond the shadow of its hue are memories of wind-stroked fields and the warm kiss of the sun. In netherworlds, the shades miss wind the most, the pure embodiment of touch, the tough and tender caresses of air's longing to add body to its breath in fire, a consummated desire to join with matter in incinerating orgy. A dangerous love affair, but all good love affairs are dangerous.

Taupe is the soft mysteries of mothers and their dark depths. Mature Demeter's care and immature Aphrodite's tease. The lush interiors of men can easily color taupe too, depending of course on which eye winks at you.

A gentle gray softened with earth browns like a distant sunlight passing through mist and barely piercing shallow soil.

Flippantly used however, taupe's an interior decorator's earthtone and the hurried fashion designer's stylish tertiary, "Start your autumn wardrobe here with tonal taupe," it might as well be the new black. Swatches and paint chips in kidskin portfolios and logoed tote bags are tiny hints of this color's total force. Though thoroughly gray, taupe can sometimes only be a less shitty brown, seasonally appropriate maybe, for those that only deal with the surface of reality. Taupe's true spirit lies in the deep and moldering earth with that first French mole whose name lent itself to the color. Nature knows her own colors best.

The ancient mushroom newly spored sports taupe when blossomed into the stem and cap of that otherworldly medicine. More animal than vegetable, the fungal color though nearly drab as russet is too alive to be mere soil and pulsates with some alien mysticism. A few of these mycological specimens will be plucked from cow patties and consumed, giving its human hosts a slight taste of their egoless dispersion and hidden kaleidoscopes, both softly throbbing just beneath the surface. But before the lightshow, when munching on a mouthful, the bitter blech and musty wretch of magic mushrooms tastes distinctly and vomitously taupe.

In the moist mulch of this hue, I find the yearning for an end, often eluded but wisely succumbed. Taupe is the inevitability of that good night no matter how hard or long we resist the dreamless dream of depthless slumber.

At the end of Hermann Hesse's *Narcissus and Goldmund* (1930), Narcissus says to Goldmund on his deathbed that he is returning to "innocence and non-being." I do not know what color we have leapt from into life, but buried in the earthen folds of the earth, it is taupe that many of us will disappear into at the end.

White

Alabaster
Cream
Linen
Ivory
Ghost
Pearl
Cloud
Lily
Bone
Snow

Alabaster

> ...that translucent alabaster of our memories, the color of which we are incapable of displaying, since we alone see it, which enables us to say truthfully to other people, speaking of things past, that they cannot form any idea of them, that they do not resemble anything that they have seen, while we are unable to think of them ourselves without a certain emotion, remembering that it is upon the existence of our thoughts that there depends, for a little time still, their survival, the brilliance of the lamps that have been extinguished and the fragrance of the arbors that will never bloom again.
>
> —Proust (from C. K. Scott Moncrieff's 1925 translation)

Memories can never be properly explained, no matter how many words or sensations we might grant our audience, but the translucence and softness of alabaster's crystalline fragility mists over my recollections, most especially the precious ones.

I was four that afternoon my mom came to school for Mother's Day. I will never be able to tell you how truly beautiful she was. The giant blossoms proudly clutched into my sweaty hand, my plaid cotton shirt stiffly buttoned to the white collar as I plodded with velcro'ed shoes through the silken skirts and polyester pantsuits looking for her. The classroom full to bursting with the swish and coos of all the mothers and grandmothers as I passed through the forest

of their legs out the front door into the courtyard beyond, a single white statue of the Virgin standing hands outstretched, garlanded with white and blue spring flowers. And there she was. And with her was a feathery burst of love, a supernova of joy. Her permed brown bob and her large ornate glasses, dark floral blouse and clinking costume jewelry, all beamed with pure emotion as I clutched her leg with unfettered affection and clenched my eyes tight to disappear totally into that feeling. I can feel the fabric's texture of her pant leg now as I can feel the sunlight's warmth and the cool, wet air of the courtyard garden. I pull back and I open my eyes and there she is again. I see it all so clearly, her so clearly, but even so, the brightness of all the colors dims just ever so slightly, touched as they are with the alabaster of memory.

One could call the color gauzy, but alabaster is not so easily folded. And the way it can color memories is not always so distant.

Days ago, Emilija picked me up from the airport. We could not hug and drove masked, windows down, in safety for each other from the horror of the ongoing pandemic. In her shoddy rental car spotted with rust, we chugged to a library converted into a testing site. My flood of dark curls flowed over a long fiery red coat, a rainbow keffiyeh tied around my neck, and my legs clad in white leopard-print pants. Under her ash blonde hair, she wore a deep blue coat, the color of ancient ice, a silky dress crawling with flowers, and orange leopard-print pants. Both of us clad in white-rimmed glasses. In all of our clashing pattern and decoration, we laughed at our accidental coordination as we stood in line behind hundreds of others that January afternoon, to see if either of us had been infected.

Two years of pandemic and death, conflict and forgiveness had chased us both, and suddenly there in that giggle of

our ridiculous clothes, all of our struggles melted away in the bright sunlight, and we simply felt the trust that only time's passage can grant and the depth that only suffering can bring. And I see the laughter in her face and it gently shimmers with alabaster's crystal white softness.

The fragile wash of color over memory, alabaster is also simply a rock. Coming in a bouquet of colors, this supple stone, softer than marble, composed of calcium, is here witnessed as white. Its softness makes it easier to carve than marble but lacks the latter's endurance. Left out in the rain, alabaster weathers and disappears. You can scratch it away with your fingernail.

The softness of alabaster is never soft enough. Its fleshiness is the cool, unyielding flesh of that which has passed. Alabaster stone is almost always funereal.

Alabaster's transparency makes for an otherworldly deliverance. Shakespeare and company coupled it with skin, that of a desired lady, though he further added azure veins and coral lips. The latter sound painfully unkissable, proving poetic love is customarily unrequited.

I cannot really give you the feeling of seeing my mother that day, but perhaps in those words is the memory of yours, or any woman who nurtured us and whom we got to witness at least once in the fullness of their radiance. Or that moment of communion you had with a loved one in the midst of hardship. These moments may never happen again, but safe under alabaster, we and they persist together. A crumbling shimmer that can never be traded. Between here and the funeral to one day come, my memories survive because of me and I survive because of them.

Perhaps the poet's alabaster is a union of bodies together even in death, limbs tangled so tight that there's no un-

gripping, and the two bodies flowing together in the grave, all life exhausted, memories eternally intertwined. Bones too are made of calcium, and as death picks away all the rest, the remains of love mingle, ribs within ribs, as John Berger writes, "With you I can imagine a place where to be phosphate of calcium is enough."

But bone is another white, and it too holds memory.

Cream

I scream, you scream, we all scream for ice cream.

Pop goes the weasel.

Just add a little sugar and a dollop of cream and the black brew of coffee softens into something not far from dessert and desserts are where cream truly belongs. Whipped, it towers into pre-teen fantasy lands, scrumptious architecture, castles in the air. A powderkeg of pillowy sugar explodes into creamy snow drifts and gooey rivers crossed by winking unicorns with rainbow eyes, silver horses run down moonbeams and a luscious lick makes everyone moan.

In the land of milk and honey, we know that the milk is cream. Thicker than water and twice as filling. And if such a place is a fantasy, happiness being anticipation with certainty according to Toni Morrison, then let the sweat accumulate on your upper lip and know that cool delicious magic of ice cream is at hand.

More than thirty-one flavors are on tap at the ice cream shop of the mind. Pick one and let it be anything your heart desires.

On my daughter's twelfth birthday, I picked her and her friends up from the mall and she handed me a creamy pink drink with the words, "Try this, it tastes like childhood." It did.

Poet Wallace Stevens' "The Emperor of Ice Cream" (1922)

is a cryptic poem, but within its passages, all cream must curdle. But for some at least, not yet. At the funeral, a body is laid out in the back, but in front they are making food for the wake, including ice cream. Whatever "concupiscent curds" of dessert that are whipped in the kitchen, the deceased has a yellow pallor to her skin that is certainly a shade of cream. The children at this funeral yearn for the deliciousness of ice cream. They are still alive and, even in the midst of death which we acknowledge here unflinchingly, the creamy pleasures of life still rule supreme.

> *Let the lamp affix its beam.*
> *The only emperor is the emperor of ice-cream.*

Linen

So many stories end in sex or death. Both even. And both often end in bed.

I've been haunted by shadows on bedroom walls and tangled sheets all of my life.

Linen is a specific shade of white, made so by its particular fibers and the wash and fold that softens and shades after our bodies pass over them in dreams, in lust, in illness, night after night, day after day. A touch of yellow and gray creeps in slowly over time and defines a color.

It's the color of the half-waking Sundays I spent only in bed reading tragedies without glasses, cheek close to the page. Uncased pillows stained with unexamined stains, the sheets thread count goes uncounted, they are papery, shapeless from wear. A thin shroud for a weary body.

It's the color of a long illness. Knowing the name of your disease may sometimes help with the cure, but some sicknesses can only be managed. I have one that does not even feel manageable, that strikes without warning and will cut me down for days and weeks. Over and again, for decades now. It cannot be cured. If I ever ghost you or disappear, know that I'm shrouded, wretched with fatigue and pain under linen.

I have spent half my life watching the changing light of a thousand days play down the walls and across my sheets. The afternoon shadows freight the light, spectred with other

afternoons, a hot sap that seeps down the walls, softening to orange, and then away. Unneeded and resting from secret sorrows, pointless nights with erratic strangers, looking and never finding a dawn. I looked past mascaras and colognes and always awoke alone, even when I was not.

The crumpled sheet hung half-thrown over my body, still fully clothed where it fell exhausted the night before, too tired even to kick off my shoes, the night's residue clinging. Muscles twisted like jagged metal, every joint and turn, crease and fold, an aching awareness. Alive, but not really.

I locked my fingers together and twisted them, one way and then the other, the joints cracked but without relief. I wrapped my left leg around the right, the leather boot kissing the back of my ankle and tensed, an unsatisfying stretch that provided some illusion of agency. I pulled my limbs apart and wrapped them the other way. The tedium and repetition of illness.

The pain gnaws away at all my energy, and I can only dazedly form melancholic half-sentences, just enough to lay there, the thoughts burbling up, gluey and inchoate. The cellphone on the nightstand tinkled with a message and I glimpsed, through my half-closed eyes, more than one on its screen. I untangled my body and turned over, bending down to unknot my laces and kicking off my shoes, hearing them drop sadly to the floor, one and then the other, followed by the socks, silent behind them. I unbuckled my jangling belt and unbuttoned my jeans and pulled them away too. I always kept my shirt on, no matter how rank it might feel. The shirt soaked up all the anguish and when the aches relented, I could peel it off, the pain going with the shirt, and slipping into the shower, bent but unbroken. The warm water, baptismal and not another chore but like a body.

Yes, another chore. Breathing, a chore. Laying still, a chore.

Pissing, a chore. Eating, walking, talking, dreaming, requires enormous effort. Every movement, every breath, every creaking minute that drips along the clock, shifting the shadows that crept across the room and disappeared in the darkness telling me the day was done, that whatever wasted thoughts and experiences that I lost, scissor-locking my limbs to relieve the pain is at least over, and tomorrow I may awake without this agony that goes and comes.

And the emails grew more desperate and the paychecks slipped away and my friends and lovers took my excuses. I call these *the shadows* to those I trust and just the flu to those I do not. Only those closest know the details of my illness.

I studied the color of my sheets, the veins branching across my eyelids. Even these actions were exhausting.

Amorphous, the pain billows silently over life like a chill fog, enveloping, hazing, disappearing everything in its thick, wet emptiness. That kind where you can only see your hands outstretched, and not even those too well. To move is to stumble, lost and without direction, trying with each unsteady footfall to find a way, a passage out, but it goes on and on. Nothing's familiar and everything's strange, and your force weakens and you lay down and accept it, relenting, surrendering. Wait for it to pass, fog can't last forever, until one day it might.

When I pull out and back to some semblance of normalcy, I forget how to live and have to relearn how to move my limbs, to fill the hours, to sit down and work, to go to the park, the beach, the forest, the store, the cafe, the bar, to watch meteor showers blaze or waves crash wetly in the sand. I call back those that I haven't chased away, begging them off again when the shadows return as they always return, or often as not, just not responding and then feeling guilt for that and not responding some more. Shadows departed, folded back like curtains, I have to learn how to speak again, not the

words but the rhythm and connection, the fluid confidence of those who know how.

Thus even when it's gone, the pain haunts my actions. I try not to make any plans, not sure if or when the shadows will come, this ache in my joints that leaves me so useless. I leave things to the last minute in a hurried city where nobody does this. Sooner or later most everyone gets frustrated and walks away. I start over again and again. But rarely deeper than the casual coupling, the occasional friend, I don't have the trust to do it again, as if trust were a finite amount that only accrues, miserly, over years, if it accrues at all.

I didn't hold a regular job or have a regular sweetheart beyond the casual for years. Commitments of any kind felt impossible for someone who can be kidnapped by illness at any moment. It's lucky I'm a writer, I could somehow survive without having to commit too much. The weird and defeating workarounds the ill concoct to achieve something like normalcy.

I dream of Proust in his bed, what dreams I might weave into words, what memories could I put in my mouth and suck on, the time spreading over my tongue, manifesting days and places not like this one.

Here and there, I take out memories of times other than this. Ecstasy and joy, unfettered, when my body felt like an instrument perfectly shaped and calibrated for pleasure, but even these feel like they happened to someone else, a half-remembered movie, they do not belong to this bestial creature shivering under the covers, sweating into his linen sheets, waiting, praying, for it or him to pass away.

When some semblance of normalcy returns, it's easy to forget you were ever sick. I wish I was being superfluous when I say at times my illness felt something in between

demonic possession and ritual torture. One website gave quite heartfelt encouragement not to commit suicide, said that the highest mortality for people with a disease like mine was suicide. This felt awful and true. I whiteknuckled. I made it through.

The stillness of being awake in bed and not sick. If you immediately roll out, bare feet slapping on hardwood, the cold tile, scratching against course carpet, you miss this calm, this still point in a turning world. Perhaps it is a wholly unnecessary stillness, brought on by sloth or indolence, but its quietude, its differences are indelible. Getting out of bed is a *truly* underestimated ability.

Shadows and sheets. These will, with some likelihood, be my last thoughts as well. The sheets, the crisp unloving whites of a hospital bed, the shadows those that dance on the glossy eggshell walls of the antiseptic ward.

But there have been other walls and other sheets.

In detective stories, tousled bed sheets are a clue, sometimes a false one.

Empty bed sheets, the lovers departed.

One of the great heartbreaks in recent art sadly gifted to us by illness is Félix González-Torres' billboard snapshot from 1991 of an empty bed, two pillows printed with the heads of the lovers who slept there. It was a memorial to Félix's partner Ross, who died of AIDS. Félix too would succumb a few years later to the disease. Their bed forever emptied.

In Naples's Cappella Sansevero, Giuseppe Sammartino's marble *Veiled Christ* from 1753 lies long and lean under the paying eyes of a million tourists. Carefully wrought, the shroud wrapping Jesus seems see-through. The body

beneath is long and lithe, beautiful. You feel in that carving a hint of lust, the violent longing found in Caravaggio's men. The veil between us and him so thin, the body so real. Make no mistake that nuns are told to consider themselves brides of Christ. An embrace that is only ever truly consummated in dreams and perhaps for some in heaven.

A better sculpture yet might be the shroud left behind, the naked Jesus resurrected, moved on to better things. His body imprinted on the tangled sheet, forever. A shroud is just a sheet with a specific purpose.

The softness of linen white can only be made with the passage of our bodies.

Ivory

In the folds of a wedding dress tucked in mothballs, a thousand tusked beasts. A soapy dream and an academic's turreted hideout from the rest of reality. The land of many-voiced singers named by traders, the coast of teeth. A piano's African memories cut into keys from the mouth of a mammal and carved to fit your fingers, sibling to the hard dense wood of ebony.

A spit of yellow marks the grace of this hard white.

> *Your neck is like an ivory tower*
> —Psalms 7:4

Beneath the sad eyes, a long muscular trunk waterfalling from a bald head of hard gray skin between two tusks, curved swords, a striking white that catches eyes on a duo of sharp points, elongated cones of dentin. Durable and unsplintered, carved by a thousand royal artisans into boats and pipes, goddesses and monsters, buttons and hairpins, chopsticks and speartips, needles and cups, billiard balls and combs. The earliest ivory carvings found in China date back six thousand years. King Solomon ruled from an ivory throne inlaid with gold. Ivory colors a symbolic magic culled from a species murdered to extinction for the sharp powers of their tusks.

Flapping deckled ears, wide flat feet scrape and drum the earth. The trees creak, the leaves shiver.

A charismatic megafauna to be sure, all creatures deserve

protection, but the trumpet of the last elephant will be the requiem of our collective demise. Ivory comes from walrus and narwhal too, but it's elephants with the largest tusks that make up most of the trade.

> *The wilderness had patted him on the head, and, behold, it was like a ball — an ivory ball; it had caressed him, and — lo! — he had withered; it had taken him, loved him, embraced him, got into his veins, consumed his flesh, and sealed his soul to its own by the inconceivable ceremonies of some devilish initiation. He was its spoiled and pampered favourite. Ivory? I should think so....*
>
> *I saw on that ivory face the expression of sombre pride, of ruthless power, of craven terror — of an intense and hopeless despair. Did he live his life again in every detail of desire, temptation, and surrender during that supreme moment of complete knowledge? He cried in a whisper at some image, at some vision — he cried out twice, a cry that was no more than a breath:*
>
> *The horror! The horror!*
>
> —Joseph Conrad, *Heart of Darkness* (1899)

Ivory is an ancient poem, a color caught in the distance, envied enough to kill a beast of such power and plodding grace, profitable enough to make a fortune and exterminate a species. The hunger for ivory invited European colonists to countless atrocities wherever elephants could be found, Conrad writes about the Belgian colonies in West Africa, capturing their unconscionable cruelty, though as Chinua Achebe wrote, "Conrad saw and condemned the evil of imperial exploitation but was strangely unaware of the racism on which it sharpened its iron tooth."

The elegance of ivory in form and color is hard to see past the graveyards of exterminated elephants and murdered humans, indeliably stained with the greed of their killers.

Ghost

But what of 'spirit' standing by itself, a naked noun, bare as a ghost to whom one would like to lend a sheet?
—Robert Musil, *The Man Without Qualities* (1930)

Pearl

The soft perfume of thrift stores and grandmotherly hope chests sighing from musty gowns, a whole era of gauzy dances and forgotten face powders, silky polyesters patterned with pastel promises. A dress like a pressed flower, a faded Polaroid. Some dream of a long gone life still breathing its subtle scent. All wrapped in a pale cardigan, fastened at the top with a single chipped pearl. I see pearl buttons with a child's awe. A hankering that doesn't yet understand the shape of its yearning, a memory to be held gently in a calloused palm.

In his 1947 novella, the luster of pearl and its promise of good fortune dooms Steinbeck's indigenous diver, Kino. Upon the discovery of a giant pearl off the coast of Baja, Kino believes its sale will save his ailing son. Instead, the pearl destroys almost everything he loves. Because of the pearl, his son is killed. Or rather, the racism, greed, and corruption around such a rare commodity is what brings him to such sorrows.

Shimmering off a knifehandle in the middle of street fight, the nacreous mother-of-pearl hides that soft white under an iridescent skin. Pearls wrap dowagers' necks, nowhere better than John Singer Sargent's portrait, *Lady Helen Vincent, Viscountess d'Abernon* from 1904, her bare shoulders and gray streak marking her mature proclivities. Something almost virginal in a rope of pearls, perhaps that's why it's a promiscuous lover's best adornment.

A minute crystalline calcium carbonate, that singular

precious stone made by irritated oysters and knifed out of clamped mouths, the pearl rolls its way into a hue, an off-white, less yellow than vanilla, a touch of blue trades a hint of that lost shine. A color best not thrown before swine, this certain white softly absorbs and marks its wearers with an enduring fragility.

Pearl white can string together memories where other colors fail.

Lily

It's purity like an insult.

Perhaps we're past the time of purity, the ideal food for fascists, excuses for moral scrubbings and racist lynchings. One of the movements trailing the Civil War in the American South was called Lily-White. Its purpose was to disenfranchise the new Black electorate. Its symbol on a farmhouse meant it was a safe place to plot, one account has them organizing over 200 lynchings, strange fruit.

> *Blood on the leaves and blood at the root*
> *Black bodies swingin' in the Southern breeze*
> *Strange fruit hangin' from the poplar trees*
> —Billie Holiday (1939)

Lily white. Another nickel phrase used by fledgling poets, often followed by skin. Another by-word for purity, the unblemished ideal has a built-in tragedy. A hothouse flower easily withered.

William Blake in 1794 sings in praise of the lily:

> *The modest Rose puts forth a thorn,*
> *The humble sheep a threat'ning horn:*
> *While the Lily white shall in love delight,*
> *Nor a thorn nor a threat stain her beauty bright.*

I prefer the thorn and horn.

The lily is hardly pure, even the Easter lily, the ideal of the

"pure lilies," *Lilium longiflorum*, the bright white of its outer petals contours to creamy yellow at the stamen. This shade of lily you'll find at paint shops reflects this creaming, a dollop of hot chroma destroying the sanctity of the whiteness. Lily white names a spectrum of colors: either here creamed or bleached-out blue in other taxonomies, but we'll draw ours from the flower.

I understand that as a flower the lily's white and perceived purity when offered in condolence is a poem intended for a spirit beyond suffering. But the unblemished nature of lily white fails to acknowledge for me that suffering shapes us towards compassion. Aesthetically and spiritually, I prefer the impure. Perhaps because I am a mongrel, covered in scars and smeared with disease, I believe that perfection (if it is even a value) is a polish only made by trials. The kind of trials that help empathy for the suffering of others to enter your heart. Scars and stains only ever deepen our beauty.

Nothing stains the lily's white because nothing ever touches it. Once handled, another, richer color is born.

Cloud

I've looked at clouds from both sides now
From up and down, and still somehow
It's cloud illusions I recall
I really don't know clouds at all
 —Joni Mitchell, "Both Sides Now" (1967)

The horizon is forever. Try to chase the setting sun to where the sky meets the earth and it will always elude you. It's not hard to see why the ancients perceived the sky as a dome. Humans divine playthings under a closed bell jar, the horizon marking the edge. It is a dome, but the firmness of that firmament is not glass or stone or even ether, but air and moisture and dust, held to the earth by gravity, enclosing without touching. The day-bright sun passes its rays through the atmosphere, scattering into a sphere of tightly held air. The horizon is only an illusion, but that hard blue is truly infinite.

The further into the sky, gravity loosens, pressure releases, and the thinning air chills. Sun-cooked rivers and rivulets, puddles and oceans evaporate. The vapor coolly condenses and clouds are born.

A warm white, softer than its harder cousins as a paint, but so far all the pixels and pigments can only just approximate the wet chroma of the real thing.

A curl of hair, a milky veil, bubbling cotton, rolling and

frazzled. Bald and towered. Fibrous, undulating, and hooked.

Moved by a revolving planet, hot and cool air collide into a jet stream that churns the atmosphere, marbling this celestial sphere with wisps of white. Surging, these clouds cruise freely throughout the heavens. Feel the wind on your skin, a purest caress and its force moves the sky.

Meteorologists divide the different clouds like animals into genus and species. Each one has its own identity and can morph and change with time, multiple species banking and shifting onto and into each other at different altitudes.

Altocumulus, Altostratus, Cirrocumulus, Cirrostratus, Cirrus, Cumulonimbus, Cumulus, Nimbostratus, Stratocumulus, Stratus.

The language of clouds is all Latin. The lingua franca of an old empire with the power to forcefully unite a fractured Europe. This dead language maintains illusions of certitude and the possibility of words that can cross borders. In Latin, *cumulus* means heaps, *cirrus* are curls, *stratus* a spread.

Heaps, curls, and spreads, clouds sound like bodies more than a visible mass of condensed water vapor suspended in the atmosphere. Master cloud painter of the 19th century John Constable called his scientifically accurate clouds "the chief organ of sentiment."

Lie in a summer field and watch the clouds whitely drift across the bluest sky. I wish I was there now. The crush of cool grass and the languor of an unfettered afternoon with a lover. Bellies full of ripe fruit, fucked into exhaustion, nowhere to be but there, we recline into the haze of gratified desire and simply let the clouds dance their mysterious dance across that infinite blue, moving without limitations into boundless horizons, and in their drifting forms find shapes.

> *Lucy: Aren't the clouds beautiful? They look like big balls of cotton… I could just lie here all day, and watch them drift by… If you use your imagination, you can see lots of things in the cloud formations… What do you think you see, Linus?*
>
> *Linus: Well, those clouds up there look like the map of the British Honduras on the Caribbean… That cloud up there looks a little like the profile of Thomas Eakins, the famous painter and sculptor… And that group of clouds over there gives me the impression of the stoning of Stephen… I can see the apostle Paul standing there to one side…*
>
> *Lucy: Uh huh… That's very good… What do you see in the clouds, Charlie Brown?*
>
> *Charlie: Well, I was going to say I saw a ducky and a horsie, but I changed my mind!*
>
> —Charles M. Schulz, *The Complete Peanuts, Vol. 5: 1959-1960*

The idled imagination sees in the clouds' shapes whatever it wishes. A fleet of ships, a zooful of animals, a gallery of faces staring down. We see whatever we see, the shapes are not random but their wisps and tendrils, billows and bends shaped by cosmic forces that make life possible are ours to see as we please.

More than one dreamer longed to catch a cloud to somewhere else, beyond the borders that men have girded, over stone walls and electrified fences, past fortressed borders and well-armed soldiers. How many prisoners watched the clouds pass the guard towers and dreamt of elsewhere?

The weatherman knows the weather knows no borders. The cloud is the true wanderer, a troubadour whose song is the slap of rain, the rattle of hail, the crack and boom of thunder.

Forever wild and unharnessed, they can wipe away cities in a flash of water or sustain civilization for millenia with a steady flow. Nomads, they owe no allegiance to anyone or anywhere. They'll spit on your passport and crumble with time any wall you throw at them, if only by watering plants that can unpiece an empire with their roots and tendrils, stone by stone.

These wet wisps and creeping mists control the fate of humans and pay little heed to their prayers and rules, dogmas and dictates. Clouds follow only their own logic. A heartfelt prayer for rain on dusty fields is only wet breath into an ocean of air.

I've breathed the air of clouds, cold and wet. Inhaled the promise of rainstorms, the secret of life, let it engulf me into its shadow, and looked into the opaque white of nowhere and forever in its interiors. But the inside and outside of clouds is a boundary made only by air and perception.

In some heavens, the gods hide in these mists. There with feathery wings and golden harps, the blessed hoof across their wooly tops and endlessly praise their makers alongside choirs of angels. These dreams are as solid as a cloud bank, the heavens hide nothing. There is only air and dust and sky forever. For technologists, the cloud is a magic phrase for distributed computing: the applications and storage happen not here but in a facility far-away, connected at the speed of light by the internet. And thus the web became a cloud.

The clouds come together and dissolve. Shapely and mutable, they dissipate into the blue, their time only ever a short one. While the cloud disappears, the water that makes it is endlessly recycled. If the clouds are the rainy kind, hold out your tongue for a taste. We are only a temporary vessel for its forces. We are only just temporary vessels for anything.

Empires rise and crumble. Borders shift and bend and break, arbitrary lines decided by warlords and kings, presidents and generals, dissolved through conquest and treaty. Ephemeral clouds eternally preside over the thrust and collapse, the ruptures and combines that make up the world of humans, twisting this way and that in the wind. The forms of clouds as changing as the borders of the countries they preside over, the continents that hold those, the rising oceans that even now inch upwards, wiping countries off the map. Even Latin one day will be forgotten, the shapely clouds will not remember the names and illusions we gave them as they drift and whorl over a world with or without humans, a shapely watershow over lands and oceans who we can shape and name, presume to map but can never control.

Bone

A shade culled from the shapely phosphate of calcium, stained by the passing of our flesh and the kiss of earth, bone is our ultimate color. It won't hide any of our secrets. That last skeleton in the closet is your own.

Bone white is too often a landlord's paint color, the hard hue easier to hide the scuffs and scrapes of passing bodies, sneakers nicking the floorboards, fingertips smearing the walls, cigarette smoke and cooking fumes with their scuzz of oil, the splatter of effluvia, the hot breaths coating it all in a human residue, the marks of life over time.

Bone resists such colorings. Not even bleach can take away its porous hue. Though truly the architecture of life, we only see bones really when their creature is no longer living, and thus bone white reminds us of death.

Bone chapels scatter the world with the rows of skulls broken-toothed and hollow-eyed, the ulnas and femurs and metacarpals and metatarsals arranged into fanning designs. Death is coming, these bone chapels whisper to us, how have you lived? And we can wonder, our eyes lively over these skeletons, what beauty or suffering fleshed these armatures, whose mother and whose son, and how did these bones once dance.

> *Shoulder bone connected to the neck bone*
> *Neck bone connected to the head bone*
> *Now hear the word of the Lord.*
> *Dem bones, dem bones gonna walk around.*

Dem bones, dem bones gonna walk around.
—James Weldon Johnson (1928)

All of us are only skeletons, freighted with flesh and spirit, waiting to come clean.

I do not handle bones idly. In my hands, they deserve as much care as the creature that once carried them. For humans as well as all other animals. I'm horrified that any museum can claim any bones in its collections. At best we are caretakers of others' skeletons. Though sometimes justly evidence, to turn a body or its parts into property is a crime.

Shakespeare's epitaph at Holy Trinity Church in Stratford-upon-Avon reads, "Good friend, for Jesus's sake forbear, / to dig the dust enclosed here. / Blessed be the man that spares these stones, / And cursed be he that moves my bones."

My bones keep the shape of me, they crook and bend beneath my sufferings, they break and heal with accident and care. And they'll be all that remains if I let this corpus molder, consciousness dispersed in decay. Together in a long pine box, they might one day rattle. My wrists and my breast plate and my pelvis, crackling together in a tympany of music. All else lost but this song of my life and death, all at once.

Snow

Drifted, my name was given on water

And laid down like hail upon my tongue.
It's become a bewilderment of white –
It snows. It does snow. It is snowing.

<div align="right">–Joan Naviyuk Kane (2012)</div>

Let it snow.

My tongue's licked flakes from the air and my booted feet have crunched over its crystalline clearings. I've snow-angelled and snow-balled and snow-boarded, piling up the stuff into shoddy snowmen, and swam in snowmelt crickling through silent forests. I have felt the coldness of its icy touch reach through wet socks and into my bones. I've laid down drowsily in a drift, ready to die. I've slid down a snowy hill in a slick black inner tube and felt swiped clean with joy with each slippery second, my brave daughter's mittened hand clutching mine. And together my daughter and I have watched that pale-faced cartoon Snow White place her red lips around that red apple.

And I've watched from a window, the snowflakes cover a city, the blur of it falling transforming cobblestone and concrete into vast blank pages, cars and trucks buried monsters, hidden except for their contours under the undulating ice, the bare birches mantled, the palms shivering like naked waifs. I've stepped into a hidden slush hole in the dirty

snow of a concrete metropolis, felt the misery of winter inch up my leg with a bitter laugh. I've woken to the phantom landscape, sucked of color, buried, erased, dead. But I really don't know snow at all. The cold forever of dead winter only ever touristed, a story that so many escapees mutter about and move on.

Baby, it's cold outside.

> *a tumultuous privacy of storm… The frolic architecture of the snow*
> —Ralph Waldo Emerson (1835)

And the soft humans caught in that infinity of white. Maybe a few leaves find themselves lingering too long on stripped trees and land, a dollop of faded color, but it's people that color all that blank grandeur. The epic silence of all that whiteness, the arcing stones naked of the softening green of vines and mantled only with ice. Almost lifeless.

But in dreams, this doesn't matter.

The winter and its leafless trees and stern stone faces and oceans of still white become in my dreams the stuff of cheesy Christmas songs. This isn't Jack London's "The White Silence," but a pop songster's "Winter Wonderland." Its grandeur is hardly cruel, but only a canvas, a backdrop, a vision across which a dreamy eye can make a body dance. Sexy Scandinavians may sweat it out in winter saunas and cold plunge naked into the snow, their heated bods a fever of color, but it's rare enough to be rare. This is the dream of winter, to see its beauty against the cruelty of a cold that will kill you without a sigh.

I've read about the snow-eating mountaineers and prospectors, explorers and hunters and Yukon anti-heroes, desperate and crazed, sprinting through white void as they

freeze to death, starved Donners and plane crash survivors gnawing their beloveds with the blank-faced beauty of snow a wordless witness.

The indigenous peoples of the north from the Yupik to the Inuit, the Chukchi to the Saami understand snow best. According to Saami linguist Ole Henrik Magga in a paper he published in the *International Social Sciences Journal* in 2006 "Diversity in Saami Terminology for Reindeer, Snow, and Ice," his people, the Northern Saami, who reside in the far north of Europe "easily" have over a thousand terms for snow, ice, freezing, and melting. (According to Magga, the Saami have just as many words relating to reindeer which gives a hint how important both can be to them.)

> *The snow doesn't give a soft white*
> *damn Whom it touches.*
>
> —Cummings (1931)

And the color of snow is just transluced light, tinged by the hue of the sun, easily stained with whatever mud or blood smears it. Compressed, the crystals strip out some wavelengths and paint it a glacial blue. Pure as the driven snow.

Touchable stillness. Months of chill white disappearing into the kaleidoscope of spring. Translucent but not transparent, the purity of ice crystals formed in the sky, gently drifting or not, a stabbing blizzard. "And Winter slumbering in the open air, / Wears on his smiling face a dream of Spring!" wrote Coleridge on February 21st, 1825.

Snow white glistens with all the colors and none of them, you wouldn't be the first to catch your death in its forever.

Pink

Blush
Hot
Puce
Bubblegum
Amaranth
Coral
Cherry Blossom
Salmon
Flamingo
Rose

Blush

First you pass through a canyon of glass bank towers, hugging the 110 on either side, concrete overpasses and underpasses, off-ramps and on-ramps, exits and service lanes. The cars and trucks and vans merge back and forth, always a chug and sputter except for late at night, and this is late afternoon. The 101 picks up in Chinatown and swings you north through Echo Park. The freeway curves to some kind of straightaway. The bottleneck snaps as the car revs up and that's when you catch the first glimpse of this blushing sunset.

An ice cream orgy and a champagne supernova, the clouds interplanetary sheep stumbling over chocolate hills covered in strawberry syrup and root beer. Either premonition or prayer, you spot the long thin letters just beneath froth and cream: they whisper a distant off-white "Hollywood." You flick your wrist and a song comes on. The freeway's moving fast now and you've got a chorus to bask in all that smeary color, bright as a dying sun.

The headlights of the passing traffic flicker on to the left, in front of you a forest of red tiger-eyes peering back. You pass Melrose and shimmy over to the right-hand lane, crossing your dotted lines with a blink. You spot the peak of the purple Brutalist spaceship that the Seventh Day Adventists use as a church. And then the KTLA tower, totally defunct since they switched to digital waves, still stretching its steel skeleton high over the freeway, a praying mantis looking for her lover.

You spiral onto Sunset Blvd. and into Hollywood, the streets lined with skinny palm trees, their funky fronds swaying in a sweet breeze. A gas station, bright-eyed and blank-faced, winks from the side of the road. Either you just left or you just entered an Ed Ruscha painting. It lasts as long as the sunset colors the sky.

But wait, I'd always hated sunsets in art.

A punk with too many buttons pressed, I was sick of everything good becoming an advertisement. Too easy a beauty, too obvious, and hardly something we could improve upon. Sublime, majestic, epic, humbling; yes, sunsets are all those things and more. A quotidian epiphany, only mawkish idlers and groping teenagers usually find time to bask in its lusty, lustrous grind. And these days, the most painfully schmaltzy cliché of all time.

All the propagandists and true believers handily hitch its epic grandeur to dictators and deities, toothpaste and anal itch cream. Fingers of light beam pious penumbras around anyone or anything needing the look of divine force. Halos are a dead giveaway for any kind of holiness. Every would-be saint is a sun god, beaming more watts than a tanning salon.

But the sunsets of Los Angeles are particular.

All that prismatic sunlight gets sucked from the sky and into the bodies of our citizens, filling them with solar heat for the cool nights under shadeless trees. All of it lit with the shivering glow of neon and streetlamps and headlights and the darting tongues of flickering matches and lighters. When the wildfires burn, the orange light licks the sky long past close of day, and their smoke only thickens into richer beauty a sunset's colors. When the soot and ash rain over the cars, the air suffuses with the smoky aroma of a campfire. It feels wrong to find pleasure in the smell.

Though others probably painted the smoggy smear of the LA sunset, Ruscha did it best, elevating rather than bringing it down. Whether gridded with streets or marked with words. Sometimes they even say "Sunset," denoting only the street in LA. The colors speak for themselves.

Probably every painter with a ray or two of romance in their blood has deigned to paint a sunset. Some better than others. The nineteenth century had its array of sunset lovers. Corot's bland pastorals choked on dust at dusk. American Thomas Cole's suns set with facile sappy burst, glowing with cheap ass religion like a Jimmy Swaggart backdrop. Albert Bierstadt chased his setting sun into the Pacific, following the US flag across the continent with divine entitlement, riding manifest destiny like an iron horse. The Europeans range from melancholia to visionary. Karl Friedrich Schinkel's bloom with watery blue, while those of his fellow German Caspar David Friedrich loom with furtive spirituality and ruination, truly crepuscular. "Oh Götterdämmerung," sigh his suns. JMW Turner had eyes only for catastrophic light-shows over a windswept navy (not surprisingly the source of his native Britain's power). Monet's stillest haystacks are turbulent with twilight color. Van Gogh's end of days bleed with frightening golds and reds.

In the following century, the setting sun took on industrial hues and maddening shape. Edvard Munch's darkening skies undulate with insanity. Even Georgia O'Keefe's sunset in 1916 is a toxic magenta halo. Though he lived in a world of sound and spirit, Čiurlionis, more than any others, captured the music of the sun as it disappeared beyond the horizon, but Romanticism and its offspring Symbolism (of which he can be included) found in spirit a reprieve from the grind of machines. In Edward Hopper's *Railroad Sunset* (1929), the signal tower's stark silhouette frames nature, here only a backdrop for human progress. Lyonel Feininger's *Sunset*

at Deep (Sunset) (1930) reveals light coming to pieces in broken angles and splintered visions along with the rest of the world. Picasso never painted a sunset as far as I can tell. I did find two by Matisse, *Sunset in Corsica* (1898), a would-be Impressionism, impastoed burst, the sun purest yellow, but the sky blue, green, pink over a landscape already deeply shadowed, a black plume menacingly billowing; and, *Young Woman at the Window, Sunset*, (1921) this second twilight is merely a wash of mauve through a window, palm trees dancing over a purple sea. You cannot tell if the young woman is opening the window to its colors or closing it to the night's coming chill.

After the war, the sunset became what it is now. Kitsch. Lichtenstein's sunset series makes dusk a stylized cartoon. Warhol's *Sunset* series of prints from 1972 look like plays with color on the most popular of popular images. "I was going for the cliché," said Dan Graham about his *Sunset to Sunrise* (1969) when interviewed by Eric de Bruyn in 1996. Irony felt like the only defense against this onslaught of easy imagery beaming from televisions and smirking from billboards. And artists started wearing "criticality" like a flak jacket.

Since this nadir of ironic detachment, a few artists in recent years have reclaimed the sunset, but mostly as another jab at its overwrought and overused pictorial beauty. While they seem to know sunsets are a cheap ploy, you can see beneath their smartish games an actual affection. Anne Collier's *Studio Sunset* (2007) isn't a sunset but a photograph of a poster of a sunset. In Lisa Oppenheim's *The Sun is Always Setting Somewhere Else* (2006), the artist takes a series of photographs (pulled together into a 35 mm slide show) of sunsets with postcards of sunsets covering the real thing. Real romantic engagement with sunsets in art felt almost impossible, always mediated by other images we've seen

of sunsets, as if we can't even see without some previous emotional manipulation coloring our eyes. Walking through the sands along the cliffs of Point Dume recently, one of my companions said "This beach is so beautiful, it's like a commercial."

David Horwitz's snapshots feel quite unabashedly romantic, even though they exist as images he tried to illicitly slip into Wikipedia as pictures of himself watching sunsets along California beaches. Its title *Public Access* (2011–2014) comes from both the California state law that all beaches up to tideline must be accessible to the public as well as Wikipedia's rules and presumptions about the nature of free images (and the anger of its editors at feeling pranked by Horwitz, their community wiping the record of his images).

It's hard to find a work by Friedrich Kunath that isn't a sunsetty smear bordering on tie-dye love-in. But like Horwitz, Kunath's heartfelt and almost unpolluted romance can't exist without the whisper of a joke. Whether pinching the setting sun along a beach between his fingers; or in two paintings with bludgeoned skys, he scrawled across one "Fuck it, I love you" and the other "I need to be more romantic." In one reappropriated photograph, the jet plane taking off into the burnt-orange of the setting sun, instead of Pan-Am or whatever, reads simply *Problems*. Kunath can't look at the California sky at the end of the day without honest and earnest emotion, but also a grin. Even the brilliant and caustic Mike Kelley couldn't help but mimic a schmaltzy album cover for the cover of his book *Day is Done* (2007). The artist stands in shadow, the sun dips into the ocean behind him in the fading light. Day is done.

But I still land back at Ruscha. He could have been mocking the cheesy romance of LA boosterism or celebrating the magical colors of California sunsets, or both. The deadpan

of his work allows for both readings. And this complexity is the true spirit of sunsets in our times. We project what we want so long as we know it's both a manipulation and a beauty, a cheap trick and the truly sublime. Whether Ed's cracking a dry joke or professing an honest affection, I can't separate his work from the skies I see everyday. I love every sunset even as I know that the ease of its aesthetic will end up in the worst and most cynical commerce. I don't let it get me down anymore. This feels generational. We all know how shitty capitalism can be, how someone will try to manhandle every authentic feeling for their own mean profit, but we find our own emotions and love and anguish for ourselves all the same. On the other side of cynicism, I've found romance.

This is not some twee denial of a hard world. We find beauty and meaning on the other side of suffering and manipulation and despite it. I see it in art, mostly in LA, but I'm sure it exists elsewhere. I see it in the projections of Samara Golden's heartstruck fifth-dimensional installations. I see it in the quiet repetition of sunset photographs throughout rooms suffused with essential scents by Ginger Wolfe-Suarez. It only makes sense that here in the heart of the heart of profiteering entertainment, a generation finds the numbness fading away.

The sun dips behind the hills. You flick your wrist again and a new song comes on, its silvery synths dance and thrum. Stopped at a red light, you watch the big-bellied moon rise over Sunset Blvd. You can see every hard sea and scar in its soft glow, full of promise and permission. The light changes to green. Your eyes shift back to the traffic and you drive on into the Los Angeles night.

Hot Pink

Cheap and schlocky, loud and superficial, a bright synthetic color for punks and floozies, ravers and badasses. A spandex bodysuit and a dyed mohawk, pink champagne in a stretch limo. A porno of strawberry ice cream drowning in whipped cream licked off the hood of Angelyne's corvette jauntily parked in the driveway of Barbie's beachhouse. A creeped-out girliness, over-gendered, hyper-sexualized, resolutely sultry.

Pink is girly according to the gender police, but hot pink holds a body angled with attitude regardless of gender. Glistening with sweat, clad in hot pants, and all out of fucks. Crowned with a bravery that knows bad taste is good taste if it's all yours, hot pink knows that a trashy weirdo is worth a hundred clones in the heat of Saturday night.

Hot pink pedals down Santa Monica Blvd. in knee-high boots and the slimmest shiver of a sequinned sheath, hair curled and cheeks rouged, nails painted and neck perfumed. Hot pink simmers with glitter, draped with a feather boa that trails like a bridal train, wedded as they are to the night. Hot pink doesn't care if they were born Mario or Bill or Christina in Gardena or Dubuque or Jalisco, belt-whipped with Catholic guilt and bullied by footballers. Hot pink knows they are a rarity, and their beauty burns with pale luminescence that flames with each swish of pantyhose. Regal and dreamy, they float along the stained and cracked cement, past the shudder and honk of the traffic slowing to admire their fire, bask in their glow. Hot pink is brazen in their beauty, inviting envy

and hatred, fear and attack, but that fearlessness struts with the knowledge that each step inspires others to prance out of the shadows and that the collective force of all the hot pinks unshrouded can crack open a closed down world.

Hot pink set free is a formidable vulnerability, the tenderest bravery.

Puce

A smashed flea filled with your blood stains puce.

French for flea, this shade of brownish-pink was first uttered seeing the bloodsucker's death streaking white sheets. In the circuit between flea and host, heartbreaker and heartbroken, torturer and tortured, there is no difference, a new beast born from their intimacy, assassinated upon separation, dying in a smear of puce. A love that kills the thing it loves, a suicidal hunger maybe, a certain abjection you can't deny yourself.

Adorable and awful. Puce is a word like a joke to designate effeminate men and discriminating women, a tea cozy color, but underneath its soft fade, always hides a bedbug's demise.

When she hits you and it feels like a kiss, its color is puce. A fistful of love, a bruise that blossoms with sickening vibrance. Examined in the mirror, its color matches your soul. Terrible and beautiful, infused with sinister magic, a lover you can fuck but never wed, easily touched and never possessed.

The word is almost owned by Kenneth Anger in *Puce Moment* (1949), a film introduced to me by a lover as "a celebration of the sweet and dangerous resignation involved in existing only within the glamour of your interior world," which of course she did. In Anger's film, a decadent beauty photocopied from silver screen vamps lives in a world populated purely by the glamour of exquisite dresses. The twinkle of stars is merely electric light on flickering sequins. She leaves to walk her trio of thoroughbred dogs, but one wonders how easily her witchy allure withers if she were to linger too long

outside the walls of her mansion.

At the end of *Sunset Blvd.* (1950), puce is the color of Norma Desmond's lipstick as this empress takes a last courtly walk into the arms of the reverent police, spiritual inferiors to a cold grandeur only Demille or von Stroheim can honor. In Dickens's *Great Expectations* (1861), puce is my color for Miss Havisham's wedding dress as she lingers, surrounded by the derelict ruins of her uneaten feast, lit only with candles and the shine of her ancient eyes, still waiting for that miracle to come.

> "With this boy? Why, he is a common laboring boy!" says Estella.
>
> I thought I overheard Miss Havisham answer,—only it seemed so unlikely,—"Well? You can break his heart."

Under the subtitle "Singular frivolity of the adulative courtiers," Isaac Disraeli relates an anecdote that in the summer of 1775, Louis XVI of France caustically remarked that his queen Marie Antoinette's silk dress was "couleur de puce," the color of fleas. It set off a craze for silk of that color. Another fickle fashion easily veiling the coming revolution.

She wore simple cotton for the executioner.

Mixing with the jeers of the terrorists, the queen perhaps heard in her head the clatter of silver plate, the hiss of a perfume bottle, the rustle of a silk dress, a few notes from an old opera song once memorized but now hard to recall. Ghostly half-dreams punctuated by sharpish trifles, some echo of fallen opulence following her as she strode to the guillotine.

Before the whistling swoop and wet thud of the blade, her last words were to the executioner. Stepping on his foot she apologized, "Pardon me, sir, I meant not to do it."

Bubblegum

I'm a high school lover, and you're my favorite flavor
—Air, "Playground Love" (1999)

Slip a sliver of softest pink onto your tongue, powdery with sugar, unfolded from a silvery sheet of thinnest paper. Tugged gently from a pack, each stick of gum waits for the suck and chew of a nervous mouth, each chaw making that pliable softness into a hunk of something almost organic, fleshy, the cud humans longed for but never had. The scent is faint, but distinct, plastic if plastic smelled good, like pencil erasers scented with synthetic strawberries, the flowery perfume of a doll's underwear drawer. A cleaner version of humanity's fleshy funk, a safer alternative to oral fixations than oral sex.

Then again, bubblegum's meant to be blown.

> *At least "blow" is not a word from commerce*
> *but the golden rule of music:*
> *know, as you would be known.*
> *Blow, as you would be blown.*
> —Sharon Olds (2011)

Tongue it through your teeth just a tease and start to blow. The elasticity of its thinnest skin inflates into a perfect pink, the slightest glimmer along its surface, just translucent enough to follow this beautiful balloon to its center and into the mouth of its maker, open lips puckered, cheeks hollowed, a look of hazy concentration as that mouth blows

harder and the bubble expands, larger and larger and larger with each puff. And then and then…pop!

All over your face, the burst always somehow a surprise. This explosion of over-exuberance, the sudden release of all that pressure. The deflated bubble, however, is no less sweet. Suck its flaccid flesh back in and blow again.

Bubbleyum and Bubblicious. Dubble Bubble and Hubba Bubba. Double Mint and Dentyne. Big League Chew and Big Red. Juicy Fruit, Trident, and Mentos. The medicinal Freedent and the addicts' Nicorette. Their jingles creepier and more erotic than anything I could write:

> *So kiss a little longer, Make it last a little longer, Longer with Big Red!*
>
> *Take a sniff. Pull it out. The taste is gonna move ya when you pop it in your mouth! Juicy Fruit, it's gonna move ya! The juice is soft, it gets right to ya! Juicy Fruit, the taste the taste the taste is gonna moo-oove ya!*

Longer, juicier. Just pop it in your mouth. Chew and blow and suck.

It's only candy.

Hardly an Everlasting Gobstopper, this confection grows gray with use and its flavor, defeated by spit and wear, dissolves into a hardened bland mass. All that's left is the texture, losing its sticky elasticity with each press between chomping molars. All bubbled out, do you finger its gooey remnant onto the bottom of a desk? Do you place it, with a certain mannered delicacy into the saved wrapper and deposit it into a trashcan? Do you toss it callously out the driver's side window of your yellow Corvette? Everyone's stuck their shoe into someone else's carelessly forsaken pleasure.

Its abandonment finds unlikely form, its stickiness gathering dirt in Rorschach patterns on city pavement. Annoying enough to anal dictators to make Singapore's single party ban the candy from the city-state. The first prime minister of Singapore when asked by BBC reporter Peter Day in 2000 that his severe laws against bubblegum would stifle the people's creativity, Lee Kuan Yew retorted: "If you can't think because you can't chew, try a banana." Another Freudian mouthful from an authoritarian papa.

In the early 2000s, artist Dan Colen cleaned up when he made a series of paintings composed of the incidental shapes of abandoned gum, the layers impastoeing in a gross allure, post-Pop abstract expression with just enough sneer to give it butch cool. And Tom Friedman for *Untitled* (1990) assembled about 1,500 pieces of chewed bubblegum into a molded sphere that was then hung at head height in the corner of the room, hanging by its own stickiness. The soft, pearlescent pink flesh shimmers like an odd body part, both weirdly attractive and a little bit gross. Like most art with such a shine, but specially for its special material, I can hardly help myself from slipping my finger into its squishy body. In *Save the Last Dance for Me* (1979), Mary Heilman's colors, bubblegum pink sheets on a black field, shimmy in your head like that titular tune by The Drifters.

And of course there's bubblegum pop, saccharine songs contrived by executives to shove down your throat, but oh they taste so sweet. Sugar on your tongue: *Sugar, sugar, honey, honey. You are my candy girl.... Yummy Yummy Yummy / I got love in my tummy / And I feel like a lovin' you; / Love / You're such a sweet thing / Good enough to eat thing / And that's just a what I'm gonna do.....*

This soft pink invites you to put it in your mouth, but try not to swallow.

Amaranth

Amaranth never fades in the perfect embrace, though all things fade after.

Lips stained by unutterable fruits, of pinched nipples pushing back, of a distant swirl in a fading western sunset, a color between the sun and the land where the two come together in bright union, one burns out the other in a evanescent sigh of amaranth.

Why do pinks always feel so light? It only takes a taste of pink to make a white sheet go red, but amaranth is a little richer than that. Amaranth is creamy, breast milk pinked with blood.

Amaranth is ancient Greek, roughly translating as *the unfading flower*, the bloom of which is where the color cribbed its name. The Greeks associated it with immortality and the gods, as its bloom lasted year-round undiminished by the changing seasons.

Amaranth the color is not an idle pink for Miami Beach motels and cartoon princesses, no grandmotherly yarns or kiddie kitsch, cotton candies or Mary Kay compacts, it is never to be found on the toothlessly effete, the flippantly louche.

Amaranth has the timely grace to exit the party at the perfect moment.

To split early is to miss the peak, the moment the exuberant

energy of mere party crests above all the walls and partitions, the formalities fall away, and the raw open force of human life coalesces into legend.

To stay too late is to take away all the lipsticked cigarette butts in your mouth and all the broken bottles in your bones. To leave at the right moment, everyone is sad to see you go but understands that all good nights have to come to an end sometime. To leave too late is to slink out, friends give curt, preoccupied adieus, distracted by this or that, the babysitter or the morning commute, that they've again had too many drinks or they aftertaste the cigarette that broke the promise of quitting.

To depart at the right time is to take away all the dynamism and hope for days afterwards, to leave your companions with the memory of the moment, still radiant, a luminous memory they can take out on darkish days.

You can be off by only minutes.

Coral

No mention shall be made of coral...

—Job 28:18

Coral summons clichés, but cliché is only poetry that's been abused.

Coral is the color of polyester leisure suits and semi-tropical fashions, wedding cake manses, of ice creams and nice dreams, the soft glossy pink easing out of the spiky back of a conch. Coral's been seen in a stretched scar, fresh wounds, and of course the undersea skeletons of precious cnidarians. A color like a jewel that advertises value, softness, leisure, even if it's just dyed polyester or a cheap coat of paint.

Blotched and smeary, coral rims the Grand Canyon, remnants of dead oceans and ossified deserts. It can be found in the rosy-fingered dawn and seeping dusk light, wheezing and whistling in and out of the heat of hot clear days.

It is the lipstick of Floridian real estate agents with painted knives on each fingertip, ready as ever to sell you an oceanfront sinker with an adjustable rate mortgage, itself stuccoed with flaking coral.

Certain suburbanites paint coral into their living rooms, familial dens for the listlessly married with a few more dollars than necessary, though never enough to wipe the smirk from the smug faces of wealthier neighbors.

Distilled into a pigment, coral loses much of its vivacity, sinking into a dead trophy of a color: emptied out and anodyne, a color strangled and barrened.

Coral is alive (or at least was). In between orange and pink, the color of course comes from the creature that leaves its bones in undulating forms: pulsating brains, stalagmites bruised Technicolor, and scraping branches, like bodiless capillaries delivering blood to the seas, or sucking it out into the earth with a rough touch.

Harvested by humans for jewelry and magic, coral's bones built empires and destroyed civilizations. In Croatia, the seas served as great mines until all the creatures were killed, an invertebrate genocide. Along the Adriatic stands more than one churchy Madonna draped in Croatian coral, presiding over dwindling believers in dying villages, the empty sea floor infertile for future fortunes. The scattered corals left in dying oceans, bleach white from industrial poisons and sultry temperatures, a last flag of surrender.

Stolen from the sea, coral protects sailors from drowning, landlubbers from storms, and children from everything. Some say it aids in the safe crossing of rivers, passages through tempests, as it can excite the nerves and deliver well-being. Though it may cure madness and give wisdom, note that coral loses its powers when broken, and is almost always broken.

One of China's Eight Precious Objects and India's Nine Sacred Gems, Mongolians sometimes ground coral to pen the sutras. Mixtecan lords in coastal jungles inlaid the stone into funeral masks. A string of coral beads bestowed knighthood in the Great Benin, losing your string meant losing your head by order of the king.

Although coral can be found all over the world, our hunger

for its qualities only lead to its destruction. We want to hold its rich hue and feel richer from it, no matter what the cost.

Coral is a place, a vision, a lost frontier. In southern Utah down a cracked and graying road through cheatgrass meadows and red rock, there sits soft and heavy sand dunes the color of coral. I've been there twice. Once as a finishing teenager, I escaped to this lonely landscape to find beauty, solitude, meaning. The second time, I jumped naked, laughing down the sides of sheer-faced dunes, feet buried deep into their sides, stretched out on a sun-kissed back into the windswept sands. Heartbroke and then healed, both times, I carried its vastness within me without stealing a grain of sand, indelibly stained with the kiss of its color.

Cherry Blossom

Always will I love the time of cherry blossoms
This time, I keep in my heart
An open wound.

—Song chanted during the Paris Commune of 1871, originally written in 1866 by Jean Baptiste Clément

A Selection of the Traditional Colors of Japan;
or Songs for Revolution I Hope One Day Are Written

Cherry Blossom

Long Spring

Dawn

Sparrow Brown

Decaying Leaves

Pale Incense

The Brown of Flattery

The Color of an Undried Wall

Golden Fallen Leaves

Contemplation in a Tea Garden

Pale Fallen Leaves

Thousand-Year-Old Green

Rusty Storeroom

Velvet

Harbor Rat

Iron Storage

Mousy Wisteria
Thin Color
Fake Purple
Vanishing Red Mouse
Half Color
Inside of A Bottle

Salmon

Ask yourself, 'What kind of happiness do I feel with this music or this picture?'
—Agnes Martin, *Beauty is the Mystery of Life* (1989)

In the hard grids of painter Agnes Martin's canvases, I find a quivering line.

In her pure color, I catch a fade.

In Martin's palette, the palest of colors have the boldest of forms, and the softest hues of salmon pink swim with powerful force, an ocean at sunset churning with the life of a school of fish heading home.

Bricked up, Martin's grids can look so much like undried walls at a glance. They are lines that do not limit; these are not slats or bricks but bands of light. You almost feel you can move your hand through them. The netting of lines shapes vision without limiting movement.

Six paintings make a single work in *With My Back to the World* (1997): cool washes of neverland blue band with creamed vanilla, salmon pink whispers, and a swathe of dusty cloud. Wider and thinner, one striped sky leads to another, six windows in one chamber, each peering onto another prairie. Do you feel their intense calm, the delicate wrist that crafted each atmosphere? Regular in their geometry but inconstant in their color, the planes cutting the light like a window's

louvered panes. With my back to the world, they are not windows out but windows in. Stare at the wall long enough, with severe meditation, and any wall will crack and score, warp and weave, and out of the nothing, color can be coaxed. The perfection of hue manifested with human imperfection, stained with pigment to make semi-permanent (nothing lasts long but the earth and the mountains, said White Antelope of the Cheyenne). This long moment found after years of solitude and presence, silence and contemplation, this work of six canvases spread across a room and made into one vision, just one, that attempts to reflect the perfection of the world back on itself, with her back to the world.

Horizon lines for still seas on winter days.

> *Beauty illustrates happiness: the wind in the grass, the glistening waves following each other, the flight of birds – all speak of happiness.*
>
> —Agnes Martin

Agnes Martin came from the Canadian Prairies (born in 1912) and went into the New Mexican desert (died 2004), both places filled with a writhing stillness. Rippling grass and naked earth, they are weighted on a clear day with the heavy emptiness of purest blue, the kind of blue that ripples with silence. Looking at an Agnes Martin painting is as close as I can ever get to being Agnes Martin, watching the prairie grass shiver, mirages rising out of the dust.

Between the Prairies and New Mexico, Martin lingered for a time in New York. Then she wandered. She stopped making paintings. When she landed in the desert, she built a little adobe house and tried to discover the depth of real solitude. An ascetic intensity. After some years, she started making paintings again. These were similar to the ones before, but lighter. Less defined, more unencumbered. A hard clarity won.

Both the earlier and the later work are beautiful to me, but in the first I feel the tug of the earth and in the second the tug of the sky. After six years away from art, Martin called her return in 1973, a portfolio of screen prints, *On a Clear Day*.

The first time I walked through Agnes Martin's retrospective, I felt overwhelmed with emotion. Hardly sentimental or personal, but a feeling of an elusive, sublime connection to people, landscapes, all the things. It's hard to feel communion with others, environments, objects, to all that happens outside our immediate perception and much of what's within, but sometimes I can find a connection and these paintings let me glimpse, through their lines and colors, a bit of the infinite. Surrounded by mountains, adrift on oceans beyond sight of land, waist-deep in a field that stretches to the edge of all horizons, I feel small. These paintings are not mountains or prairies or oceans, but they are awfully close, about as close as any of us can get.

The hexagonal room installed in her retrospective at the Los Angeles County Museum of Art in 2016 was a stained glass chapel, a cave of softest jewels fingered with shafts of sunlight, a silent disco made only of the flicker of steady lights reflected from a stilled mirror, a borderless territory. And here in this chapel, I pray. In this cave, I spelunk. In this silent disco, I dance a dance without motion in an infinite landscape, sitting on a big square bench in the middle of a gallery with white wood floors and hard white walls lined with pictures of the softest visions and richest spirit that can be cut from creation and made into paint. Sitting next to my daughter, her patience adds its own color.

A whole palette belongs to Agnes Martin. Her pinks alone, always soft, range from palest powder to freshest salmon (as *Faraway Love* and *Holiday*, both from 1999). Her colors

and lines always perfectly imperfect, a wordless prayer all their own. The vibrant life pulled from the pink of a salmon's flesh, containing a thousand rivers and the drive of its nature, seasonal, constant, alive, feels a powerful shade from her colors to honor her, even if she says her work is "anti-nature" and isn't about color but composition in "The Untroubled Mind." Yet she also says, "The wiggle of a worm is as important as the assassination of a president," with which any salmon would surely agree.

Flamingo

A gangster's dream casino named after a leggy lover, a transgressive midnight movie, a lawn ornament, and simply a rosy bird. The name nabbed from the Latin for "flaming."

Maybe you heard the words first from a leathered greaser at an all-nite coffee shop in the hip part of Omaha or from an old queen at the trashiest gay bar in Wisconsin, one or the other uttered *Pink Flamingos* (1972) and the name "John Waters." You haven't heard of either but sort of pretend anyway, mumbling something uncommitedly slippery and face-saving like "Yeah, I think I've heard of him." And the tattooed tough or the sassy royal tells you (you're only thirteen after all or eighteen maybe, but totally sheltered), "No, you haven't, but that's okay. We're going to fix that right now." I caught *Pink Flamingos* on TV late one night, parental Catholicism stymied in the face of cable.

"The Filthiest Person Alive," the divine Divine misbehaves in the first big movie for Waters, concluding the flick with a shit-eating grin that made it dirty enough to thrill a crew of late nighters already stuffed with the talented Linda Lovelace disappearing a few interesting bits into her mouth on screen a few gulps earlier that same year.

His *Pink Flamingos* gathers its name from the pink flamingo. Not the bird, or at least not directly, but the humble plastic ornaments adorning the front lawn as the movie begins. Designed by Donald Featherstone in 1957 as his second assignment at Union Products in Leominster, Massachusetts,

"the Plastics Capital of the World," these would-be exotics dotted not only the lawn of Waters' flick but often the scrappy yards of the poorer houses built in a hurry, all looking the same. "You had to mark your house somehow," Featherstone said. "A woman could pick up a flamingo at the store and come home with a piece of tropical elegance under her arm to change her humdrum house." Also, "people just thought it was pretty," added Featherstone's wife, Nancy. They had became a byword for all kinds of kitsch, but post-Waters it became a classist in-joke, and the director flung away his own collection. The Featherstones, not too eager to change, wore similar clothing to each other for 35 years with knowing or unknowing kitsch.

The flamingo gets its color from carotenoids eaten in its diet of algae, going pink or orange depending on what color it munches on most; those birds in captivity tend to go pale pink unless fed a colorful diet. The healthier their color, the sexier those beaky birds grow to each other. Deep pink dollopped with orange and dyed into plastic, the color ends its life fading in the sun on a front lawn, as a shade of frosting on tropic hotels, a candied chick, in an Easter basket, and in Bugsy Siegel's eyes as the assassin's bullets pierced his body, too many dollars lost in the desert sands on that damned casino that proved visionary before his body went cold, a color that still mentioned gives a gag and a chortle, a dream of some place far away only known in dreams.

Rose

After my mother's funeral, I did not know what to do with her flowers. She grew a quartet of gargantuan rose bushes (white, orange, red, and pink) in her side yard. Their blossoms were equally magnificent in their thickness and aroma. They became her funeral flowers too. Of my siblings, I lived nearest to my mother. Reluctant to relegate the flowers from her service to the trash, I gathered all the lush wreaths and bouquets and took them into my tiny apartment. The colors and aroma overpowered my kitchen, most particularly the hundreds of carefully arranged and brilliantly colored roses. The power of their scent and the brilliance of their color gave her death a beauty and perfume I dearly needed, rather than just the void created by her absence in this world. They helped me to mourn.

As they started to fade and dry, I could not bring myself again to simply throw them away. So a month after her death, I gathered them together in a sash of fine fabric and drove myself and my daughter Stella to the Los Angeles River. We overlook its flow everyday from the hill where we live together.

And at sunset, I read her eulogy and wept. Then Stella and I set each of the flowers into the river and let the water carry them away. A ritual for my mother, Sharon, and her roses. Rose of Sharon.

> *I am the rose of Sharon, and the lily of the valleys.*
> *As the lily among thorns, so is my love among the daughters.*

> *As the apple tree among the trees of the wood, so is my beloved among the sons.*
> —The Song of Songs 2:1-3

A rose is so many things, but a rose and the color we name from it are only ever truly and simply themselves.

A rose is a rose is a rose is a rose…

Each five-petal kiss of color blooms from sharply tangled green stems. A broken-hearted smear, a yearning expressed through the formality of its presentation, the rose's simple obviousness is its charm.

In many languages, the word for "rose" and "pink" are the same. *La Vie en Rose*… with over three hundred species and more than ten thousand cultivars, the colors of this storied flower bend the spectrum with an ancient elegance, a clichéd passion, and the gentlest perfume of love.

All of us hide roses in our pockets. The better of the two rose emojis on every phone is that of a dark red rose, a leaf like a hard spade pointing earthward, a single petal lilting down from its bloom…bent tenderly, softly, yieldingly downward, as if to lick the cut it just gave you, beckoning you to stick your face into its folds, a gentle nod to all of our inevitable corruption. A cut flower is both full of life and already dead. The brilliance of this rose emoji's color and the single descending petal acknowledges both simultaneously. Even so it's only a picture, that petal perpetually falling, forever arrested in its decadence. And yet utterly disposable, just pixels on your phone, erased with a single swipe, tossed with next year's model.

The rose grows thorns to protect themselves from predators. The allures of this flower are not only olfactory and visual, but gustatory for the right grazers and insects, and these

pointed prickles are an attempt at deterrence. More than one rose has drawn my blood, the dripping finger quickly mouthed, or when its thorn's pulled from my flesh, that hard, smooth little tooth, the blood blossoms with a deep red but never so deep as its perpetrator.

Rose is a shield, a glamor, a delusion.

> *Rose tints my world*
> *Keeps me safe from my trouble and pain.*
> —*The Rocky Horror Picture Show* (1975)

Stella once told me that red-flags just look like flags when you wear rose-colored glasses.

Rose gives me pleasure, though I don't spend the strength of its cliché without pause. Even so, the true meaning of this flower and its color are always elusive to me. The meaning of rose mists and flows, cuts and ghosts, fireworks and fails, refusing to be held.

> *"Roses," she thought sardonically, "All trash, m'dear."*
> —Virginia Woolf, *Mrs. Dalloway* (1925)

Rose, floating in the pond, a dead flower in the eddies of the silver surface spangled with light. A sensuous bathtub blanket for the weary, a romantic's bedspread. Rose, a gesture, a lover's lament, a spouse's apology, an empty signifier that swallows whatever we wish to fill it with. A shapely scented flower, a succulent metaphor… rose, by any other name still a name, nearly timeless but just a little old-fashioned…a rose for Emily.

> *…because the rose is a symbolic figure so rich in meanings that by now it hardly has any meaning left.*
> —Umberto Eco in the postscript to *The Name of the Rose* (1980)

Georgia O'Keefe knew surely what she was doing with her folded blooms, plumped petals peeled back. Victorians corseted by rigid morality spent repressed hours devotedly fingering their carefully cultivated flowers. Fresh blossoms will wilt on the vine whether they are nabbed or not.

Sub-rosa...words spoken under the rose remain secret, or should be. The secrets of roses are not open to everyone.

A poet once told me she only enjoyed cut flowers knowing that something was dying expressly for her pleasure.

Every rose has its thorn...

Flowers began as a funeral tradition to mask the odor of decomposition. Wreathed, bouqueted, and sprayed, apple blossoms and heliotropes, chrysanthemums and camellias, hyacinths and delphiniums, snapdragons and, of course, the dowager queen, the Red Lady, roses. Anything goes for funeral flowers, just so long as they are fresh.

As bright blooms fade, what is the color of decay? Spotted and mottled, both wet and dusty, alive with its own decline and aromatic with rot, the color is unsteady at best, a hue with a checkered future.

Tuck a rose away, let it dry and though the life goes and the color deepens, its form remains though easily crumbles with thoughtless handling.

> *Ah Little Rose -- how easy*
> *For such as thee to die!*
>
> —Emily Dickinson (1858)

And I won't forget to put roses on your grave.

"What is a wound but a flower," wrote the poet Dorianne

Laux in 2018. And my mother left me both many wounds and many flowers.

Before we sold my mother's house, where she had lived with my father for a half-century, where she raised all her five children, where she, like my father before, spent her last moments, I clipped a few roses from her garden.

I keep all the flowers I buy from the florist and all that are gifted to me. They become an altar, an offering that grows larger with each passing week. And on the anniversary of my mother's death, I take them all into a sash of fine fabric and return to the river. I read her eulogy again and weep again and set all the flowers, all the roses, all her roses into the water and let the current carry them, through the curves and under bridges and past parks and homes, and finally onward to where the river meets the sea and away.

Purple

Royal
Lavender
Plum
Orchid
Mauve
Amethyst
Lilac
Magenta
Violet
Wine

Royal

Purple is a silk scarf easily knotted into a noose.

Reserved by the Romans at first for generals and patricians, it crossed the Rubicon with Caesar and became imperial. The kind-hearted emperor Nero confiscated all property of any soul found buying it, before he executed them.

Medieval kings often coveting the lost empire claimed purple as their birthright, but with few hobbled and titular exceptions, the age of emperors had given way to kings. Imperial ran royal, and this purple changed names.

But its true and first name was always simply ever purple, tongued by the Greeks, their name for sea snails whose glands, when squeezed, leaked mucus that changed colors and settled through treatment into a rich dye. The Greek word itself was mothered by another meaning "blood red," and perhaps this ancient lineage is why the Romans granted their triumphant generals the honorific title *imperator* along with robes colored with purple's patriotic gore.

The land now known as Lebanon, the Greeks called Phoenicia—Land of the Purple. Phoenicians called themselves Canaanites if they thought of themselves outside of their hometowns at all. The Hebrew Bible talks of exodusing Israelites murdering the Canaanites for the promised land, though archaeologists say that Israelites were really just another kind of Canaanite after all.

The kings of Israel wore purple, so did their conquerors,

the Persians. Plato considered purple an emblem of empty wealth and effeminate besides. The Persians conquered Athens too. But when Alexander the Great destroyed the emperor of Persia, Darius III, whatever remnants of Greek hatred against imperial purple for more democratic hues evaporated with their native son's martial triumph.

To distinguish it from later shades, some call the original purple Tyrian, after the Phoenician city-state of Tyre that mastered the trade of collecting and killing the mollusk. It took some 12,000 shellfish to extract 1.5 grams of the pure dye. Tyre itself was putrid with mountains of broken shells and rotting seaflesh. The Greek geographer Strabo (c. 64 BCE - 24 CE) politely commented that the purple cities of Tyre and Sidon, were "unpleasant for residence." The dye-workers hands were stained permanently purple.

Though shades of color hold infinite association, through empire, this purple became a color of oppression. But not always, of course. In Alice Walker's *The Color Purple* (1982), a novel full of hurt, this shade barely appears, but when it does, it hints at a better life. For Hindus, purple is the color of the Crown Chakra and symbolizes oneness with God. So often with purple, we look upward and beyond, claiming this color can have its power.

Later revolutionaries claimed red, the purer primary against the royal purple of corrupt kings. The ancient vices of conspicuous consumption, wealth, and power, all clothed themselves in this ancient color. Though some Catholic agents still claim purple for piety and penance, no costumes of rulers bear the imperial color's stain any longer. It is now a decadent color seeped from a decadent age. As the few scattered bodies who still claim crowns, royal purple now looks toothless, an empty honorific of a disappearing age. The color once dethroned is a senile shade, lovely only to

those who can still see the blood-soaked banners and fearsome armies in the broken columns of ruined empires.

The original dye was so valued because that purple never fades, it only ever gets brighter with age.

Lavender

Lavender is the color of forgetting.

Firstly, a flower and more than that, a scent, but here a color. Later perhaps, the three may separate. Here, they are wholly indivisible.

Purple spikes in about 45 separate species and 450 cultivars, the flowers of this mediterranean mint lent their name to the hue. They sprout in bushy arrays close to the ground with leaves usually feathered in pairs off the stem, hairs heavy with aromatic oil. The whole plant emanates the scent of lightness, of forgetting.

Lavender is difficult to remember, all memories fall out. The color tumbles out of a box packed with the culinary flower, a gift to to someone past gifting…it drifts from my mother's boudoir, where the floral notes hide in rifled drawers trying to divine who she was, who mothers were, who women were…it spills from bottles like jewels that line the body shops, each a soothing palm, a smoother of crumpled time, a fresh breath for the striated gasps of aging, for all the hardships that wear heavy on our faces and around the iridescent flecks in our eyes. We rub our bodies with salves and put droplets of lavender salt in long hot baths and we dream of what might be, the reborn quality we are gifted when our memories go away.

The word for lavender either comes from the Latin words for washing *lavare* or livid, bluish *lavendula*. I like to think of the forgetful flow of lavender as a kind of a wash, its flow

taking away all the accumulated history and grime, and leaving one cool and clean, scented with an aroma that could only ever be safe, soothing, forgiving. Forgetfulness is that way.

The land of the lotus eaters I'm sure was bathed in lavender.

Forgetting can be foggy, some say. A heaviness. But the best forgetting is clear, so clear everything past is obliterated: gone, disappeared, a landscape barrened and renewed leaving only the thrush of purple flowers and their feathered leaves.

Clean and soft, some call the scent of lavender intoxicating, but it doesn't make its lovers lose control as much as forget controls or that the desire for control ever existed. The softening touch of this pale indigo cleans rather than poisons, though lavender's amnesia perhaps hues both.

Most colors lope into language from nature, only later do they advance to abstractions, cut cleanly from earthbound origins. The amethyst stone, the bruised sky, the lavender flower. Their poetry vanishes into the blunt force of "purple:" a color only truly appropriate to people-eaters, Princely rain, Hendrixian hazes, and the hearts of wounded soldiers. Lavender, however, is lavender is lavender.

Lavender is the steam of soap, the oil running through clipped hair and the breeze from fields passed by on summer roads, a blush of pale purple, a sigh of beauty. Lavender is queer shorthand of course or straight shorthand for queers, reclaimed and repurposed. The precise histories of certain shades can be difficult to trace, but the flourish of purple dyes at the end of the 19th century and its association with prominent queer aesthetes of that era gave lavender a certain flavor. Given a pejorative tone by many straight authorities in the early 20th century, hundreds of lavender sashes and armbands were distributed to those marching for gay civil

rights in 1969 during a commemoration of the uprising at the Stonewall Inn. No better way to reshape radical futures than to wash away past injustices in soft waves of lavender.

Lavender is a very dangerous color. Too much soothing and we grow petty, easily spooked, terribly rattled by small variations, ever more ensconced in the safety of our scents, immune or at least hateful to other colors.

I have already forgotten so many memories, purposefully. Pain washed away with pleasures, whole years blanked. Is it better to forget, to learn to forget, to set our faces deep into the lavender bushes and fade into new pleasantries, history a mountain behind the horizon?

Passing through the veils of lavender, all origins are forgotten, and only loose atmospheres linger, memories like scents, disappeared in everything but spirit.

Plum

I have eaten
the plums
that were in
the icebox

and which
you were probably
saving
for breakfast

Forgive me
they were delicious
so sweet
and so cold

—William Carlos Williams (1934)

"Forbidden fruit a flavor has," says Emily Dickinson. A hand hovering over a bowl of fresh plums will feel the coolness of their life. Linger too long and the sweetmeat grows warm and insipid, a sloshy ghost of itself. Each one a mouthful, tart and sweet, their taut skin easily broken with a tender bite.

The fruit wears a dozen delicious dresses, but the hue colors a creamy purple, heavy and eccentric. Along with pearl gray gloves and bottle green trousers, Willy Wonka wears a plum velvet tailcoat that flares as he skips to welcome the children to his singular chocolate factory. Plum wears well on the makers of music and the dreamers of dreams.

Colors can be worn by many, but to me plum is Sandy. A fighter for equal rights, one of my oldest friends and so completely my family, a mother to our child and two more after our parting. With depth and strength, she wears thick lipstick and dark eyeshadow, laugh lines and the contemplative furrows with a fierce elegance.

A curved melody floating in perfume, an unflourished night blossom, she lightly bears her wisdom. Joys known but hardly exhausted, she eases the upset with an unhurried hand. Her silken dress folds open just enough to peek her many faded tattoos dancing up her neck and over her face. With a delinquent sliver of earned strength, her presence possesses quiet charm lest called to unleash its powers.

Thick-skinned with an unbreakable heart, a mother but a fully realized human in all ways, Sandy and her spirit offer satiation and sustenance, help and forgiveness. Powdered with moondust and alive with sunlight, her steady hand always ready to shake any tree.

Orchid

GEN. STERNWOOD
The orchids are an excuse for the heat. You like orchids?

MARLOWE
Not particularly.

GEN. STERNWOOD
Nasty things. That flesh is too much like the flesh of men. Their perfume has a rotten sweetness of corruption…
—*The Big Sleep* (1946)

The shape of this flowering plant's pendulous doubled root ball suggested to some ancient Hellenic botanist the particular danglers in a body's kit, and orchid got its name from the Greek word for testes. Thus the dainty beloved of aristocratic gardeners and fussy flower breeders are buried balls, dirty nuts. Try not to snicker when granny effuses, "I simply adore orchids." Flowers have always been symbolic of sexuality, and even more so for those for whom it's suppressed. Women, especially older ones, have been forced by social norms to staunch their desires, rarely granted the allowance to fuck freely. It gladdens the heart in its own weird way to hear old folks homes have the highest transmissions of STDs these days. Not because it's good for anyone to catch the clap, but because it means they fuck with more abandon than most might care to admit.

To some, orchids make the sexiest of flowers. Their namesake

roots lie buried in most variants while those strange blooms pump horticultural hearts with lively colors, generous curves, and alluring orifices. As flowers, orchids fall into an uncanny valley. Too close but not close enough, the effect is just creepy to me rather than alluring. Flowers often invite an inserted nose, floral perfumes infused with a deep breath. The fleshy orchid varies in its aromas from putrid to pretty, but has so often been sold scentless.

"Crypt orchid" is the term for an undescended testicle, though I dream of a flower that can only blossom in tombs.

The bright, rich purple creeps its name from the flower, one of innumerable possibilities for a plant with wild variation. Though it has the crackle of electricity beneath its buzz, orchid's too muted to be much beyond a suggestion. Bright but not the brightest, rich without being creamy, orchid's a faded purple haze on a bright day, a sighing neon past its prime.

Mauve

Mauve weeps.

She sits in the suds of an evening bath and cries, wet knees poking above the soapy swirl of lukewarm water. Flowery scents waft from various lotions in marbled plastic bottles and aromatic salts decanted from glass vials. The tiles scaled with soap and hard water don't quite gleam as they once did and the porcelain skinning the iron tub long ago lost its virginal shine. (Is this scene cast with the flickering light of a few scented, drugstore candles? It is.) The bathroom window opens onto a dank air shaft and remains almost resolutely closed, a fold of yellowing, secondhand lace hung loosely over the useless translucence of its glass. Next to it, the mirror gives everything a tinge of shadow, a softness, a nostalgia. Over a century of beaming back at all the ghostly tenants, its reflections have somewhat faded.

The faucet drips a sympathetic drip.

Mauve's pantyhose hangs on a towelrack next to her bra. Mauve's dress shimmied to the floor sits crumpled on a pair of not-too-immodest high heels, just tall enough flirt but not enough to invite even a faint possibility of purchase. "Yes, I fuck," the high heels whisper. "But probably not you."

Is it loneliness that makes Mauve weep? A faded flower, the first chemical dye to tumble out of some teenager's experiments (William Henry Perkin, aged 18, in 1859), later a Second Empire fad for the fashionable ingenues and fancier lads. Thomas Beer's book of the 1890s, *The Mauve Decade* is

a sharp, smarmy account that goes everywhere and nowhere simultaneously. Published in the champagne-drenched year of 1926, this book's an easy replacement for any meandering cocktail party with the overeducated and underachieving tasting just a lick or three of stolen pleasures. Mauve may have passed through these parties, even defined them, as any cosmopolitan lady will, but she hardly lingers to the last wheezing witticism. Mauve worn by matrons and teenagers in tugged cummerbunds and knotted silk ties comes in and out of fashion perhaps, but this color always finds a lover whatever the trend.

Is it time that makes Mauve weep? The fade and wear of years from that birth in an aniline accident have long faded the color. Certain Victorians, caught in the weird rules of a restrictive era wore it as a shade of quarter-mourning. Bohemians and nonconformists, bless them, wore Mauve with all the frivolity of those freed from convention, not a few of them using it as a cue. Gay men rarely wave away Mauve, but welcome her with a truly wild party as only the liberated can.

Why does she weep then? Mauve can't help but be just a little bit maudlin. Not quite purple enough for royal pretensions, not quite soft enough for lavender's merciful wash, Mauve can never forget the morning after. The freedom of Mauve has a hangover that she can never quite shake. Far from joyless, she still can't help but feel the pain of high gone low. An enduring beauty, powerful in its blush, simultaneously forward and yielding, she gives freely but feels the loss with every kiss.

Mauve knows what Oscar Wilde wrote in *The Picture of Dorian Gray* (1890): "Never trust a woman who wears mauve, whatever her age may be. [....] It always means that they have a history." And she's proud of her history, the sins and triumphs that got her here.

Down sometimes but never out. Toweling long limbs, draining the brackish water from the old tub with a flick of a supple wrist, she puts on a fresh pair of silken undies, shifts into a new dress, paints her face with a sultry lipstick, a brooding eyeliner. She wears her hair loose. Born into a misgendered body, Mauve *always* knew she was a woman. Passing into another celebratory night to soften the weary days, she leaves behind just the faintest hint of an enigmatic perfume.

Amethyst

The stranger with the amethyst hair.

A bruised twilight. Just a shift of sun, James Joyce fingered that gemmy color in a poem, "The twilight turns from amethyst / to deep and deeper blue", and it's true.

An afternoon reading old love letters, the day drags itself to night, passing softly for a moment through a wintry streak of softest purple. Tender words passed with light from screen to screen, inbox to inbox. All this stuff is just on screens these days, so no tear-stained papers, scented with perfume, spidery script. There are those too, buried in a drawer, but such relics still ripple with bitter resignation. I get a little numb just thinking about them. Don't read old love letters on lonesome December days.

Reading them is an attempt to find what love looked like. What vulnerability or embarrassing sexual propositions, what strained poetry and sentimental cliché got mixed into the overflows of emotion, attempts at seduction. Wet words hotly whispered, does their poetry survive the afterglow?

It's only a memory these days. And the stranger with the amethyst hair turned familiar, and our attempts, a most recent bruise.

They blamelessly left an impossible human, uncoupleable, but came back again and again. Was I some kind of safety for them? Was it that I could always make them sigh? Some love that couldn't find itself easily, just limbs reaching out in

the darkness, tentacles in a wine-dark sea, trying to find a somebody, warm and still, in the shadowy turbulence.

A slumbrous caress sweeps an empty bed, a lasting perfume.

The Greeks named amethyst and the color name simply translated means "not drunk." A gem with powers to stave off intoxication, keep your head whilst the world blurs and stumbles. It was their favorite stone, favorite color, a word with an infinite horizon when they spoke it.

After we broke, they clipped and dyed all their locks to a priestly black.

I don't know why we still found each other, why our tangled limbs and kisses continued, perhaps our caresses steadied a shaking world. Two refugees on Rimbaud's drunken boat.

> *But, in truth, I have wept too much! Dawns are heart-breaking.*
> *Every moon is atrocious and every sun bitter.*
> *Acrid love has swollen me with intoxicating torpor*
> *O let my keel burst! O let me go into the sea!*

If the sea is as soft as amethyst, I will sink calmly under the wet kiss of those purple waves.

Lilac

I lost myself on a cool damp night
Gave myself in that misty light
Was hypnotized by a strange delight
Under a lilac tree
I made wine from the lilac tree
Put my heart in its recipe
It makes me see what I want to see
and be what I want to be
When I think more than I want to think
Do things I never should do
I drink much more that I ought to drink
Because it brings me back you...

Lilac wine is sweet and heady, like my love
Lilac wine, I feel unsteady, like my love

—as sung by Nina Simone in 1966

Pale purples are the saddest. Lavender's forgetful wash. Mauve's lonely decadence. And Lilac. The color of unwilling resignation to lost passion. The pale fade, a lost spring.

> *APRIL is the cruellest month,*
> *breeding Lilacs out of the dead land, mixing*
> *Memory and desire, stirring*
> *Dull roots with spring rain.*
>
> —T.S. Eliot (1922)

The lilac flower originated in the Croatian coast. From there, it found its way into the gardens of Turkish emperors, and from Istanbul to the rest of Europe in the 16th century, not reaching the Americas until the 17th. The scent of lilac has become for many the scent of spring. Carried by indole which is also found in shit, lilac's aroma carries with its fade a special decay, heavy and narcotic. To a nose that does not know the tricks of the master perfumer, indole dropped in chocolate and coffees makes a product smell natural.

A note found in perfume, bottled spring, often worn by elder ladies.

In the Descanso Gardens in Los Angeles, they have a forest of 250 varieties of lilac, their names a horticulturist's poetry of yearning: Dark Night and Sylvan Beauty, Snow Shower and Spring Parade, Maiden's Blush and Vesper Song.

I missed their bloom this year, gone to the snowy mountains where the flowers blossom late, but to walk amongst the towering shrubs is to be punched in the face with perfume. So sweet, so heady. Running my fingers over its heart-shaped leaf, failing to feel my leaf-shaped heart.

> *One lilac may hide another and then a lot of lilacs*
> —Kenneth Koch (1994)

Whitman dropped a sprig on the passing coffin of a murdered president and birthed a poem for dooryards and students. Not his most beautiful by far, but its love is real. As any love for a distant leader can only be so real, but the lilac is love. Staring into its color, I am both spring and its destruction. Its bright lovely burst of life, its wilt and loss. The cool kiss of night, naked skin shivers but still you stay. And you stay and drink its sweetness and its rot, you stay and eat your bitter heart.

*In the desert
I saw a creature, naked, bestial,
Who, squatting upon the ground,
Held his heart in his hands,
And ate of it.
I said, "Is it good, friend?"
"It is bitter—bitter," he answered;*

*"But I like it
"Because it is bitter,
"And because it is my heart."*

—S. Crane (1895)

Magenta

Tricky magenta was a chemist's discovery with an honorific name.

Some colorist or another concocted the color out of coal tar. Mauve was the first aniline dye, but fuchsine and rosaniline came just after and thus so did magenta. There had just been a battle in 1859 in Italy near the town of Magenta, a crack in the creaking behemoth of the Austro-Hungarian Empire, and the Sardinians allied with the French to hand the emperor his ass. A victory for Italy (mostly) and the dye was named in the battle's honor.

Remove lime green wavelengths from the purity of white light in a science experiment and what's left for our eye to see is the magenta, where short violet and long red wavelengths extraspectrally couple. Yellow and cyan when joined by magenta constitute the three subtractive primary colors of pigment. With black, they became the CMYK printing process, invented in the 1890s when newspapers began to publish color comic strips and magenta made a better print for Little Nemos and Krazy Kats.

As you know, color is so often a technology.

The paper or the screen you read this on has its own ready limits, never as rich as nature which we only ever attempt to mimic, to fake, to capture, as if by capturing it we can keep it. The stuffed tiger and the taxidermied leopard are worse than dead, they suck life from their keepers. Photographs, films, and paintings capture with color an image of a passing

reality, marking a moment with some kind of permanence. They become in their way amulets of lost time, amulets to ward off the inevitably of death. We cannot beat death, but with color we can hold it back for a time. Perhaps this is enough.

Magenta, a battle mostly forgotten, a chemical dye already replaced by other technologies, one more color between us and whatever voids and shadows lie on the other side of the rainbow.

Violet

The soft danger of violet, a slip of something raw, tender. There is a violence in violet to be sure, an unblossoming bruise, the fingerprints of a rough-handling days later. A shrinking violet has reason to back away.

> *Gimme danger, little stranger*
> *And I'll give you a piece*
> *Gimme danger, little stranger*
> *And I'll feel your disease [...]*
> *Find a little strip and find a little stranger*
> *Yeah, you're gonna feel my hand*
>
> —The Stooges (1973)

Pulled from the flower like a torn petal, Isaac Newton thought to name the end of the spectrum purple at first but changed his mind to violet. At first, he found only five colors in the spectrum, but added orange and split purple into indigo and violet to correspond to the seven notes in the musical scale before the return to the octave. In *Opticks* (1704), he wrote of violet "the weakest and darkest of the Colours."

Perfumed and powdered, lavishly attired, a pale lipstick, a brush of blush, eyes lined, hair carefully coiffed, glistening with jewels, but not always.

As a name, it has something chic and Englishy. Upper-class and stylish. Many a duchess and marchioness wore Violet as a name. Willy Wonka was equal opportunity in how he let

the children punish themselves, but none leave the factory with quite the same color as Violet Beauregarde.

A true color according to optics, violet on your computer screen is just a mix of red and blue, and not quite the edge of the visual that this spectral shade can make. Amethyst attempts sobriety, lavender lets you forget, but violet is a bruise that just won't heal at the end of spectrum.

Beyond violet, the color goes ultra, a shade which can't be seen. Stay too long in the sun and this hyperspectral hue will give you a cancerous sunburn.

The sunset can cream the fugitive color over the sky. A dying moan, the beginning of night. A striptease that reveals nothing, except the darkness.

> *When they get what they want,*
> *they never want it again*
> *Go on,*
> *take everything,*
> *take everything,*
> *I want you to.*
>
> —Hole, "Violet" (1994)

Folded open, soft and fragrant. Break its stem with a twist of your fingers, so easy to pluck, so difficult to heal.

Wine

> *...wine supports a varied mythology which does not trouble about contradictions...it is above all a converting substance, capable of reversing situations and states, and of extracting from objects their opposites...*
> —Roland Barthes, "Wine and Milk" (1957)

The ceremony is about to begin.

Casked and barrelled, bottled and boxed, flasked and skinned, squeezed from grapes and fermented into magic, wine drips down the centuries from the Trans-Caucasus, the first humans to discover (so far as we can tell) the wet, smacking pleasure of wine. Persian myths put this discovery in the hands of a distressed and lovelorn princess, trying to commit suicide with fermented grape. She instead wakes up feeling better. With wine in hand, she wins over her love, King Jamshad, and they share her discovery with the world. No surprise we owe such a necessary medicine to women. The grape doesn't need much to make fruit juice into moonjuice, and humans have been guzzling the stuff for at least 8,000 years.

The legend doesn't tell the first color of the first wine to drip down our Persian princess's chin, but we know it was what they call "red." Stains better than blood but just as rich, wine makes white teeth show a purpled grin, eyes twinkle with the magic of transformation, a dribble of spiritual ecstasy and the heady charms of the rational being booted for the irrational in the wet gulp of wine.

> *With beaded bubbles winking at the brim,*
> *And purple-stained mouth;*
> *That I might drink, and leave the world unseen...*
>
> —John Keats (1819)

All the priests and priestesses, shamans and medicine women, wisemen and witchdoctors put on their silk robes and spit-polished cowrie shells, carved masks and gilded mitres. Chests are painted, incense is burned, entrails consulted, pre-game tailgating prayers recited, and no one blames the holy for a tipple of wine to get into the mood. The harvest gathered, the winter snows heavy, the world reborn with spring blossoms. After three days or three months, the daughter returns from the shade and the mother rejoices, the son bounces back from a bad Good Friday, all require a celebratory swim in alcohol. Cheers to any god that turns water into wine.

> *Wine comes in at the mouth*
> *And love comes in at the eye;*
> *That's all we shall know for truth*
> *Before we grow old and die.*
> *I lift the glass to my mouth,*
> *I look at you, and I sigh.*
>
> —Yeats (1916)

With a few gulps, the mean get nice, the angry laugh, the wise act foolish, and the foolish find wisdom. Drink too much and you'll drown in transformation, powerful medicine always requires the right dose.

Too sober and the color of wine is a little rude, get a little drunk and it's rapturous. Pleasure can always be a little like this.

The people gather at the theater, the grove, the temple, the

church, the pool. Dressed in silks and linens, clad in feathers and furs, leather hot pants and sharkskin suits. They come heavily robed and in nothing but the breeze. The wine flows. Homer starts a song about wine-dark seas and how lust can topple a world. Banjos are plucked, drums tambored, zithers shiver. A flamenco fingers his guitar with the speed of a dusty lightning bolt. Monks start to chant, but break off laughing too hard at the wheezy accordions, the moan of the theremins, the tumble of gamelans, the tinkle of crystal harmonicas, and the hum of the didgeridoos all playing at once. Horned and goaty Dionysus rides up on a chariot pulled by polar bears and frogs, foxes and dragonflies, elk and unicorns, he (or she or they, Dionysus is two-spirited) brings more wine than infinite mouths can drink and the wine deity intends to fuck every single drunkard in whatever way gives them the most pleasure. If they can still get it up or get wet or both, and if their bodies fail, Dionysus will pleasure them in their dreams.

The music tumbles into some kind of rhythm, the drums find the strings find the horns find the synthesizers and the wild dance begins. Tap dancers and breakdancers and ballerinas arc and bend and move their bodies. They stomp and twirl, shimmy and jive, pirouette and backflip. Tangos and tarantellas, bardo chhams and boogie-woogies, chachas and cancans, krumps and humpaas and hokey-pokeys, mazurkas and meringues, pogos and ponies, soustas and sarabands, wollossos and watusis. Someone does the time warp again. Every ass shakes, every foot loose, not a single limb hangs still. Everyone dances. They pant, they heave, they sweat. Coats thrown off, blouses unbutton, jeweled necklaces snap and headdresses tumble. The stink of wine and the funk of bodies blots out the incense and the air billows with musk. The wine is gulped and swallowed and spilled. Bodies and clothes stain with the claret, loose and sticky and ripe.

The dance goes on and on, day and night passes. The dancers stumble and trip and fall, they jump out into the shadows, the forest, the confessional booth and couple till they pass out with pleasure — *your love an inexhaustible / cascade of wine*...wrote Neruda. The dancers fall asleep on their feet, whilst pissing in the bushes, in mid-guzzle of another gulp. The leftover musicians crash snoring into their drums, cradling their tubas, balalaikas makeshift pillows.

And Li Bai, the dreamy poet, is the last reveler awake, drinking wine with the moon, reciting poems that echo a thousand years...

> *and once I'm drunk, all heaven and earth*
> *vanish, leaving me suddenly alone in bed,*
> *forgetting that person I am even exists.*
> *Of all our joys, this must be the deepest.*

Red

Scarlet
Raspberry
Crimson
Ruby
Vermilion
Oxblood
Burgundy
Maroon
Auburn

Scarlet

There's the scarlet thread of murder running through the colourless skein of life, and our duty is to unravel it, and isolate it, and expose every inch of it.
 —Sherlock Holmes in *A Study in Scarlet* (1887)

Red, redder, reddest. Shame always stains scarlet, a ruddy shade that never washes out. I learned last night at dinner that guilt is when you feel you've done something wrong and shame is when you (your being, your person, your existence) *are* wrong. Suicide, the man said, is an attempt to undo your own wrongness from the world. Making it right. We took sips of our wine, each gently petting the fur of our shame deep inside and feeling its purr.

Hardly the fading blush of embarrassment, shame never quite goes away.

Though an off-quote in the bible first gave scarlet its shame, Hawthorne wove the two together forever in *The Scarlet Letter* (1850). The descendent of self-righteous Puritans running his fingers over the ragged red threads left over from their cruelty. And I think about the loneliness of Hester Prynne and the Reverend Dimmesdale and their hurried lovemaking, illicit to laws and churches. Her pregnancy finally giving it all away. Her silence and her bravery. Reading it as a boy, I wondered why she stayed. My shame first made me scream and run, to fight and curse and spit. I felt it with each lash of the belt and swore I'd always rage.

This shame, my shame burned hot and long. The shame that's shaped me, the wrong of me. A shame gifted with cruelty, spoken like covenants and painted with unwashable authority, burned and beaten into a fragile body, the crimes of those I've never known splattering me, the scarlet seeping in and out, until there is no part of me that wasn't colored. The wrong that I am, the wrong that my fears and desires make me. I wear it in my skin and taste it in my spit. I feel the shame, sticky and hot cover my body. And the strange things a mind will do to survive being a wrong thing. The suffering I've caused myself to prove again and again that I have some power over a single scarlet wound, if only to make it bleed.

And I feel Sherlock's magnifying glass on that gash and his pinched fingers drawing out that sticky thread inch by inch from my body and the thread is so long and red that it takes a lifetime for him to pull it all out. And sometimes I wear scarlet to let others know how shameless I can be. I wear it tight over a shameful body, on my lips and fingers. I am shameless and I pretend the power of shame has no power over me, except that it is why I am shameless and I feel the sticky spread on my body anyhow and let it flow. When I look in the mirror some days, I can't see my skin anymore, I can't see anything but it. And I eat devils to feel the hot red rush with every swallow. I say yes to shame and yes again and I become more and more wet with it and the wrongness of it feels good, a relief from the fear and doubt. I am wrong and I delight in it. The shame isn't theirs anymore, it's mine. And I drink it over and over, and let it cover me again and again until I am silky with it.

And somehow, somehow, washed with the sweat of orgies and waterfalls of champagne, the stain faded. It never went away, but it fades. And I see my own skin again, the richness of its colors, the softness of its expanses and folds, I look in the mirror and I see a body, my body. Naked at last and I

almost no longer recognize it as mine. I've swallowed most of the devils. And in all the madness, the wound has almost healed. And shame's wetness disappears and when I touch others, it no longer stains them either. I washed my body with sin and came out clean. And I am Hester Prynne, and I know why she stayed as I know why I stayed. And even if love doesn't remove the scarlet, compassion lets you own it.

This shame, my shame in all its brilliant scarlet was a wound and then a shield, a dance and a ritual that burned it all away and all that was left was me. This can happen sometimes, the passage costs dearly but I have survived its price. This can happen if you stay and not everyone does. They find other red ways to right a wrong.

Raspberry

"I'm so wild about your raspberry mouth."

Or least this is the way I misremembered the title of a German poem from the 1930s by Paul Zech… "Ich bin so wild nach deinem Erdbeermund."

This is all to say that poetry misremembered matters too, and fruit and mouths can always be fugitive.

Twin lips colored anything, puckered just so can make lovers silently smolder. A raspberry mouth, thin or plumped, painted with the color of the summered fruit does something all its own, the color perhaps taunting a primal eye. (If it tints the teeth, the desire waxes nostalgic to drugstore tubes of lipstick stuffed into teenage purses.) A few savvy scientists figured, as most without lab coats already knew, that reddened cheeks and lips signify that this fruit is ripe to be plucked.

Hardly the hard flame-out of fire engine, this mellowed reddish-pink marks a beauty fully realized, a color in its fullness, well-employed with supple inclination to give a deeper pleasure than the simple raw exuberance afforded by those hues perceived perhaps as sprightlier. Those others might perk and release, but they don't tangle you up in desire, edging taut emotions close to sorrow, over and over, before you sublime into the softness of its depth.

"Where have all the raspberry women gone?" sang Prince in 1985. "They say the first time ain't the greatest. But I tell ya, if I had a chance to do it over again, I wouldn't change a stroke."

Crimson

Caravaggio's *Saint John the Baptist in the Wilderness*, (c. 1604).

Is this truly John the Baptist? Jesus's notable cousin, claimed second coming of Elijah and pre-ambler to the messiah, the fiery Jewish prophet, whose head a mere few paintings away gets plattered for the sexy, slithery, fourteen-year-old Salome? This pale European beau never burned in a Judean summer or strained too strenuously under an imperial Roman yoke, this John, who in the gospel wanders the deserts till the moment he manifests to Israel, seems to have instead spent a long winter elsewhere. He might have made a dashing companion to Moreau's Salome, even with that brooding face, framed just so by tousled hair and chiaroscuro.

Here is John almost naked at what seems the first blush of a joyless spring. Is that a reed in his hand or is he just happy to see us? The camel hair raiment that coyly covers his parts and wraps delicately around his arms has all the suggestions an imagination could want. A loose robe waterfalls crimson fabric over his legs and around his body, almost a second body to balance his own. Enshrouded in Christ's blood or just a color to bring out the pale beauty of his lithe body, the robe's rich red lends the painting a certain ruddy heat. Never has another robe rippled in quite the same way.

There is a spot of dirt in his toenails but just barely. An art director's suggestion of struggle, grime, hardship. The wilderness around him a shiver of dark leaves, a few plants at the prophet's lightly soiled foot. Each limb, rather than

disappearing in the dark has the slightest hint of light at its edge, as if the light itself wanted to wrap this youth's body, couldn't let the darkness take it all.

Alright, so we've lusted after this youth a spell, but all the things that at glance make this sacred man so lipsmackingly profane perhaps also make him false. Is he a prettyboy model when we want the desert nomad, hardened by heat and faith?

Perhaps Caravaggio, the brawler, the drinker, the murderer, was man enough and he poured the delicacy of his artistic being into painting such a brilliant boy for his patron Costa, who for his own reasons appreciated the painting just so that he put a copy of it in the altarpiece it was meant for and kept the original for himself. One wonders exactly where he hung it in his house, what young men might have found tenderness in Costa's ringed hand under this shadow and light. One wonders how well Michelangelo Merisi da Caravaggio got to know *his* John the Baptist.

This is all conjecture and it's bad to conjecture in general about artists and their intentions, or patrons and theirs. Costa might have been a pious man with nary a hankering for manlove. (He did have two wives and thirteen children after all.) Caravaggio, despite his famous historical record for being a rascal, might have been religious to the point of fervor, never a profane thought passing his stormy mind. Then again, maybe not. Scholars seem to take his gayness as a given. Piety and sexuality are not necessarily mutually exclusive. We have our poems by Michelangelo Buonarroti. For Leonardo Da Vinci we have rumors, his denunciation before magistrates for sodomy in 1476, and so many beautiful men in his paintings.

It's silly to guess at the sexuality of the painter, but how you see the tenderness and inward storm of this John the Baptist

in the wilderness might hint at your fervors. No matter your sexual proclivities, one can appreciate the fragile beauty of this John, his crimson robes, the shadows of wilderness, even if we know that the original was more likely a half-crazed and dirty man, bearded and dreadlocked, eyes filled with the fire of god, alight with an allure all his own.

Ruby

A washed-out seawall, a pierced cliff, beneath the mountains. A place to hide, a place where things are hidden. A cool darkness, mossy-walled and crystalline. The stalagmites rise to kiss growing stalactites for thousands of years, one droplet of water at a time before they touch. The ancient humans pierced only the surface of the earth in shallow caves. Blowing ochre and drawing with charcoal in the flickering fire of a tallow torch, a few of our first technologies. Gods and monsters crept from the flicker of those shadows. Whatever we made in those caves, now it makes us.

I recall a cave below the underworld, from an old book, the evil empress's enchantments dissolved with her death. Awaking from their magical slavery, her minions rushed to escape back to their homes in the heart of the heart of the earth. The heroes plucked one running from the masses and he told them of his country in the deeplands, along rivers of fire where dragons and salamanders hissed with wisdom from the flames. "Yes," said the earthman. "I have heard of those little scratches in the crust that you Topdwellers call mines. But that's where you get dead gold, dead silver, dead gems. Down in Bism we have them alive and growing. There I'll pick you bunches of rubies that you can eat and squeeze you a cup full of diamond-juice. You won't care much about fingering the cold, dead treasures of your shallow mines after you have tasted the live ones..."

The juices of gems wetly drip down chins and the emerald's fresh cream dribbles into grimy beards. Violent amethyst

indulgences. Thirsty for ruby wine and life's other unknown gems, I dreamed for years of those luminous caverns, color-carved and quivering with the light of living stone. And once I tried to go there, to find the jewels growing wild like common vines over a river of fire, with the core all around, deeper than devils can see.

I left with my love. Free and yielding, we searched the darkness for an entrance to the underworld. He sang songs of the caverns where the fresh jewels grew plump with radiant nectar. I can see him, jerking from a branch a new, well-shaped fruit. It shines in his hand, alive with light. Every fruit glowed with hot fire. His mouth took no chances, deathly, he judged the fruit. The fruit's fire flamed up his iris, a sapient look.

I see the caves, the gems, with wet and dreamy eyes, not only because of some shitty circumstance, but because his departure was so much more uneasy than either or any could guess. Isolation's not easy, but there's no true distance. Think of deeper caves, not just any, but the lost ones. Besmirched caverns like those in books, like with Coleridge and Xanadu.

Believe me that all we could be was living beneath the surface, meeting and yielding. All caverns lead back to the molten core, nothing separates the seas and lands, deeply nestled in the interior of the earth. The Khan's domes of ice and caverns measureless to man, in starless, immense chasms, the arcades and tunnels all led to us. Always the lanes, the roads that connect from outside my house and lead to Patagonia and up to the Arctic Circle and the road that still now stretches from me to him. These only overlay a sly top, covering only the sunkissed lands, but we truly adored all those places that cannot be seen. Without adoration, we reveled, we exalted, we shivered as we drank diamond wine daily, but in those fathomless chambers, we lived our ethereal lives, plucking

the fruits, dancing in the incandescent glow of those deep lands that can't be seen by just anybody.

I lost him to the wind. I've traded in my fingers for words. Beneath all these fragile phrases, each a decaying flower, there are caves deeper still, wine more heady, other dulcimer songs to call me to the underworld...

> *Could I revive within me*
> *Her symphony and song,*
> *To such a deep delight 'twould win me,*
> *That with music loud and long,*
> *I would build that dome in air,*
> *That sunny dome! those caves of ice!*
> *And all who heard should see them there,*
> *And all should cry, Beware! Beware!*
> *His flashing eyes, his floating hair!*
> *Weave a circle round him thrice,*
> *And close your eyes with holy dread*
> *For he on honey-dew hath fed,*
> *And drunk the milk of Paradise.*

Vermilion

What I dream of is an art of balance, of purity and serenity, devoid of troubling or depressing subject-matter, an art which could be for every mental worker, for the businessman as well as the man of letters, for example, a soothing, calming influence on the mind, something like a good armchair which provides relaxation from physical fatigue.
—Matisse, "Notes of a Painter" (1908)

I wouldn't mind turning into a vermilion goldfish.
—Matisse quoted posthumously by Schneider in *Matisse* (1984)

Sit too long in that armchair and the wallpaper will creep. The mundane stillness of domestic parlor games for bourgeois businessmen, the stagnancy of air plumped with stale tobacco smoke and roast chicken and potpourri, the numbed-ass stasis of sitting in that comfy armchair, hour after hour, year after year, and the wallpaper will creep for sure.

Vines undulate and tangle, roping their way through the windows, the glass webbing into conjoined shards, its translucent body refusing to fully shatter. Fat, thickening green arms vein over the ceiling, the plaster crackling and dusting, sprouting tufts of leaves that hydra into arms of their own. The pouched lips of pods perch above the bookshelf and peel back to unsheath ornamental daggers with poisonous jewel

petals, the colors so sumptuous they can only mean death. But even from that comfy armchair, those colors itch to be tongued, the daggers throated, a dangerous little *Bonheur de Vivre*.

In this room, white birthed a brood of color, each a chip off the old beam, prismed out into unique forevers, literally radiant. The pure, scattered hue skitters throughout the room and in their unfettered flight might as well be birds. The carpet boils, the wood slats crumble to mulch and the threaded Persian filigrees sprout, joining the cacophony of life bursting in this drawing room jungle.

The vines are trees, the trees a jungle and the wallpaper tatters, the walls disappear into fetid wet trunks, each waxy leaf a sharpened tongue, and even the slightest movement makes them lap like a dog's, dripping with hunger.

Our armchairist thinks it's a garden and we let him.

> *The chief function of color should be to serve expression as well as possible…. the icy purity of the sour blue sky will express the season just as well as the nuances of foliage.*
> —Matisse, "Notes of a Painter" (1908)

> *For me, a color is a force. My pictures are made up of four or five colors that collide with one another, and the collision gives a sense of energy. When I put green, it doesn't mean grass. When I put blue, it doesn't mean sky.*
> —Matisse again, interviewed by Pierre Courthion (1941)

The regal procession of a warrior queen passes through the gnarled and roped tree trunks, her sun-kissed handmaidens wear gold daggers cinched to their waists, breasts bound with the pelts of jungle cats and wildebeests. Plump odalisques

with inviting forms, but a hungry hand might quickly regret taking these warriors for concubine slaves. Any daring to finger their curves might not sense their arm's chopped clean till it wetly smacks the earth.

Each of the queen's handmaidens drip with decorative jewels of jasper and jade, ruby and sapphire, carrying in their arms a particular treasure from a wide and ancient world. Greek amphorae and Etruscan oenochoes, Korean celadons and Tang porcelain, glass tiles flowing with arabesques from Mecca and Alexandria, mosaics from Teotihuacan, Rome, and Byzantium and Lapita burial urns nabbed from New Caledonia, Turkish embroidery and kabuki masks, Persian carpets and Indian miniatures. Her highness's taste tended toward fragile glass and ceramic. If women are, to the patriarchy, soft and supple as sand, then their heat had transformed her tribe into glass, glittering in beauty and sharp as necessary. If made from clay thought to be so easily molded, she would fire her women into stone with hardened skins and flaunting colors.

The Queen arrives and that armchair-bound adventurer can not quite see her. His eyes birthed this pornography of color, but he can no longer control his creations. They are wild things like their father in his fauvist youth.

Hours pass. Then they are not hours, they are millenia. The continents shift and the oceans rise, seawater seeps into the room and the hot air cools into languid liquid, the trees make way for the slow dance of seaweeds and the fish slither their bodies against the long, loose stalks. Other creatures, their names just divers' jokes and Latin colorings weft their way in, fronded bodies like long-fingered hands that soak and suck their way across an ocean. The handmaids transform to mermaids, no less fierce for their fins. The man turns ultramarine and with a long and beautiful thrush of

limbs suddenly loosed from time, he cyclones the edge of the room, then swims away in a burst of blue.

The ocean recedes, the room returns, but this comfy 19th-century parlor has been warped by its metamorphoses. All that's left of the passage for our armchairist, of all this transformation is a vermilion smear of paint on his face, missed in the clean-up, brighter than blood but just as alive.

Oxblood

Danny Johanson wore oxblood boots with white laces yanked tight the afternoon Big Joe knocked him out with a single punch in the alley behind Murdy Park. The crew surrounded him. When Joe's fist hit him, Danny crumpled. He landed right on his pimply face with a wet, crunchy smack. I heard the sound of his body breaking and felt loved by the violence. Two of the crew turned over the hulk of his body, all six feet six inches and two hundred and fifty pounds of him. The gravel flayed all the skin of the right side of his face. Like a Freddy Kruger mask. But it wasn't a mask, it was his face. I was twelve. Our gang was Black, Mexican, white. We called ourselves the Westside Mafialife Crips.

Our crew kept the peace with Danny's two best friends, the skinhead twins, Keith and Cody (white-pride, not power, just peckerwoods). But even they didn't back Danny up when Big Joe came for that afternoon enforcement. Danny had ganked an eighth of weed from my backpack on delivery. But it wasn't the stolen buds that made me vow revenge but that Roseanna Lucas saw it. Black-bereted with Sylvia Plath and clove cigarettes in her purse, thick dark eyebrows above bright, glassy eyes, Roseanna wore her hair drug-store dyed and shoulder-length. I loved and mistreated her for a few youthful years whilst hiding under the aura of a gangbanger and finding whatever laid beneath the bravado of Tres Flores and shell-toe Adidas, stolen menthols and Old E, low-riders and pressed dickies, slinging weed and getting high everyday.

More than the punch or his fucked-up face or why it went down, I remember those boots, polished, laced, and splayed, useless on useless feet. And that violence like love.

Oxblood as a color will always be those boots. And boots just like his. White-laced, thick-soled, treaded like geared teeth. Eight, twelve, fourteen eyelets, tied high and tight with pressed work pants and bomber jackets, beer bottles and blue jeans, suspenders and wife beaters. Punks and rockers, riot grrls and skinheads: SHARPs, traditionals, and Nazi, would-bes and wanna-bes. For the uninitiated, SHARPs means Skin Heads Against Racial Prejudice. Traditionals were cultural descendents of British working-class kids with an affection for mod music and Jamaican rude boys (and not usually racist). Nazi skins were white power thugs. Though there were elders, most I knew were teenage boys and girls with thicker soles than skins, all shod themselves with oxblood boots.

Tougher and bluer than burgundy, the two get often mistaken. Burgundy is for hair, dyed from a shoplifted box, worn smooth and loose for circling the suburbs, listening to The Smashing Pumpkins and The Smiths, hanging low during bong rips in some crowded living room, the carpet whorled and swirled with a thousand clumsy parties, legs folded. The unwieldy boots beneath knees still scarred from childhood scrapes are surely oxblood, their dull shine as if the titular blood flowed still wet and fresh.

In suburban angst and white working-class malaise, oxblood boots uniformed disaffected youth, advertised in music mags and album covers, sold next to Manic Panic and pegged jeans at the piercing parlor in the back past the leopard print tights. Oxblood sounded strong, ancient even, for those with runic words and garbled Viking myths jangling round their shaved and Chelsea'd heads.

I heard of curbings before I witnessed one. I was not brave enough to look directly at it, my recollections are fugitive, the horror of it was too much. I think I was twelve.

The police tape and flickering police light and the raspy chatter of walkie-talkies dangling from leather belts. Some memories from those years I can't quite remember.

We all talked of curbing with distinct horror and something like awe. We yearned to be hard, but not that kind of hard. Toughness only ever a virtue, but the Nazis and their weird cruel shit made our skin crawl. The only guys we knew who were crazier were a few gangsters from the Insane Crip Gang. They would tear out your eyes, fishhook your cheek, rape your sister, make you hurt.

Crips never curbed though that I ever knew, at least we didn't, only Nazi skins did. Beaten and bloody, your open mouth set just so on the edge of the concrete curb, then they'd take aim at the crown of your head with a single wet, swooping stomp of an oxblood boot.

Burgundy

Burgundy is always to me the smoothly tousled locks of the actress Claire Danes playing Angela Chase in *My So-Called Life* (1994). Was it other girls in those years? Surely, a million teenage imitators and originators, girls a hundred times more punk and less constructed and more heartbreaking because we could smell their vanilla perfumes and watermelon lipgloss as they passed in lockered hallways and airy malls. But burgundy was the shade, synthetic and silken, the way that only dyes can make hair, stripped and smoothed, harder to pull, to hold, but more delicious in your fingers. The morose hue, the wine stain of red deepened by brown, made cooler, fallen, autumnal even to all wearers still freshly bloomed, but still maintaining its synthetic glow, a flash of neon or fluorescent tube lights flickering in the snaking tiled tunnels in the long hours of the night.

The dry red of the pinot noir and its originating region in France gives the color its name. Grown in soil toiled for a couple thousand years at least, the grapes cluster like black pine cones in strict terroirs. Derived from a Germanic people wandered far from a Baltic island long forgotten, the word "Burgundy" may have meant rocks or crags, but those chieftains gave way to vice-consuls and they to kings and emperors, Bold and Bald, Stammerer and Fat, and then to monks, lastly in the hands of bourgeois merchant-farmers. Grand dukes fell to grand crus and the history of burgundy wines is the history of Europe. Now collected by Russian oligarchs and Chinese entrepreneurs, cellered and drunk by dictators and CEOs, the milk of Burgundy wets the history of the world.

But Claire's locks, more rightly owned by her character, Angela Chase, her fragile face, an uncrushed petal to be sure, made paler with the rich red of her burgundy hair. Those locks in that television show and all the girls who carried hair like it let burgundy disappear as a region in France, as a wine whose subtle tones give color to the claret. Hijacked by hair dyers to be this, an economy coloring purchased at any corner store, synthetic and for some moments still alluring. Synthetics lose allure when it pretends authenticity, fake is only desirable when it owns the fantasy, the unreality is admitted, claimed, and indulged. The 90s dyes were a rejection of nature, of what came before and wouldn't come again. Name changes couple with dyes easily, another rebellion against what was born into, what can be defined or redefined at will, what can be owned after the erasure of revolution. Year One has a color and it's not rouge, but burgundy.

When worn as a lipstick, it doesn't scream like the luminous sheen of pure primary red. Burgundy smolders, a fire quenched but not out, ready to burn hot and quickly but with deliberation.

Maroon

Mix mud with blood and you'll get maroon.

Beginning with a hum, it ends with a ghost's moan. Both lull and murmur, the hard center deepening its soft blow. Long and lost and sultry. A distant story, a faraway place, never touristed. A survivor's refuge from a distant catastrophe never spoken of, backboned with an equally unspeakable gratitude for its escape. But ghosts can't really moan. So the sound passes from living lips more spirit than flesh. The moan that gathers mouths for maroon still whispers with a trade wind.

Some say maroon comes from the French word for *chestnut*, but wandering languages and lashing tongues trip into each other. Besides, chestnut simply lacks the sanguinary stain of maroon.

Maroon can have a more dubious origin. Perhaps a Spaniard's *cimarrón*, literally "mountain top dwellers," but more truthfully used for escaped household animals. Some francophones claim *marron* for "feral," and other scholars say the word falls to English from Arawak. Before their enslavement and murder, the Arawaks handed down the words "barbeque," "canoe," and "tobacco," the last a lasting poison and solace for all those marooned, a parting curse from an assassinated people.

In each case, it means the same. Dangerously wild, fierce and free.

Maroon names the escaped slaves who hid in the wilderness from Jamaica to the Great Dismal Swamp, living on the fringes. Plantation raiders and emancipators, maroons crushed some colonials into extracting treaties, others befriended and mixed with the natives, escaping prison, slavery, and certain death.

Maroon is the color of hard freedom.

Auburn

Jolene, Jolene, Jolene, Jolene
Please don't take him just because you can
Your beauty is beyond compare
With flaming locks of auburn hair
With ivory skin and eyes of emerald green.
Your smile is like a breath of spring
Your voice is soft like summer rain
And I cannot compete with you, Jolene

—Dolly Parton (1974)

I looked all over for a lock of auburn hair. Soft brown dolloped with red, a glowering fire found only in tresses. A foxed brunette, an unwashed red. Copper and orange, burgundy and chestnut, ginger and then auburn, such subtlety for a hair color owned by less than 1% of humans. On men, auburn possesses a quiet mischief, more suspicious even then the crazed, tempestuous blaze of carrot-tops. On women, it is both regal and slattern, a moral freedom once only allowed empresses. On those of neither gender or both, it can possess any and all. No surprises that Napoleon and Elizabeth I were redheads, the first likely a chestnut and the second a ginger.

Sometimes dark locks will sun into that nuance of red-brown, but auburn's rarity has found an ancient friend in henna. Crush the leaves of *Lawsonia inermis* and the paste will trace the skin into a lattice and filigree of arcane designs. In the 1970s and 90s, henna got marketed as nature's own

hair dye to earthy women, but for the righteous it stains traitors and the obviously impure. Leonardo hennaed the mop and beard of a swarthy Judas Iscariot, scowling over his bag of silver in *The Last Supper* (c. 1495-1498) (maybe one piece short of thirty for his time at the salon). Nine thousand years in use, the dye found its way to Cleopatra and Nefertiti. The Queen of Sheba in her solemn march to Solomon wore, in her devotion, this creamy red-brown, at least according to Fra Angelico and a tribe of medieval painters. More than a few Ancient Egyptian tombs preserved hennaed hair. James Frazier in *The Golden Bough* (1890) writes, according to Manetho, the pharaohs sacrificed redheads at the temple of Osiris, their ashes spread with winnowing fans, to quicken the grain god to color those green fields golden red.

In ancient Britain, her territory seized and her daughters raped, with auburn tresses hanging down to her waist, Queen Boudica of the Iceni led her people and their allies against the Roman occupiers, burning London to the ground and killing almost 100,000. Her fate is uncertain, her defeat is not. Romans enslaved and vassaled the Britons until the collapse of the Western Empire.

> *All redheads, you see, are mutants.... abnormal beings, bioelectrically connected to realms of strange power, rage, risk and ecstasy. What is your mission among us, you daughters of ancient Henna, you agents of the harvest moon?...And why are your curls the same shade as heartbreak?*
>
> —Tom Robbins (1998)

Redheads litter history like housefires, their exact shade not always easy to determine, but their hair marking a power that only obeys its own orders. Such outsiders either run civilizations or are burned by them. A flash of red can make or break a world.

Yellow

Lemon
Goldenrod
Blonde
Canary
Gold
Butter
Citrine
Piss

Lemon

A sliver of tart sunlight, the fruit's pert nipples and smooth skin soaks in rays and spits it back with a sweet and sour juice, a little acid on your tongue. The hue beams a brash joy, a bright defiance. Lemon hardly belongs in the dour dishabille of a lawyer's flannel suits, the worker's grease-stained coveralls, the priest's invariably joyless robes. In Los Angeles, on squalid streets barely paved, in tiny yards behind wrought iron and chain link fences alongside houses stuccoed with paint like dirty laundry, smudged and stained, the lemon tree thrives. The fleshy spheres of bright yellow nestle in amongst the green leaves year round. The sunlight here can be hard as the concrete that strands these domiciles, unrepentantly reflecting back the California sun's unfaulting rays. Lemon yellow bears the weight of sunlight, 3.2kg/s over the entire surface of the earth, and holds it true, producing life beneath the gravity of its radiant force. An artist once took a lemon from a tree next to my apartment and returned it, cast in lead.

I need lemon, though I'm rarely so brave to wear it. I need those soft little globes of sunlight peeking from smog-smothered leaves. I glimpse it in the lemon chiffon dress of a woman leaning on the rails of the pier staring into the endless tide of the ocean, the taut bodies of surfers perched atop boards rolling and ducking beneath the swells until the perfect wave rolls out of the deep and they ride the ocean's power with naked grace and slippery joy. I admire lemon jauntily worn in the silk ties of old men in white linen suits strolling through cosmopolitan parks, feeding the ducks out of brown paper

bags and tipping their hats to every passing lady. I can't look away from the lemon yellow Lamborghinis, shuddering with speed, their rare and misshapen beauty rolling through the tree-lined avenues of Beverly Hills and the terraced curves of Monaco, always invariably driven by an older man with tanned skin and gray hair, his face a picture of Dorian Gray, trying to capture some lost joy of youth with the dubious magic of money and velocity.

Stuccoed too but regularly up-kept, the unkempt rose bushes and birds of paradise poking from the front garden (a jungle of Easter lilies filled the side yard), hemmed in with Bermuda grass and oleanders, the house I grew up in was painted lemon yellow. With bright white shutters, the colors of the exterior matched the avocados, goldenrods, and harvest golds of the interior. All painted with the optimism of California before the boom and rush of real estate ran away with itself, before fifty years of factory work broke the body of my father and fifty years of domestic servitude broke the spirit of my mother, before five children grew and ate and shat and wept and laughed and fucked in one of its many rooms before leaving one by one to seek their fortunes in faraway cities, its bright color lasting fifty Christmases and fifty summer holidays, every ten years getting another spray coat, building layer of yellow over yellow that beams even now from the tract suburb that my parents toured when it was empty streets subdividing plots of dirt. The lemon yellow paint held the house together, unceasing in its cheerfulness, rough in texture. When you run your fingernails across its uneven surface, the stucco chips and crumbles, leaving behind the scar of your hand's passage across its color.

Goldenrod

Now all I know
is what the name infers:
a life of pure sensation
or the rod some angel brings—[....]
The wind blows through the goldenrod
like death flows through a crowd.
Nothing is accomplished
and the world is changed by it.

—Ian Parks (2002)

Highway 395. No other cars for hours. In the distance, a road block, a white truck, a helmeted man. The worker, subcontracted by the feds, told me to wait awhile. They were destroying fugitive armaments left over from WWII off the road. Too old and too volatile to recycle. Not the first bombs to kiss this desert.

Alongside the highway, tiny yellow desert flowers peeked from rocks along the gravelling asphalt, somehow mysteriously watered by the sweat of passing cars. The size of pupils, an ancient aroma, the color of a geriatric sun. A stooped wisdom, ready to retire. Beyond the yellows, just shrubby dirt for dry miles until the cliffs. Perpetual surprise in their broken bodies, stripped naked in the sun. Nature caught towelless, I'm never displeased by the vision.

A trio of kabooms with three mushroom clouds, three new scars cut in the unforgetful desert. The worker waved me on,

a clutch of wildflowers on my dash, windows peeled down, raspy air sucking through the car, loose hair licking and spitting, dust on my tongue.

Blonde

Does she . . . or doesn't she? Is it true blondes have more fun? If I've only one life to live, let me live it as a blonde.
—Shirley Polykoff's Clairol ads (1950s/60s)

A cinched ponytail bobbing. Palest wood. A long, tall beer.

On the terrace of the gallery during the opening, she told me her date had stood her up. A cascade of blonde curls, shivering beauty in her eyes, and a stab of red lipstick. I told Alessia I'd be her date.

The trailing golden hair of a comet. Hitchcock only cast blondes for his femme fatales, not all of them had pleasant ends.

It is the angles that I like about her. The softest skin and the hardest jutting elbows. A nose like architecture. And a mess of hair, five different blondes, curled and fussing, wildly unruly, the kind that a hairband can only direct but never restrain.

Flaxen and yellow, ash and sandy, dirty and dishwater, straw-berried and honeyed, bottled and sunbleached, blonde hair can range from coolest platinum to ashy brown. Ice queens, bombshells, bimbos. No one much talks about blond men, except Nazis. Sometimes a blond surfer bro might tumble out of pop culture, board and blunt in hand. Then again, surf nazis.

Gentlemen Prefer Blondes. Blonde Ambition. Totally Blonde.

The Real Blonde. Legally Blonde. Legally Blonde 2. Don't Bet on Blondes.

Reckless and authoritative, Alessia tells me she likes me knowing I'll never fall in love with her. And a year later, that I simply shouldn't. I nestle my face in her hair when we sleep, her blonde curls mix with my black ones. This is how we dream.

Ancient Roman women tried to lighten their hair with pigeon dung. In the early years of the Empire, it was required that prostitutes wear blonde to announce their profession. In Renaissance Venice, they used horse urine for hair dye, though they sometimes wore special hats to protect their faces as they let the sun bleach their locks soaked in lye. Some went blind or lost their minds from the long hours of hard light.

Since 1867, hydrogen peroxide has been the preferred colorant. The original Hollywood blonde bombshell, Jean Harlow, dyed her hair with a mixture of peroxide, household bleach, soap flakes, and ammonia until it fell out and she was forced to wear a wig.

The most blondes by percentage live in Scandinavia, but the color's found in the locks of the Pamiri in Afghanistan and the curls of the Melanesians of Vanuatu, Fiji, and islands beyond, amongst the Berbers of North Africa and the Uyghur of China. The European spread of blond was a recessive gene which emerged around the Ice Age 11,000 years ago and radiated out to distant lands. The Melanesians have a completely different genetic origin for their blondness, but collectively only 2% of the world has blonde hair.

We talk for hours and hours, chain-smoking cigarettes and drinking gin out of fragile glasses. I spread my hands over the blonde wood of the table and my skin looks so dark

against its grain, as it does when I spread it over the palest skin of her naked back as she sleeps. Her house is made of paper and pierced with light. She moves effortlessly through its beauty. Root vegetables, crusted with earth, drape over the concrete counters. Folded on the sofas are strange and rare textiles from Gee's Bend and Kolkata. The floors stretch in pale, unbroken white oak. When she buys the land next door, there'll be sheep. Her taste is exquisite in all things domestic.

Is my pleasure being with her a yearning for home? Maybe, I don't think so though. It is her tense intelligence and ability. It is sex in the alley behind my house. It is her effortless knowledge and aesthetics. It is her jittery eyes and striking poise. The dozen tattoos that deckle her arms and judgeless kindness for those she loves, myself of course not necessarily amongst them.

I do not understand what makes her beautiful really. I am magnetized by the pulse of her strange energy, like the waves of the Northern Lights. Untouchable color.

Alessia says we are the same person.

I listen and nod, but we both know I'll never be blond.

Canary

A cartoon. A headdress on an eccentric older woman. A flutter of yellow in the wet darkness of earth.

A canary in the coal mine, its yellow gaudy everywhere but there. Follow that cliché to its conclusion and a tropical bird asphyxiates in a dank pit. The color a comfort, her silence an alarm. Far from jungle branches, this exotic beauty chirped in the darkest mines deep in the earth, where no bird belongs and few if any men. Birds require extraordinary breath to fly and double intake for every single human inhalation. Taking in twice as much, they die twice as fast huffing the scentless, poison gas released from pockets and unseen explosions. When their beaks go silent and their little bodies tumble to the bottom of the cage, savvy miners bolt to the surface. Regularly bred in the 19th century as pets, the songbirds were cheap and the mines collected canaries that the shops couldn't sell. A song like a dirge, the funeral begins with their silence.

Gold

*The gold
of all the Californias isn't enough
for my desires' riotous horde.*

—Mayakovsky (1916)

The sun weighted with the heaviest of metals sinks into the farthest west, heaving downward into jagged mountains. Pierced, the sinking star's hot skin leaks a most precious blood across the sky, into the air and water, into the bodies of animals, crumpling with the winter's kiss on the leaves of trees.

Liquid gold. Such heavy metals are not so easily made. Any alchemist can tell you, transmutations take subtle knowledge never discovered, a philosopher's stone, a Midas touch.

The air bends with twilight. A glitter ripples through the sky turning base clouds into rich monsters with bodies that undulate and writhe, growing beyond the edges of vision, clumping into a thousand arms, those rays a hydra of unbreakable necks smeared with a descent of colors, growling down the spectrum as the easy shades get caught in the monster's flesh, gilding them, encrusting them with a galaxy of precious jewels. Molten, they mutate with folds and bursts, filled with nuclear tidings and incandescent plasma.

Fleshy fold over fleshy fold, this avalanche of unkempt lust frightens and enraptures all who witness it.

Cowering and emboldened, some see the searing power of the sunburst and hide in their huts and bungalows, apartments and castles, whilst others feel the flame lick the flecks of gold in their eyes and a fearsome heat fires them into desire beyond measure. They lick the air, they claw uselessly at the sky. They dam the golden rivers and stone by stone dismantle the mountains, their veins dripping with gold.

Rumor spreads and the land fills with strangers, armies of miners and madmen, bellies knotted with insatiable hunger, minds thinned by the hardship of their own ambitions. Barely clinging to their bodies, their souls need the heft of the gold to keep from misting into ether. Most of the ravenous die in graves that they dug themselves deep in the earth, only a prospector's claim to mark their final resting places. Suicides and murders only clear beds to make room for more. Prophets and profiteers, bankers and businessmen follow the flood, haunting, cajoling, promising with gold-flecked words all manner of prosperity to anyone desperate to believe. The land's picked clean like fire ants over a corpse leaving nothing but the bones and a few fat, fleshy winners, easily stripped bare by suits and saviors. The survivors drown looking for gold in the bottom of bottles.

Alchemy cannot transmute base minerals into gold, but dreams can. The gold floods simmered and churned into night-black pools of viscous petroleum, into verdant valley fields with rich alluvial soil, big bellied 747s screaming across the sky stuffed with sauced globe-trotters and multilingual businessmen, a million miles of turning film that marks every dream in light with its fragile chemistry, into silicon sliced thin as molecules and shot through with codes and control.

Each iteration booms and spurts and sputters, always with a golden shimmer that unlocks a desire beyond desire. The

gold standards disappear into ghostly fiat, but the heavy yellow glistens on. Worn as jewelry, gold bears itself silently. Never do those draped and adorned realize their ropes and bangles of gold chain lock them to the element, a slaver's shackles to the burn of powers beyond their control. Soft and heavy and destructive as sunfire. Blinded by its luster, everyone who yearns for gold disappears into the heat of its hunger. Watch dreams dance on amber waves of grain or an angled sun ripple across water, watch them stream from the sky and shiver across a screen.

All that glistens is not gold and for some this precious metal sparkles least.

A poor material easily bent into facile metaphors, softest gold always breaks in the end.

Butter

I stole butter and I studied love.
—Lisa Robertson (2005)

Just like butter.

the most delicate of food among barbarous nations
—Pliny the Elder (77 CE)

Butter's the smoothest move, agile, graceful, simple, not made for an audience but still witnessed, side-eyed and admired.

Butter yellow is filling. A fat color I can put in my mouth, spread over words and make them melt.

I like bread and butter,
I like toast and jam,
That's what my baby feeds me,
I'm her loving man.

—The Newbeats (1964)

Butter's old hunger, a craving of not enough for far too long. A stomach creaks, eyes flicker and search for crumbs, teeth chew themselves, and food is not a flavor, a scheduled meal, simple sustenance, but a fantasy of plenitude, a full cupboard, a table heaving, a vat of butter, perfectly churned, that a hand dips into up to the elbow and the cool slip of butter fat and body heat makes it greasy, and only in dreams, the rest of the arm, and a body (all four limbs with fingers and toes, belly buttons and shoulder blades) jumps into the butter like a

pool, as if every pore of your body was a mouth. You lose yourself in the creamy yellow, the color like sun on soft, dry grass.

This is where butter's yellow derives, the beta carotene in grasses munched by grazers, hay made creamy. But factory farmers know the color of our hunger and add dye to convince consumers of its (false) quality. Though U.S. law prohibits coloring margarine to look like butter, I wonder the mechanism of its enforcement, the butter police in butter uniforms judging the aesthetics of margarine to ensure that the trick of its synthetic verisimilitude is not too convincing.

Butter's simply food.

> *Guns will make us powerful; butter will only make us fat.*
> —Hermann Göring

> *Hurray, the butter is all gone!*
> —John Heartfield (both 1935)

I heard on the radio once that the English blockade of Germany during and after the first World War caused catastrophic starvation and that German soldiers under the Nazis cited the memory of childhood starvation as a primary motivation for fighting.

Guns and butter. Butter guns. Butter battles. Bread and Butter. Do you know which side your bread is buttered on? Want your bread buttered on both sides? Butter them up, Butterfingers.

The quickest way to make a revolution is to starve a populace. Bread shortages in Egypt accelerated the overthrow of dictator Hosni Mubarek in 2011. Boston Globe headline Aug 22, 2015: "The Arab Spring was a revolution of the

hungry." "There are only nine meals between mankind and anarchy," said Alfred Henry Lewis (1855-1914), later adding, "It may be taken as axiomatic that a starving man is never a good citizen."

Let them eat butter.

Citrine

There are colors that cannot be captured. Not with anything that I or any other human has been able to come up with. They exist only where they are sighted and often not even there.

Then there are colors we cannot see beyond our visible spectrum, variations we lack the subtlety to perceive, to understand, to wield.

The golden yellow of citrine contains the first phrase of a setting sun, long before the creamy umbers and wispy wisterias of an imminent twilight. Citrine signals an end of day but only just, still warm but prone to cool, softened enough for the nighthawks to leave the cover of their hangovers and a jolt to children that the endless day without school might yet darken and close. A color just beyond the utter slackness of summertime.

The forest bulges, orchards hang pregnant, sound slows to a sibilate blur and steeped in stillness, a city afternoon lolls shirtless from brownstones, and even grumbling traffic smooths its transit to a hiss. The world sedately crawls on, stopping only momentarily to gaze skyward on first sighting of citrine.

Citrine is a dandelion wine, cooled by a single degree, apt for casking, but too pungent for consumption.

Though citrine is a color in nature, found most beautifully in some birds' muddied yellow feathers, it is best known as

hint, a tone, a shade through which light passes, citrine-colored glasses. As a static color inked on a page, you witness little of its true power.

Our color's namesake, the citron fruit fully colors citrine upon ripening, sunlight soaked into its thick skin. The ugliest and most beautiful of the citrons is the Buddha's hand, pure rind with a nest of smooth and fragrant fingers slithering from the stem. Buddhists prefer it held downward, hand closed in prayer, when laid in offering. Citron is one of the four ancient fruits from which all citrus derive and she wears her colors with earned immanence. Edible but only just, mostly citron finds itself succaded into candy, a light zest for heavy soups, with a spiritual cameo under Jewish sukkah.

Citrine seeped into stones gives quartz a syrupy color, aged, heavier than the brighter, thinner varieties of yellow that signal lightness but not depth. Does age deliver profundity? Hardly, but citrine has depth. Peer into its richness, a flicker of green, a smattering of brown, a settling into something different than gold (which jangles with gaudy commerce), but more simply golden, a quality of luminance, the color of enlightenment.

When the sun finally swells and fails, the first hint to any eyes still left to witness it will be the mellowing of hot yellow into warm citrine.

Piss

I do not remember precisely when her apartment began to smell like piss. All summer long, we drank and fucked and read books in her studio in the Summerland Apartments. She might leave for her job at the flag store, Flags with a Flair (my prank calls to her were regular and surreal), and I'd fold my naked sixteen-year-old body into her bean bag chair, the fake leather squelchy with sweat, and read for hours. I read all the Vonnegut novels there, one after the other, naked, post-coital, sweetly sore and hungover.

It was love. She taught me how to wash my hair the first shower we took together. She was twenty-one and I knew she had some distress, mostly from her family, for dating me. They were very religious and never forgave her for divorcing her first husband, a kind and gentle weirdo who I'm sure had no idea her family had pushed her into that marriage to cover her sin with a bridal gown. As they did for the two husbands who came after me, both scoundrels.

But it was summer, and we walked to watch the fireworks over the harbor in the bruised dusk light and sat with families and grannies watching the hot light burst and flare across the starry black beyond of sky.

Her drinking got worse and worse. The varieties of vodka, which had started out as respectable middle-shelf brands, had dropped to the bottom, below the bottom. Liquor you wouldn't clean a wound with. She'd bring home their frosted bottles in brown paper bags and we'd drink and fuck and read.

At the time, this felt like the best thing that could possibly happen to me.

But something was wrong with the cats. I don't remember but I think there were three. She lived on the first floor but all the windows were barred and screened. She did have a curious airshaft off the bathroom. When it opened, you saw other tenants' bathroom windows, all stretching up through the dark heart of the building's stories.

The cats were clearly unhappy. I don't think she was feeding them regularly. Even though I spent days over days there, I wasn't there all the time. I had a job at the cafe where we met that I had to return to for my shifts. My parents had resigned to my freedom, but they did their best to poison it with tears and recriminations, so I went home on occasion so my mother would know that even if I could not tolerate her acid madness that I still loved her enough to come back occasionally.

And then the apartment started to stink of piss. In my lover's depression, she had begun to neglect the house, including the litter box.

I didn't know how to do anything. I didn't know how to wash my hair. I didn't know how to clean a litter box. I didn't know how to help a 21-year-old divorcée with a 16-year-old lover how to not sink into the gooey blackness of her mental illness. So we drank and fucked and read and the smell got worse. And the first cat escaped.

She went into a panic and bolted barefoot out into the streets, searching the neighborhood and trying to tempt it back with its favorite foods, but it did not last. We both crawled back into the bottle. She played me all the goofy college rock she'd grown to love. And I memorized an album or three of They Might Be Giants and The Beautiful South.

Then the second cat went. She had grown resigned. The third (did he exist?) left soon after. And so did I.

I bought a ticket for a train to ride across the United States, to meet a friend who'd joined the Navy and see the world with all the romance of a boy who's read too many books and seen too few places.

The night before I left, we made love. This was also fucking and sex and every other word for it, it was dirty and adventurous, raunchy and deep, but also filled with compassion and care and tenderness, filled with love.

The piss smell of the apartment had begun to dissipate with the exodus of the cats, but it lingered. The hard hot ammonia, the failing chemistry of the kitty litter trying to capture the scent but that just made it worse as it sweltered through the summer.

And I left for a month.

When I got back, she'd lost her apartment and moved back in with her family. Her hard, sour nurse mother and jokey, unemployed preacher father barely tolerated me. We fucked a lot in the back of her car on the dark end of the street, next to a park near my house, and in the back office of the cafe after it closed. We'd drink vodka and Squirt with the lights out. It had a romance to it, something illicit and fun. It wasn't a grown-up who'd failed at being a grown-up and her teenage boyfriend at his service sector job. It was shadowy and loving. It was autumn and I was a senior and the cool air felt intimate as we searched for secret places for our desire.

I'm not sure precisely when she began to sleep with various friends of ours, regulars at the cafe. Even years later, after she apologized for all the rotten things she did to me (and I to her in my selfishness and naivete). She did it to break

up with me in a way that didn't involve actually breaking up with me, making our relationship so intolerable that I'd have to break up with her. I'm sure it also, of course, had to do with her desire for these men. She was young. She had a wide smile with the slightest gap between her front teeth like the Wife of Bath and clear bright eyes and had no nonsense in pursuing her desires with prowess. But it all felt so dark at the time, an inch deeper into the ooze.

We became friends years later. And our forgiveness felt cool and clean as our first shower.

Forever after though, the smell of piss was the smell of depression.

Piss yellow is a relief of a kind but never a clean one. It is the color of clinical sadness, unkempt, but maybe not sinking into the blackness but ever deeper into piss. A Bukowski word, a Henry Miller word, a corporeal torrent of stink, but still bright, almost cheerful in its hue. Like the yellow wallpaper in Charlotte Perkins Gilman's story, we can almost believe it will cheer us up, this bright, sunny color, but it only makes us crazier.

Not without joy or even love, but piss yellow is summer grown sour in the sun, which only a cool autumn rain can wash away.

Orange

Peach
Poppy
Carrot
Tangerine
Melon
Honey
Tiger
Amber
Harvest Gold
Pumpkin
Rust

Peach

Tucked under the velveteen fuzz of this tame church lady's Easter dress is something sticky, a splurt of nectar that drips from lips and down chins. A color drawn from the sliced flesh of a fresh peach, that hairy little heartstone is a tooth-chipping dirty joke underneath all that lovely sweet meat. "I really love your peaches, want to shake your tree," croons Steve Miller in his pompatus of love. A wholesome desire, carnal without corruption, its color a soft blush on a virgin's face, even a toothless elder can gum one and feel the vivacity of this pliable stonefruit as it dribbles down through creased skin, syrupy fruit one of the few sensual pleasures left those at a late end.

While Georgians and South Carolinians like nothing better than proclaiming their peaches, it is on the mountain slopes of China that this drupe first drooped. Pictured lingering on a Pompeian panel, the peach still-lifes throughout tourist-tramped miles of museums. For Caravaggio the plump little beauties, invariably handled by handsome young men, glow in these gentlemen's baskets and hands like a couple of gently shaved balls. When the artist Haim Steinbach, master collector, organizer, revealer of bric-a-brac meanings posts in a print on found wallpaper in 2011, "I went looking for peaches and came back with a pair:" well, the lust is plump as the fruits, but so is their possession.

Peaches promptly belong in modern art, looking a little sickly in Manet and robustly in Renoir, but it's Cézanne who best brushes the soft color into preternatural appeal, alluding and

eliding, softening and blending when some Calvinist Netherlander might make that mouth-watery succulence look all stone and no fruit. "Painting from nature is not copying the object," Cézanne said, "it is realizing one's sensations." You know Picasso's channeling his only master when he says, of notably dubious attribution, "One does a whole painting for one peach and people think just the opposite—that particular peach is but a detail." But a painting of a peach isn't really a peach after all, *ceci n'est pas une pêche*.

But peaches certainly don't belong to boys alone. "I'm amorous but out of reach, a still life drawing of a peach," croons Fiona Apple (her tart bite is well-suited for her eponymous fruit). Marilyn Minter harrowingly details each delicate hair on a woman's face in her work from 2003 called of course *Peach Fuzz*. *The Teaches of Peaches* has the songstress, Peaches Nisker, clearly declare in each word and turn of her hard struts that a little fuzz is fun for all mouths.

Peach is not lust though, just the suggestion of it: the sensuality is a dream of possibility, and so this soft tone fits as another of those colors that oozed out of California in the '70s. Goldenrod and avocado for the kitchen, peach for the bed and bath. A cover shade of a Rod McKuen book, a leisure suit hue for cocktailing in the Hills, the beachy watercolor on a brochure for a cult. No mystery that the '60s finish-fetishists found room for peachy sheens, as did James Turrell in his softly lit chambers, that the color leaks through the sci-fi landscapes of William Leavitt, or more recently coloring the paintings of younger practitioners from California: in Friedrich Kunath's coastal dreams and tie-dye washes, in Alex Olson's action-packed screens most clearly in *As a Verb, As a Noun, In Peach and Silver* from 2010, a cracked chevron in a Rebecca Morris abstraction, or as the background hue in Dianna Molzan, flecked like a fast-food countertop. It is a sunset color seen through smog, a juice smear of light at the

beginning or end of the day over the sea.

Peach begins as a fruit but this soft shade clearly peaks in apotheosis as a color, the pure embodiment of itself, a gummy lusciousness that by any other name is just as peachy.

Poppy

Come on home.
The poppies are all grown knee-deep by now.
Blossoms all have fallen, and the pollen ruins the plow.
—Joanna Newsom (2006)

California. Say it slowly now, soften the edges and let it drawl out. A hard Latinate grown smooth in the ocean like bottles polished by the sea.

It is a buttery avocado spooned onto your tongue, oranges tumbling out of a sack onto the linoleum floor, a gaggle of jet planes swooping over the giggle of bikini-clad girls on the beach below. It is barren hills festooned with bright orange wildflowers, the California poppy. Wildflowers bloom where they will, no gardener has yet controlled them. They are the state flower for a reason.

To Okie farmers dusted out of land by bankers, the word was like the tinkle of rain on thirsty fields. When they said California, it was like teeth breaking the skin of a freshly plucked plum, its juice dribbling down their chins.

I left for freedom. It was an imagined country but I loved and feared it. I learned the separation between reality and the imagination is permeable, so much as as to not truly be separate, but intertwined like the limbs of lovers.

Traveling so fast over the land, I left behind California and

its dreams, tires like zephyrs, the flickering gas stations and truck stops more luminous than stars. I left in airplanes, window blind closed to all the land being left behind. I left on trains, heavy metal wheels slipping over the continent on infinite tracks, heading east and north and sometimes south, every direction but home.

I came back alone, my plane ticket riddled with punctuation errors. Though California flickers with ghosts and shadows of collapsed fantasies, the light failing like a broken projector, it is still no more yielding but a dream. California… coming home.

Everything grows here.

Carrot

The day is coming when a single carrot freshly observed will set off a revolution.
 —Paul Cézanne in Joachim Gasquet's *Cézanne: A Memoir with Conversations* (1921)

Is the revolution in the carrot or how we see it?

First cultivated in the Persian plains, but most likely for medicine more than food, skinny white and hard as horns, these first carrots were never orange. To honor their assassinated national hero who led the fight for independence, William of Orange, the carrot-growing Dutch allegedly bred red cultivars to white and made this humble vegetable root forever orange.

Bulged lines fold along a long chubby body, its long taproot a tumescent finger. Planted and plucked from long rows by their tufts of green leaves, bundled and sold, they still wear a dream of soil over their bright skin. The orange of the carrot, though muddied by its earthy existence, has none of the russet potato's endurance. Not a single spicy tear to match the onion's hot torrents or a drop of the deadly serious beet's blood, the carrot is downright frivolous, an indulgence, a mouthy reward for a beast of burden that looks tastier than the stick.

Diced and julienned, chopped and slivered, raw and boiled, sautéed and fried, the hearty carrot can take whatever teeth

and heat can throw at it, forgiving of spice and easily oiled. The carrot fills a stomach with the piety of a vegetable but with a color that though not quite sinful, is certainly just a little indecent, without a lick of licentiousness.

Last night, drinking cocktails of vodka and carrot juice, the variety felt almost healthy though it did not lead to a single shimmy or smooch at the party which broke early so that we could digest our orange drinks with a good night's sleep. Though I could never hate the mercies of slumber, many a glorious dance party has been ruined by its boringly insistent need.

A sharp pang of passion has rarely shaken this carroty color, though a different, brighter shade is worn by Protestant adherents to William III of Orange. Not always known for their kindly ways, especially during their parades through Northern Ireland every July 12, which have been marked by violence from the beginning. Are we surprised that cinematic schoolyard bullies are often carrot-tops?

Can carrot orange shake its healthy rep, its indecently unsexual aura? What can churn this vegetable hue into something more visceral or celebratory, tragic or glorious, something better than a conservative Protestant's strut and a piously loud hue like the whine of a doctrinal vegetarian? What can change this color, or will the unnuanced patriotism of its origin forever color this color?

I do not feel I've found it, but in this bright and healthy hue, I still look for Cézanne's revolution.

Tangerine

Hello banana, I am a tangerine.
Is it a dream? Oh, no! I don't think so, but
My head is spinning, I am a carousel.
 —Tommy James and the Shondells (1968)

Tangerine, are you out there? I'd like to send these words to you.

Tangerine, I can see you in the window. The frame folds and grows, intertwining like perfect branches, into soft diamonds with curved edges. You're standing behind curtains, lace I think, not yellowed, but still old. Softly translucent, almost like a breeze could blow right through them.

I've never walked down this street before, though I passed it along Figueroa where it rises above the boulevard past the park with the leafy oaks and the graceful sycamores. The house is white and the window hangs in a big round room like a castle turret. I've always wanted a room like that, ancient and elven and somehow made with skill and magic long forgotten, but it's just a room in an old apartment building with air conditioners poking out from other windows on a regular street with blue and black and green plastic trash bins lit with the orange glow of an old street lamp.

Somewhere in the rain-wet night, I can't see the perfume of jasmine, but I can see you, though only a silhouette, the curve of your back, the shape of your poise. Though only ten

yards from the crackled sidewalk past the patchy grass to that window, the distance is vast, the window might as well be a painting or a movie, an illusion so complete that it will only stay real so long as I do not try to touch it.

Your silhouette disappears and so do I.

Tangerine, are you at the party tonight?

Somewhere in the hills, the laughs and chatter and the thrum of music carry out over the delicate white and deep purple flowers of a bougainvillea gone wild and the coughing traffic is still not far away, but softened, the energy and action of a city just beyond, a ready and lively place just beyond. Up the stairs, I look for your face in the smoking strangers on the front patio, among those sniffing lines off the glassy table in the living room, in the graceful contortions of those dancing in the dark kitchen. Will you be standing next to the bar?

There you are, can I ask you for a light? But then you turn and it's not you, but he sees me looking and smiles, two clear eyes above two soft pink lips. I smile but still turn back to the party to see if you're there, even though I know that you are not.

Tangerine, will you be at the cafe, hunched over a book whose title I can't read? So absorbed you can't see beyond the page, even me, but then your hand reaches for a steaming mug of lavender tea, so close I can almost taste it. Will I see you amongst the succulents in the gardens, leaving the gravelly trail to step softly into the grove of ancient figs?

Oh Tangerine, your pert color, so cold and so sweet, it fills me with a bright, clean light. You are a birthday present I want to unwrap at night and rewrap in the morning, again and again, peeling away the layers to reveal you there, vulnerable, beautiful. I could put you in my mouth.

But you're not there. Was it a dream or a fantasy? Is love just a place in my soul that your hand has found, that others, so few, but others have found too? I do not know what makes me wish to unwrap you but the courage of your color unwraps me and I do not know why.

I do not have your address, so these words are just words, whorling and angled letters on a page that you cannot see however I might wish you to see them. So this is only a letter I drop in the street, I toss into the sea, I scrawl into the bark of a tree, I write with wind on water hoping that you can feel its wet breath. You will not know it is mine, but I know you will feel it as I feel it, wherever it might find you. Its pleasure will caress your cheek, its sadness and delights whispering into your ear. Through your limbs, you will feel the warmth of its gratitude that it has found you somewhere in the world and that you can feel it.

Melon

Sun-soaked, a cool color, the sweet chill of this soft, tropical orange ripens under its rind, like a door that only a slim knife or a hard crack can open.

The land of milk and honey never felt quite right, a farmer's idea of paradise. The real paradise is instead the land of passion fruit and papaya, lychee and guava, dragon fruit and star fruit, creamy cherimoya and of course, sweet and juicy melon. Deliciousness provided, one has only to reach up to pluck fruit from a tree.

Melon's a funny word, almost indecent. A greasy businessman in the econo-class seat next to you, leans in with Old Spice and onions to say "Check out the melons on that broad." And you cringe. Not because you don't like breasts or melons, and the fruitful nature of both isn't lost on you, but as delicious as melons may be, they are not breasts. Vice versa. Besides, such declarations lack poetry. The melon is more than just a shape, more than a sweetness, but also like all fruits, a seed holder. The basis for new life. A pregnant belly's more a melon than a plump tit, but not all lovers find an allure in a ripe mother's particular protuberance.

Fruits are such steady stand-ins for mortality, beauty, bodies, life. And the decay of fruits, a singular metaphor of its own.

When fruits fell from the Tree of Knowledge unplucked, what was the scent of their decay? Was the knowledge rotten too? Cooked or fresh, parfaited or crisped, strudeled, pied,

compoted, sorbeted, diced or pickled, what knowledge is cooked out of that fruit properly reciped, or unreciped, just a smear in the dirt? Have the vultures and jackals, worms and flies gained the wisdom, deep indeed, that there is never a shortage of carrion?

What in English is called "still-life," in French is "nature-mort." Dead nature. Depictions of flowers and fruits, glistening fish and gutted rabbits, are better handled by the latter language. In English we deny that these things are now things, lacking whatever spark of life that made them alive. Neither life nor death is stillness: motionless, quiet, and pacific.

The still life is the tension between death and life. The Flemish painter Frans Snyders (1579-1657) mastered the breathing of past life into dead images, especially fruit and animals, and Peter Paul Rubens often hired him to take care of these things in his own paintings. A patron once confused their work, Rubens retorted: no one could depict dead animals better than Snyders, but for the living, he, Rubens, was the best.

Snyders is precise in detailing the coarse, unruly curves and cracks of nature. His bourgeois larders are packed with apricots, pears, and plums, contorted squashes with fat warty faces, bundles of sweet white garlic, round melons cracked with a fleshy slit peeking all the deliciousness within, pearlescent grapes bubbled and piled into quivering peaks, gnarly parsnips and stubby carrots lay like chopped fingers and arms, apples brocaded in fire and gold lay next to zebra-striped green tomatoes, and curled into each other like teenage teardrops made flesh waits a basket of brown figs, a sanguine inflorescence ready to be tongued by the plump maid handling them. All these fruits piled amidst an assembly of dead animals, peacocks unplucked lie near a platter of hard

red lobsters, a broken-necked goose, so white and graceful, flanks a tawny deer, all bounce bounced from its bent legs and splayed hooves.

Each detail perfectly rendered with colors richer than nature provides, necessarily so perhaps as paintings have to birth life out of mere pigment. They are more than alive. The human attendants in the paintings are mere ciphers to the plenitude of their spoils. The excess is nauseating. Snyders' meticulous hand churns the stomach. It is too much. Each animal and plant is imbued with such individuality, to see them splayed and dead upon the table, they might as well be bodies. Whatever their hue and glow, they are dead.

The fruits are dust, the maid a skeleton at best, Snyders' too, and whether or not the photographer of the painting I'm now looking at is alive is a question; but one that with enough time, we can be assured of its answer.

With paintings it's easier to forget, but when looking into the flora and fauna of old photographs, I often fail to remember the life looking back is long dead.

Photography always was just a feeble insurance against the inevitable, painting too really, but now everyone has snapshots of themselves and those they love: sweethearts and friends, parents and children, the distantly admired and the painfully desired.

The "still-life," the "nature morte," any picture capturing a mere moment of life before it vanishes, whether painted, drafted, snapshotted, or photoshopped, each document of fruits, flowers, animals or people is a humble effigy against the eventuality of death. Memory persists and mortality is immortalized. A simple prayer. Out of inevitable demise leaps a communion with creation and something new is made.

With careful metaphor and diligent documents, we chart the sun as it passes. Art asserts the sensual life and the potential for beauty against the energetic indifference of nature and the thumping finality of death.

Uneaten, fruits ooze into soft, saccharine skins. Wilted flowers champagned with decay possess their own sickly sweet aroma. The lingering perfume grows putrid. The hint of decomposition bruises and deepens, then turns. They deflate and melt, desiccate and dust.

The colors of decay are indissoluble from their scent.

Tucked away from winter winds, the painting still blazes a cornucopia of color and fecundity, sensuality and life for years upon years. Photographs make dead eyes shimmer with life, images harder to snuff out than people.

All the paintings will one day fail. The photographs too will fade. Both and all will disappear, but not yet. We still have mouths, tongues to taste, and bellies to fill with fruit, the orange flesh of a fresh melon.

Honey

Just like honey
Just like honey
Just like honey
Just like honey
Just like honey
Just like honey
Just like honey
Just like honey
Just like honey
Just like honey
Just like honey
Just like honey
Just like honey
Just like honey
Just like honey
Just like honey
Just like honey

—the Jesus and Mary Chain (1985)

We ain't got no money, honey, but we got love.

Dip a finger into that pale, warm orange, a lick of summer sun and pure sweetness drawn from the floral forays of bees. Sticky and gooey, that sugar squelches and slides with thick viscosity. That finger dipped in honey and then mouthed has a special, sultry something. The color contains all the sweet, viscid complexity of its namesake.

I want to drown like a fly in the honey, says Tom Waits.

It was a party. Behind an alternative art space in a courtyard, the cough of the highway close by, the red dragon neon of Chinatown and the dismal orange glow of street lamps coating the streets. Cans of beer hissed open amidst the hum and jangle, small-talking artists.

Standing with her back to the block wall, she stood with her cloth shift fallen beneath her bare chest, an ornate cross tattooed on her breastplate. Almost ignored in the scrum of the party. Body arced skyward, head tilted back, mouth open. The honey came down in a long slim unbroken stream into her mouth, pooling around her lips, dropping down her cheeks flowing down onto her shoulders, her breasts. A small black square around her feet caught the overflowing liquid. Fifty-five pounds of honey in one hour. I watched her, Julie Tolentino. And then got distracted, stuck in a conversation, handed one of those cheap icy cans and forgot for a few moments that she was there, in that sweet agonizing performance, enduring the ooze of it down and over her body. With a shiver of awareness, I turned back to the strange and sensual agony of her act, watching the sheet and pool of honey over and down the soft brown of her skin, dripping off her and down into the folds of cloth around her waist.

Titillating maybe at first but the difficulty went beyond the simple, illicit pleasures of voyeurism into complex and labored endurance. I watched with something like reverence. She had followed some inchoate dream to its conclusion. Not the first in modern performance to use honey, Karen Finley famously before, but the utter elegant simplicity of this action let the artist own this color without any reference beyond that of ancient rituals, lost to memory but not entirely to our bodies. Drawn away before its conclusion, I pulled free into the night, a honey color still sticking to my tongue.

Tiger

In every shadow hides a tiger. Crouched into the dark of a midnight closet, down a dreary alley, in the rustle of the dusky trees, this feral feline creeps quietly licking its sharp white teeth. A faintest pant and a rumbling belly, waiting for some unsuspecting kid to amble along, to fall fitfully, unguardedly asleep.

Tiger, tiger, in the forests of the night, can any color contain your fearful symmetry?

> *Calvin: We have houses, electricity, plumbing, heat... maybe we're so sheltered and comfortable that we've lost touch with the natural world and forgotten our place in it. Maybe we've lost our awe of nature.*
>
> *That's why I want to ask you, as a tiger, a wild animal close to nature, what you think we're put on Earth to do. What's our purpose in life? Why are we here?*
>
> *Hobbes: We're here to devour each other alive.*
>
> —Bill Watterston, *Calvin and Hobbes*,
> February 23, 1992

In the bright glare of a screen, from the blaring colors of a children's book, this soft orange begs for a hug. Cartoon tigers and team mascots shill us breakfast cereal and bounce instead of pounce, their growls only a sales pitch and their color more fuzzy than fearsome. But the striped orange down the tiger's back camouflages their shadowy creeps through stippled jungle leaves and dry brown grasses as they prowl

for prey. Humans love to assert their shrewdness over the obvious powers of other animals. Though tigers don't much like human flesh, they'll easily chew up a lonely kid if they're hungry enough. When soldiers call themselves tigers, they're ready to eat you raw. "And if the population should greet us with indignation / We chop' em to bits because we like our hamburgers raw," croon a couple of soldiers for Brecht in 1928.

Tiger orange looks like a spice you can almost taste for a hunger that can't be satisfied. An outfit meant to be taken off. A costume that's only a tease. A brightness that looks social, even playful, but it's a color that sets one apart too far, outside the herd, a solitary shade easily mistaken for something else. Complacency to its superficial softness is certainly a mistake.

Any villager who's heard a midnight growl will testify there's nothing adorable about a tiger. A huge paw might slap its prey for a little play, but a toothy mouth around a tender neck's enough. Tempt a tiger, tug his tail, and you get what you deserve.

A tiger lily, a tiger's eye, the orange beckons. However debased, we can't take the stalking hunger from its hue.

Amber

Nicias, again, will have it, that it is a liquid produced by the rays of the sun; and that these rays, at the moment of the sun's setting, striking with the greatest force upon the surface of the soil, leave upon it an unctuous sweat, which is carried off by the tides of the Ocean, and thrown up upon the shores of Germany....

Such is the fact, no doubt, but for a person seriously to advance such an absurdity with reference to a thing so common as amber, which is imported every day and so easily proves the mendacity of this assertion, is neither more nor less than to evince a supreme contempt for the opinions of mankind, and to assert with impunity an intolerable falsehood.

—Pliny the Elder, *The Natural History* (77-79 CE)

The mermaid goddess Jūratė fell in love with a fisherman. According to legend, Perkūnas, the god of thunder, upset by her affection for a mortal, smashed her amber palace in revenge. Lithuanians sometimes call the amber that washes up on their shores Jūratė's tears.

Amber can be melted under extreme pressure and when sparked will fire, but they lack the hard endurance made by the supreme pressure that births a diamond. Organic but still stone, a cheap jewel with rare exceptions, semi-precious. Though often inexpensive, this does not diminish its beauty

except to those who can't tell the difference between price and value.

An orange-yellow like boiled honey, amber when rubbed emits electricity, from whence the charge gets its name as the Romans called amber *electrum*.

Amber I always knew as a name, common as common where I grew up.

Amber Smith with the scarred chipmunk cheeks and the long locks hennaed a cheap red, her giggle skittering through her father's car. Amber Nguyen with the pert eyes blushed lavender and sneering mouth smeared red, her arcing shoulder blades two wings for a rebel angel. Amber Estevez with the horsey laugh, the chestnut bob and scientific genius. Amber Rasmussen with the teardrop tattoos, pale freckled skin, and broken teeth, the stripclub paying for Ren Faire corsets and gallons of nervous coffee.

Was Amber a de rigeur name that season? The designation is like any other name stolen from a shiny stone, parents hoping the gem lends luster to its bearer. Rubys always wear in their name the sequin and sparkle of vaudeville to me. Crystals, invariably beautiful and sharp, the poisonous lead in cut glass always adds to the shine. Emeralds smirk with gleeful mischief and invariably veer closely to catastrophe. In this jeweler's array of names, do all the Ambers resemble the resinous stone, the pine pitch made permanent, this sun sweat licked and lapped by the turbid seas?

Of the thousand jewels in Vishnu's crown most central in my dreams is amber, and inside of the polished teardrop that dangles onto his forehead is preserved a single mosquito, trapped forever in the sticky translucent heart of this semi-precious preserver, hiding in his guts the genetic recipes for a theme park full of extinct monsters with stiletto

teeth and claws long enough to push even the most bitter corporate spy past crocodile tears.

In a giant hazelnut carriage with wagon spokes of spider's legs and a cover of grasshopper's wings, Queen Mab whips with cricket's bone the skeletons that draw her carriage into the noses of sleepers to fulfill their longings and wishes. Through lovers' brains as they dream of love. Over lawyers' fingers as they dream of fees. Over soldiers' necks as they dream of cutting throats. Though only the size of an agate stone according to Shakespeare, the eyes of this faerie's midwife blaze with gratified desire and burn for me a rich and creamy amber and weep tears charged with all the sore exhaustion at the end of days.

Pumpkin

Ready to carve your soul, the Pumpkin King steers a deviant Cinderella's carriage into Sleepy Hollow with a coven of witches for a down-and-dirty danse macabre. That old-timey gourd, chunked and pied, spiced just so, scowls on porches while Linus and his blanket sit in the patch in a lonesome vigil for the Great Pumpkin, a Halloween Santa Claus, another Godot who never quite comes. This ribbed cultivar of squash, hard-skinned and slimey-gutted, plumps into a homely shape, an oozy orange glob crowned with a gnarly stalk. Pumpkinhead is hardly a honeyed compliment, but with its face knifed into a toothy grin, this autumnal fruit finds revenge.

Their flickering candles light spooky shadows along the paths of trick-or-treaters to sweet cavities and childish mischief. That warty sphere a hardened, half-deflated party balloon, is more than just seasonal crop, but all the delicious darkness of childhood mystery. Outside the glare of the street light and the porch lamps of suburban homes lurks all the grim unknown, a hurt without a face, those familiar sunlit streets past dusk lurking with strangers and strange things. An eerie thrill that creeps even into adulthood in every piss-stained alley and starless wilderness. The hooded passerby's hidden knife. The hushed forest's rustling beasts. Even only imagined, evil men and devilish women do haunt the cities, though never marked so clearly as a green-faced witch or a glow-in-the-dark ghoul.

While kiddies play-act with masks and candy, teenagers

yearn for the luscious dangers of darkness, the flickering mischief met in a lip-glossed mouth and a strained zipper. The darkness a tender concealer, a mask to fears awkwardly met with gangly limbs and pockmarked faces. The night hides a body bursting with aching self-awareness, a new toy tried out in parked cars on unlit side-streets and moonlit fields free from the glaring eyes of prohibitive parents. Fucks and fistfights, pranks and drugs, liquor and sweet sin.

The loving fists of Super, Big Joe, Rollo, and Sker jumping their youngest brother into the crew past dusklight. Jackbooted Dave Williams blearily handing around a ziploc bag dank with psilocybin on the midnight hill overlooking Golden View Elementary. The merciful Candice pink-mouthing innocence into experience after school in my postered bedroom. The strong hands of Jean-Pierre clutching my hair as I knelt down before him. Still drunk with freedom, the runaway rummaging through trashcans for a stale bagel and a half-smoked cigarette before dawn.

Pumpkin orange doesn't quite designate these dark rites and shadowy passages, but a hindrance to them. Those concupiscent adolescents find pumpkins and their bright, soft color a symbol to be dispensed with, an outgrown stand-in for the real that frightens and titillates.

To teenage fantasies, pumpkin orange is just child's play.

Much later though, when their kiddies crawl the streets with thin cotton pillowcases rustling with plastic-wrapped chocolate bars and candy corn, sugary suckers and gummy boxed sweets, these children turned adults stand aside with mournful smiles, nostalgic for symbolic dangers, too well-acquainted with the mundane monsters and drear responsibilities, the demons inside that no candy can comfort.

On All Saints' morning, the smashed fragments of pumpkin

orange smear the streets, casualties of gleeful vandals, teenage iconoclasts cracking their childhoods into gooey pulp.

Harvest Gold

Summer's over.

Dip your fingers into the Southwestern paint box and if you run them through the sky across a smeary summer, you'll leave a trail that leads straight to autumn. Rust reds and creamy umbers, a flicker of primrose and pinks that might make a conch shell blush, all flow handily into the brown leaves of red October dusks. Out in California all those fingerpaints get seeped through smog and when they arrive under twilight, we're caught watching days turn to night like summer's children, skin still naked to a warmth that refuses to quit, heading to evening art openings and baseball games in short sleeves and gauzy dresses. The summer's over and we all have to stumble back to work, or at least set our minds firmly away from that passing season's sultry pleasures all coming together into a harvest gold.

The year begins not with a drunken clang at midnight on the first of January but at the close of summer. The cool air calls people back to school, back to work, pulling on wooly sweaters and sniffing the air for the wet drips and drops of a puddling storm. Autumnal pleasures can only be stolen. Summer's slutty excesses reined in, when the leaves burn and cream on the trees into harvest gold, piling into crumpled piles and the last harvests keep the farmers in the fields till past dusk, these joys are in between the stroll from school to home, caught in the smoky scent of the first chimney fires. These days, everything looks like barns and supper time. In "October in the Railroad Earth," (1957) Kerouac whispers

into a bottle of tokay, "till the time of evening supper in homes of the railroad earth when high in the sky the magic stars ride above."

Not frigid like winter's bony fingers, but still chill. Mugs of hot tea and cider fall into cold hands with pleasure, aproned mamas mix in cinnamon sticks and a pinch of cloves. Autumnal bodies remember too well the lust and languor of summer, they miss it.

> *Breakfast in cemetery*
> *Boy tastin' wild cherry*
> *Touch girl, apple blossom*
> *Just a boy playin' possum*
> *We'll come back for Indian Summer*
> *We'll come back for Indian Summer*
> *We'll come back for Indian Summer*
> —The Beat Happening, "Indian Summer" (1988)

The pleasures of autumn still hot with the ardor of summer can't help but hunger for the colors that fall from trees, the comforting squish of cooked squash, the steamy stews mushed with the last vegetables from the last heat of a dying summer. A sudden warm day in the middle of all this autumnal cool, the last one as you feel its waning heat kiss your skin. One last dip in the creek, the last before it ices over. Stripped naked, you dip your toes and feel the season. It's bracingly cool, you know that snow's only so many days away, but in the dying riot of color, the moldering wet beauty, you still find a lick of freedom in this elusive moment. You shiver back in your clothes and run home, shoelaces loose, shirt untucked, fast as you can to the warmth of your house just over yonder.

And the night huddles round and a cold storm breezes its icy breath across the surface of the water and the first flakes

of snow tickle and ripple the surface of the water, catching in the limbs of naked trees, heaving onto the eaves and winter is here.

Rust

Rust never sleeps

—Neil Young (1979)

Forks and knives and spoons, pots and pans, butterfly knives and handguns, plates of steel and bars of iron, dumbbells and smartphones, rebar skeletons and dead engines, costume jewelry and baseball bats, bent nails and corkscrews, tin cans and door knobs, broken pipes and pumps and grates, cracked chutes and stepless ladders, charred artillery and toy robots, miles of wire and gangs of chain, planes, trains, and automobiles, children's braces and oldsters' walkers. All trashed and abandoned, broken beyond use, rusted. At the Love Shack, it all pauses for "tin roof… rusted."

Rust is only oxygen's love of iron, iron's affection for air. Matter loves to come together, to make new things, to breathe into life and think into consciousness. Forms are only temporary gaming for charmed stardust, that might at the end or the beginning come together once again, only to come apart again, big banging and crunching over and over since forever. Gravity might be a kind of love. But the coupling of iron and air births a rust that destroys metal, a love affair that leads to its demise.

> **JULIET**. *Yea, noise? Then I'll be brief. O happy dagger. This is thy sheath. There rust and let me die.*

An old red, a broken brown. A scrapyard color, metal's blush

as it finally yields. So easy for rust to color the ravage and decay of industry. A diesel truck, a suspension bridge, all the factories that loomed over a countryside, eating workers and vomiting smoke, hated for their grind are sorely missed for their jobs when they shutter. All the evidence of our industrial desires, pile and creak and rust. Millions of cars cracked by chance and time, all the soft desire for next year's model, all that heavy metal dissolving into a sigh of dust. With a creep of color, rust will sink a warship, topple a skyscraper, crash a civilization.

> *We both know what memories can bring*
> *They bring diamonds and rust*
> —Joan Baez (1975)

Let them rust.

The arrogance of metal always thinks it can win against everything else. Steel can chew a mountain into a valley to suck out its coal, can destroy a world with a nuclear payload tucked into its belly, all the locked and loaded rifles, all the bulldozers and cranes. It can add speed, pipe out sludge and pipe in water, but more readily splatters a soft body with its hard material. All iron and its alloys, all of it, will rust. Whipped with wet rain, the cool kiss of dew, and time, the rust eats away at all of them and me. Empires destroyed with the creep of this color.

We dream a future of pristine surfaces and unblemished purity, sanitized spaceships glittering with undimmed power, white and deathless, the cold clean of post-scarcity techno-utopias, a world born from machines in service of the soft humans who first dreamed their creations. Forget all this. There is only rust. The wood rots, the concrete cracks, the metal rusts. All the shining ego of the past, arrogance of what we wrought, will rust away.

So silent too. Until it's not. Decades of decay, the metal bolts encased in concrete on the old bridge slowly, quietly rusting. Until finally the weight of a million cars slugging across, a thousand soldiers booting over, the weight too much and it folds with a boom and splash into the white churn of the river. Crashing like a bomb's booming echo, like a thunder clap, like hundreds of thousands of pounds of concrete and steel falling with a deadly noise. A cloud of dust sighs from the ruins, and as the reverb dies, the cries of the survivors carry over the roar of the river.

These derelict bones, a skeleton dancing beneath this softening flesh, once steeled and hard are rusting too.

Stella and I circle the Richard Serra sculpture, a curving ribbon of steel designed to hold a skin of rust without the corrosive eating the body, a weathering steel. The curve is a maze, and the security guards are nowhere to be seen. I run my hand along its curve, trying to feel in my body this strange turn, gentle in angle but still hard steel. I let my finger nail scratch its surface and the thin layer of rust comes off and a thin whitish line mars its veneer of industrial chic. Stella is only seven years old that day but she gets it. We look at each other. We look around. We look back to each other and we start to run, circling the curving steel, laughing all the way, the turns leading inward to an inner sanctum and we collapse into each other's arms, a little girl and her father, finding joy in the hard curl of rust.

Brown

Beige
Chocolate
Sand
Russet
Dirt
Copper
Ochre
Golden
Bronze
Cinnamon

Beige

The hard beige walls fold into soft beige carpets lit with fluorescent lamps. The secretary taps away at the pebbled plastic of her beige keyboard and answers the shrill call of her shiny beige phone. I wait. She pulls pencils from her swirled beehive, her ornate wire-rimmed glasses perched like an exotic insect on the face of a toad. The floral print of her polyester blouse is the only color in the room, a jungle swamp and her bulging neck a fleshy lilypad for that face, waiting to slurp out its tongue for an errant fly. The big hand sweeps over black numbers featureless on an ivory face, the glass ever so slightly curved. A portrait of Jesus stares from the wall, his face like a cake you can't eat.

This is the office where children await their punishment.

And the beige of the room, the beige of all beige rooms. Khaki and camel and oatmeal are cousins, the first a summery military shade for man-boys who wished they'd been soldiers, the second softer, but a skinned beast of burden all the same, the last is better named gruel. Once called ecru and roughly the same as buff, they're all neutral colors, all synonymous with beige, the shade of power for neoliberal politicians, for bureaucratic capitalism, for a tastelessly modern form of power. A color to which all the Bartlebys of the world can only say "I prefer not," as it slowly squeezes out their life in classrooms, in offices, until beige turns gray in a prison crematorium.

A color like an infection, watch the rot of beige spread,

blunting all opposition, silencing the cacophony of voices for the whir of the air conditioners and the machines the servants and secretaries tap away at for the masters, all of them one after another replaced by better machines and then chucked into the street. A disease that makes you sleepy and complacent, makes all your colors fade, makes all foods blander, makes all your dreams look petty and small in the face of its impenetrably gluey expanse. Beige makes you grateful to have the weekends off rather than owning all your days. Beige puts a price on your time, your abilities, your life, all lives, everything.

Sitting in the office of the principal, the boss, the prosecutor, their beige faces coming to pass their judgements, surrounded by beige paint behind beige desks floating in beige carpets. Will they make an example of you for the others? Will they simply put you away, a broken tool? Will they make you grateful for their punishment?

"I'm doing this for your own good…"

All the soft color calms you into docility, until you're able to accept, whatever they say, that there are no walls but these.

Chocolate

Chocolate City, are you with me out there?
 —Parliament (1975)

Put it in your mouth. Let it melt, sticky and sweet. Over your tongue and down your throat, coating everything all the way down. Smile and others will spy its color all over your teeth. Now lick them clean. Take another bite.

Raw Chocolate
Milk Chocolate
Couverture Chocolate
Bittersweet Chocolate

Count Chocula rules from the Chocolate Mountains over a desert of cocoa. His serfs toil on the island off the coast beyond a muddy sea, gathering the fatty seeds, fermenting them under the sun, processing out the bitterness, burning the sugarcane, and milking the cows. The peasants and merchants die young of obesity and theobromine poisoning. The Count never dies.

Chocolate Chips
Chocolate Fudge
Chocolate Bars

From Nahuatl, some say a beaten frothy drink made from the fruit of the tropical *Theobroma cacao* tree. Named by Linnaeus, the Latin genus for chocolate translates to "food of the gods." Most of the Mesoamericans drank some

version and many attributed it to divinity, the earliest traces of its use have been found in the Amazon Basin in Ecuador from before 3200 BCE.

These days, chocolate's a global confectionery. Mixed with sugar and milk, it makes a color we want to sweetly paint on all those rich, creamy browns that give us pleasure.

> *Chocolate Brownies*
> *Chocolate Cake*
> *Chocolate Cookies*

> *And every day, little Charlie Bucket, trudging through the snow on his way to school, would have to pass Mr Willy Wonka's giant chocolate factory. And every day, as he came near to it, he would lift his small pointed nose high in the air and sniff the wonderful sweet smell of melting chocolate. Sometimes, he would stand motionless outside the gates for several minutes on end, taking deep swallowing breaths as though he were trying to eat the smell itself.*
>
> *'That child,' said Grandpa Joe, poking his head up from under the blanket one icy morning, 'that child has got to have more food.... He's beginning to look like a skeleton!'*
>
> *The cruel weather went on and on.*
>
> —Roald Dahl, *Charlie and the Chocolate Factory* (1964)

> *Chocolate Souffle*
> *Chocolate Mousse*
> *Chocolate Pudding*

Indigenous peoples throughout Mesoamerica used cacao beans as currency. The Aztec empire took tributes from their conquered neighbors in cacao beans. Though all colonists' accounts are dubious by their very nature, according to Francisco Oviedo y Valdés, among the Nicaro of Nicaragua,

ten beans would be you a rabbit or a prostitute. A hundred would buy you a slave.

Chocolate Pops
Chocolate Puffs
Chocolate Milk

Columbus brought back stolen cacao beans to Spain from the Americas after his last voyage in 1502, though he didn't understand them at all. It wasn't until Hernán Cortés encountered chicolatl poured from fifty jugs into fifty golden cups at the court of Moctezuma Xocoyotzin in 1519 did any European conquerors understand how this treasured crop might be more fully hijacked. Europeans sputteringly adopted it over the next centuries, though it wasn't until 1847 that the first chocolate candy bars were minted.

Chocolate Doughnuts
Chocolate Syrup
Chocolate Truffles

Two-thirds of the world's cacao beans come from West Africa. By some accounts, 90% of growers there use some form of slave labor.

Chocolate Ice Cream
Chocolate Pie
Chocolate Tart

Does this delicious color have to mean genocide, colonialism, slavery, industry, and decay? Yes, five hundred years is hard to unswallow. But chocolate in all varieties and its rich hue is also a heart-shaped box to your Valentine, a little sweetness on your tongue, a sin safe enough for a priest, a small pleasure in a life with perhaps too few of them.

A candied color of soft comfort, though not for the slaves who grow it.

Sand

Sand is a caress. The memories of mountains castled by children and destroyed with a sigh. The soft end of time hourglassed to this.

Down metal stairs rusted into lace, the beach.

A seaspit breeze thrushes over the dead seal tangled in a bed of kelp, and around the surfers rolling over swells astride waxy boards. Between the hard brown cliffs draped with clinging vines and the churning brackish blue of the vast foaming ocean, stretches a thin band of softest color. Run it through your hands and feel the grains dusting your fingertips.

Holiday cliché, beaches begin in yearning. *Sous les pavés, la plage*. Salt in your hair, the song of the waves polishes your thoughts like seaglass. Yachts slowly cut the horizon with their sharp white sails. Further on, cargo ships the size of cities heave hordes of plastic from distant ports.

> *Staring at the sea, staring at the sand.*
> —The Cure (1979)

In nature, sand can be almost any color. Black lava and whitest silica, pink from a blush of hematite, green from erosion of volcanic olivine, gray from crumbled shale. Some might say abstractly that sand is beige or tan, but beige is for cotton and tan for flesh, neither captures the strange softness that only pulverized stone possesses. Desert sand, devoid of the wetness of life, is just a paler shade, but many ancient oceans

have found driest ends in vast deserts. Neither silt or gravel, the true color of sand creams the particles of thousands of different stones and a million different shellfish and coral and bones into a softly giving grit. Sand invites a nap, maybe even a coupling, though any beach lover will tell you that rasping particulates can be punishing on tender flesh.

> *Walking in the sand*
> *(Remember) Walking hand in hand*
> *(Remember) The night was so exciting*
> *(Remember) His smile was so inviting*
> *(Remember) Then he touched my cheek*
> *(Remember) With his finger tips*
> *(Remember) Softly, softly we'd meet with our lips*
> —The Shangri-Las (1965)

Sand's old as the earth itself, but however ancient, nothing built with the stuff can last. *And so castles made of sand, fall in the sea, eventually*, sang Jimi Hendrix in 1967. The beach beckons for dreams and idles, a place to cast fantasies in shifting sand, build them up to be washed away. Both permanence and impermanence, this hush of brown whispers the tales of mountains worn to dust.

> *To see a World in a Grain of Sand*
> *And a Heaven in a Wild Flower,*
> *Hold Infinity in the palm of your hand*
> *And Eternity in an hour.*
> —William Blake, "Auguries of Innocence" (1803)

Made of memory, this color remembers nothing but everything can find solace in its enduring fragility.

Russet

By the statute of 1363, poor English were required to wear russet. Tudor sumptuary laws were designed to limit what each class could wear based on their station, regulating textiles, fur, jewelry, and colors. For carters, ploughmen, dairymaids, the herders of oxen, cows, and swine, along with everyone else working the land who did not possess 40 shillings of goods, no cloth was permitted except cheap blanket and russet.

Dye wool with woad and madder and you'll get this ruddy brown. The red in its hue descended from the orange and purple that saturates the color. Sunsets distilled into a serf's muddy bruise.

Cromwellians and Shakespeare handled this autumnal shade, another name for rough-hewn peasants. And it still is, russet is the color of a worked earth and workers of the earth.

Blue jeans are the common cloth these days for the tillers of fields and the pickers of fruit, but these handily rub russet with the smear of clay and soil.

Russet stains with the blood and shit of worms and coiled black potato bugs, centipedes and slithy toves, underworld animals and subterranean creatures. The blind gopher sees only russet. The fingers of roots strain through its color like capillaries, adding a sanguinary stain. Russet is soil. It is the soul of dreamy fields and fresh harvests, of peasant farmers and knuckling fascists. The brown shirts of Mussolini were not russet but they could have been. Fascism is the country-boy's revenge on the ravages of progress, communism the

bitter and heartfelt riposte of the factory drudge, generations separated from his landed ancestors: *paganus*, *terrone*, country-folk. When the tree of liberty is watered with the blood of tyrants and patriots, the mud oozes russet over the snarling roots.

Stay with your hands steadied on a shovel during a long workday and your skin returns russet where the sunlight hits and the flesh wears calluses.

Mostly uttered as a prefix to potato, russet is written as such in every neon fruit supermarket across America, named so by legendary horticulturist Luther Burbank, inventor of hundreds of varieties of plants with names like psalms, Fire Poppy and Flaming Gold, Royal Walnut and Freestone Peach. Aged twenty-six, he concocted the russet to solve some problems of the Irish potato that had blighted and starved the occupied island. He sold the rights to his new cultivar for $150, trading Massachusetts winters for California sun. The first choice for French fries, this starchy tuber, sliced into fingers and fried in oceans of oil, finds its home in fast food stomachs stretching with obesity. Its dark brown skin bears its birth in the soil. Even when washed and scrubbed, the russet potato cannot shake the earthy texture, its true color.

Burbank assured others that though plants did not understand the spoken word, they could be communicated with telepathically. What dreams and thoughts, what feelings did Burbank gift his potato? Did Burbank whisper into its future the burn of oil? Did he dream into its flesh the hardiness of this proletarian vegetable? It is the potato and not a peach or a poppy that gives enough to fill an empty belly, keep nations from starving. Did he whisper into the timbre of its hue? Is it its color that makes it strong?

Dirt

To take your lovers on the road with you, for all that you leave them behind you,
To know the universe itself as a road—as many roads—as roads for traveling souls.

—Walt Whitman, "Song of the Open Road" (1856)

Crisscrossing the great Western landscape, lacing the fields and forests, deserts and mountains, plains and coastlines, wefting and warping with subtlety around the hills and rivers, teasing every American with the promise of wanderlust and the expanse of possibility are the long and lonesome and, if even only illusory, dreams of freedom we call simply dirt roads. Flowing over the natural undulation of the land, wheeled by tires from miners and lumberjacks, farmers and hikers, fishermen and firemen, outdoorsman and outsiders, dirt roads rank above rugged tracks cut by other animals but just barely.

Dirt roads ribbon easily through groves and past cliffs without a stick of dynamite, just the wear of its travellers. Unlike those asphalted and cemented, these lack permanence (and government intervention). They wander and move in a slow waltz, drifting with use and washed out with a good rain. Ephemerally made by humans and impossible to pin down, they refuse facile mapping by all but locals. Country people suspect outsiders, especially officious ones. A fierce and isolated libertarianism eyes any power but their own as potential tyranny.

Unsigned and difficult to trace, dirt roads speak the language of self-reliance: independent, unrestrained, beholden to none, far from the cruelty of crowds and open to the possibilities of an endless horizon as well as the possibility of communion with occasional others in these wide open spaces, but not too much. Both motion and solitude, every crack and rock and bump is wholly felt, the illusion of separation between object, verb, and subject drifts away like a lonesome cirrus cloud off over the mountains. In a land regularly tamed and conquered, dirt roads testify that there are still places where humans are rare and the wilderness unsparing. Life on dirt roads is usually hard, but certainly satisfies those hankering to be free.

In 1968, artist Robert Kinmont photographed his favorite dirt roads. Simple and deadpan, *My Favorite Dirt Roads* shows each one cut through the wilderness, its name or rough location penned in the corner (though their simple poetry doesn't easily lead to any too specific of a place). Coupled with powerlines, shrubs growing in the center of the fine dust tracked by tires, strewn with stones and sandy-sided, towards ever distant hills and mountains, to remote ranches and remoter battlegrounds, backed by infinite skies wandered across by clouds the size of cities, the roads are beautiful. The simplicity of their presentation only emphasizes the weird romance such open roads to open spaces inspire as wanderlust. Square format and sepiaed, they look almost Instagrammed, or rather they're the original romance that this other technology can only copy.

With all the indexicality of the Bechers who were (seriously and without a hint of humor) documenting industrial buildings, Kinmont's photographs have an ethereal and funny poetry that make them dreamy, easy to love for anyone who feels the lure of an open road and Western promises. Close in spirit to fellow Californians Ed Ruscha and John

Baldessari, except Kinmont went off to find his story in the desert.

Maybe I love the work of Robert Kinmont because I love the California desert, and his work is inseparable from it. The sunset shadows cast by the slow dance of Joshua Trees, the broke-down shack untroubled by habitation, the vast void, as if you can feel the millions of tons of earth blown away by millions of years of hot, scraping winds, an absence that makes the blue sky crushing in its weight and your solitary wanderings near Biblical. The scattered human denizens of the desert scrape out hard-scrabble lives from the skinny bounty of that arid clime. The harshness and solitude lures outlaws and searchers, cranks and free spirits, drifters and dreamers, cons and criminals. In the desert, solitude tastes like freedom.

Amos Oz wrote, with a wisdom that seems like it fell out of folklore, "When I come back home and switch on the radio and I hear politicians using words such as 'never', 'forever', or 'for eternity', I know the stones out in the desert are laughing at them." Kinmont titled a work that says almost everything you need to know about it: *Two Educated 120 Million Year Old Boulders Trying To Encourage 47 Young Willows To Be Patient* (2012). The boulders licked with a bit of paint, the title's words carefully carved into the side of the wooden box that holds the birch, envision this piece in a thousand years, two thousand. The conversation continues, the stones are still laughing, an absurdist play that could go on for millennia. Though he lives in the friendlier climate closer to the coast in California now, the stark truths of the desert (tempered by his own particular sense of humor) backbone his oeuvre.

In 1972, Kinmont planted some copper pots near Deep Springs College where he was faculty at the time, filled with water and piped into the ground into the desert, a lure for wildflowers. After the work was completed, he stored the

relics of the event in a wooden box with this handwritten note:

> *I put these copper pots there in the desert where no one goes and decided to fill them with water each morning for one month to see what would grow, knowing that some seeds stay dormant in the desert for several years waiting for enough water. Everyday I would walk out to water them and sometimes have a hard time finding them. After about one week I noticed I was beginning to track up the desert and it began to bother me. I decided to take the path so I would not interfere. I still would get lost from time to time until the path got evident enough and I got continually deliberate enough. Then I realized that my success there would be in the clarity with which I did that and not in what I planned.*

A self-aware process, an indexical deskilling, a sensitive connection to landscape, a Zen humor, Kinmont feels at the juncture of so many other things going on around him: Conceptualism, Land Art, the introduction of Eastern thought to the US, but concocting his dreamy jokes out West as only he can. Emerging in the 1960s, Kinmont appeared in one of his *8 Natural Handstands* (1968) in Lucy Lippard's pivotal book on conceptualism, *Six Years*…. The series pictures the artist with simple black-and-white photographs doing handstands in eight different places of a typically mythical Western landscape of craggy rocks, big skies, lone and level scrubland. The lightness of the handstand talks to the heaviness of the stones. Seriously done and straightforwardly realized, they are also absurd, silly, grinning with beatific wisdom. The only people besides cheerleaders that do handstands are yogis, spiritual searchers. The desert attracts all kinds but especially these.

Then in 1974, he stopped making art. To take care of his

family, to start a school, to become a carpenter and incidentally to study Zen and meditate. He didn't make art for thirty years. His new work picks up where he left off. Before he stopped making work, he'd fill logs retrieved from the desert and its inhabitants, cut open and filled with materials, often found and somewhat fantastical: *Log Hollowed Out and Filled with all the Feathers from a Peacock* (1973) or *Log Filled with Amanita Muscaria* (1974). (Amanita muscaria is a poisonous hallucinogenic fungus.) The logs are sealed, the contents invisible to the viewer, who must take the artist's word on faith. Continuing this series in 2009, Kinmont's secret materials had grown more ethereal, though the deadpan titles stayed roughly the same: *Cottonwood Log Filled With Fear* and *Log Hollowed Out and Filled with the Memory of the Artist*.

Included in Philipp Kaiser and Miwon Kwon's historical survey of Land Art in 2010, *Ends of the Earth*, as well as the Getty-funded Pacific Standard Time exhibition of California Conceptualism circa 1970 *State of Mind* a year later, Kinmont falls between the two movements. He happily lacks some of the prominent members of Land Art's industrialist megalomania (Michael Heizer the primary offender), who wrote their names with concrete and steel across the face of the desert, with a cheesy attempt at eternal returns. Though only seriously introduced in the West recently, Kinmont feels more like the Zen-inflected Japanese Mono-Ha of the 60s than the American heavy metal of minimalism. With a bend towards the potently invisible, Kinmont's work holds a more natural affinity with the ethereal turn in Conceptualism than Land Art besides, especially Robert Barry and James Lee Byars, but also the proto-Conceptualist Yves Klein. Despite his own unique version of dematerialization, Kinmont's too anchored by the vast landscape to float away into the invisibility of the void. A student of Zen, Kinmont's wizened work, subtle and deeply embedded in the natural

world, carries the seriously sly sense of humor of a good koan, spiritually profound with nary a kumbaya.

In *Just the Right Size* (1970/2008), the artist, easily sighted as a rough denizen of the West, in blue jeans, t-shirt, and beard, holds up simple objects across 8 photographs: a pot, a bouquet of flowers, an old boot, a two-by-four. These things, all things, are the size they are supposed to be. The truth is so obvious and simple, but weirdly makes the world feel a bit more harmonious than before.

Robert Kinmont riddles us quietly, gently, with a secret smile, taking us down a favorite dirt road, however artlessly made, a soft brown brushstroke painted across a world.

Copper

Copper carries lust but cannot keep it: in consummation the color disappears. Ever a medium to what lies beyond, a pure attraction of energy across space and time that cannot linger. Pale skin tanned by the sun colors copper, carrying for a time the light of the sun even if destined to fade. Tensile, ductile, and conductive, copper bends and carries but does not keep.

Around her lithe body, copper locks curl, brushed by a sea breeze, bundled curiously by a white band in the back, but let loose to flow freely down and around her curves, twisting just so to veil a sigh of pink. On a shimmery half-shell, she floats in on an ocean more color than water, that breeze blown by a minor deity, delivering to the sands this terrible beauty born from sea foam, the causer of war and protectress of prostitutes, the goddess Aphrodite.

Botticelli painted her just so in 1486, modelled according to some by the greatest beauty of Florence, the copper-haired Simonetta Vespucci. She died young, at 22. A haunting woman, Botticelli's desire for her only ever found consummation in paint and perhaps in death. He wished his bones to be buried at her feet. So she is forever Aphrodite. It is no surprise that Aphrodite's husband is the god of metal-benders, though she was never faithful to him. The Ancient Greeks vaguely believed that the night began when the sky, Uranus, coupled with the earth, Gaia, covering her with his body during their coupling. Later his balls were cut off by time, his son Cronus, and thrown into the ocean,

giving birth to love, both physical and divine, this celestial delight, Aphrodite.

In mythology and alchemy, Aphrodite owned copper because of its lustrous beauty, its ancient use in producing mirrors, and its association with Cyprus, birthplace of the goddess and a historic source for the mineral. Its name coming, according to some, from the Latin for "Cyprian metal." Copper, that elemental color, one of only four metals not gray, an electrical transition of atomic energy charges it to cast an orangey sheen. The first metal, neolithic humans handled it for just long enough to realize it needed alloy. When the ancients (independently in different places) coupled it with many other metals (though most usefully tin), copper became bronze and began a new age. Though the cheaper iron cut that era to a close, copper was the first, its orange shine the spark that inspired human inspiration to fashion statues and swords, coins and plows, swords and guns, locomotives and jets. Not only the first but the best in cheaply carrying electricity still, moving flows of energy across continents, linking house to house, station to station. A bringer of Luciferian light, lace it together into the electrical grid, copper illuminates modern life, turning shadowy cities into bejeweled circuitboards. This power makes Aphrodite's element essential for modernity and more than one landscape has been despoiled to satisfy a mechanized world's gluttonous need for more. A desire once consummated is irreparable.

Rosetti's Lilith and John Collier's Godiva and Waterhouse's Lady of Shalott all wear copper hair. In John Everett Millais's Ophelia from 1852, see that love-crazed maiden drift down river, her diaphanous dress unfurled through the water, wildflowers still clutched in her hand. Past the still eyes and parted pink lips, the tresses coiling around her upturned face are clearly copper.

Ochre

The blood of the Earth. Ochre lathered our bodies for rituals as we invented them, a primeval makeup on simian faces flickering into consciousness, one of the only paints we can be sure those first sentient ancestors sprayed and spread and loved.

Ancient hominids painted their skin and dusted the bones of their dead in this bleeding yellowish-brown hue. Whether for worship or simple aesthetic affection for its tinge, we can never know for sure. From the caves of Altamira to the flesh of Beothuk and Maori warriors, humans everywhere found a beauty in this pigment easily smeared from wet clay, crusting still the hair and glazing the skin of Himba women in Tanzania and still finding force in wet paint caking canvases in painters' studios from Brooklyn to Beijing, though there it stains backgrounds more than features as frontage. The silhouetted hand stenciled in ochre 25,000 years ago in Chauvet dreams of ancient fathers and mothers. I imagine pressing my hand to it on the rough stone, thousands of summers separating our touch.

The most abundant mineral on Earth, iron exposed lends itself to a host of colors, but ochre is certainly its most ancient pigment. Since standardized in laboratories and factories to a definite shade of brown, natural ochre's hue varies wildly. Hematite and limonite spread throughout clay richly deepens its skin from ruddy red to mellow gold, changing from place to place, a fugitive hue. The iron makes the color last, while organic pigments crushed from plants succumbed to the

millennia, disappearing beyond what science and story can discover. Linguistically, ochre comes from an Ancient Greek yellow, its variant there doubtlessly bright as summer, but it has since settled into a shade between shanty rust and dying sun, a brown we dubbed Indian Clay as sandbox children who dug too deep.

European painters used ochre unsparingly, finding a fair hue for the ruddy skin of girls with pearl earrings and martyred saints, but this sanguinary shade has fallen out of use, reserved for the rutted dirt roads, dusty places, and earthen people. Across literature, the word still colors but rarely. Each time the writer fingers an array of colors, in a likely list from a well-thumbed thesaurus, they find in the curl of its color and the sound of its stutter a perfect poetry:

Oh Cur, Oak Her, Oke Ur.

Half-choked, it still rolls.

I see ochres in old port towns, rust-belted and terminal. Leaked from the wounds of dying iron, not rust but its bleed on weathered wood, dripping down into the cut seams and folds of buildings, the paint flaked and clinging to only the saddest fade of its wet youth. If Richard Serra's steel monuments could bleed, they'd bleed ochre.

Its smear is spotted in stones littering Monument Valley and the American Southwest, the bands of ochre ringing pale rock in dusted desert cathedrals more sublime than humans can ever craft. Ochre colors the arches and buttes where Wile E. Coyote's technical genius always fails to defeat the Road Runner's native intelligence and natural grace, never ever sinking those cartoon canines into his evasive prey.

A generation of minimalists and land artists favored the American desert: Michael Heizer to cut his city of stone,

James Turrell to carve a naked eye observatory out of a caldera, and Noah Purifoy to assemble a junk garden. They found in Coyote country a freedom to act and make far from civilization and its corruptions, and so does Alma Allen and Andrea Zittel and all the artists in High Desert Test Sites along with countless other freaks and weirdos, visionaries and geniuses still sifting their ideas through the desert dust.

In ochre we find our most ancient connections to the land and its color, where technology reveals itself as that mechanism that not only fails to deliver desire but will likely lead us to our eventual self-destruction.

The Road Runner, never caught, always free, again and again leaves his enemy eating dust, twinged just for me with the softest whisper of ancient ochre.

Golden Brown

Golden Brown texture like sun
Lays me down with my mind she runs
Throughout the night
No need to fight
Never a frown with Golden Brown
<div align="right">—The Stranglers (1981)</div>

Golden brown colors the crystals of unbleached sugar, the hot bloom of creamy foam in a cappuccino, a chocolate milk supernova.

Bake your cookies, and the sweet, warm aroma tendrils through a cozy home. Its sugars may caramelize, but lovingly egged, buttered, floured, and chipped, that sweet treat burnishes golden brown from the oven's hot mouth. The richest taste of this color can be found in its soft, melty dough. Crack open any recipe book and from onions to toast, golden brown is the most desirable color for culinary masters.

Though *caput mortuum* paint made for a dustier shade, mummies stolen from ancient tombs and ground into pigment still dream of Egypt through the cracks of old paintings (as their desecration still haunts its looters). Brown tints everything there and its shade beckons to a perpetual afterlife beyond the penumbra of the sinking sun over a thirsty delta.

Golden brown is a color of delicious warmth, of a softer paradise than the most fantasists allow, a color of wet sand gleaming in the sun and of the humans who live off its shine.

While russet wrapped peasants by English decree, golden brown is breathed into flesh by a distant sun god, a color that holds the power of a celestial sphere in its hue, the passage burnishing the skin from a paler shade of winter to a color that glows with smoldering fire and equatorial exposures of a long a summer.

The sadness of golden brown is the distance of its source, a color that hints at powers never to be touched, just a remnant of the sun's awesome force, the transformative powers of heat that can easily cook flesh, moisten with perspiration before desiccating into a dried husk.

Golden brown is the wet color before the burn.

Bronze

Naked skin. A third place medallion. An ancient idol.

As long hours laze by with a drifting day, gently lotioned flesh darkens from honeyed to tanned, past copper into the deepest glaze of bronze. Coloring adds shadow and depth, the greater contour to curves. Belly to blankets, the girls unstrap bikini tops for lineless color and a leisure class glow; the sunbathing boys just barely wear bottoms for muscle beach brown. To battle the burn, bodies make melanin to protect skin from the sear of solar heat. The recovery captures the beachy beams and casts them into the chill drear of gray cities for at least a few weeks after the holiday sunset's spent.

Down the drugstore aisle beyond the bright pink and white lotions with their numbered SPFs and the orange oils with smirking bananas and swaying palm trees, sometimes you'll find a little brown bottle with a pretense of darkening power labelled bronzer (just as easily shelved in the cosmetics department an aisle over). This unguent, when smeared all over an un-sunned body, burnishes it into the thick, rich color of the ancient alloy, a synthetic capture without the sun's spectral force.

Bronze is firstly a metal. When found and rarely in nature, this unexposed alloy of tin and copper seems a salmon pink, but weathered it darkens into the familiar shimmer of reddish brown. For prehistoric blacksmiths, bronze could be really any metal mixed with copper, including arsenic in its first brews. Later on, they preferred the lower quality iron

to bronze, so much cheaper and more plentiful for smelting weapons and tools. And thus ended that age. Later, steel beat both and bronze came in third. And always does, though usually now after gold and silver. A third-string achievement, the also-ran of the also-ran. Bronze doesn't give a fuck that it's third place. And that is its beauty.

The bronzed Olympian, twinkle-eyed, often declares into the outstretched microphones, "I'm just glad to be here." Second place silver knows with a bitter bite how close she came to greatness and failed. And as metals and medals go, gold is a show-boater, an ostentatious bit of bling. The only thing going for gold is its pliability and rarity, which make it excellent for ornaments and nearly useless for anything that requires force. Furthermore, first place, its goal met, has little more to do but polish their trinket of glory, living in the afterglow. Bronze moves on.

Tooled and statued, formed and fetished, the casters of idols and statues prefer bronze for its particular properties. Ductile and enduring, bronze when setting expands just slightly to fill a mold's finest details. It can be poured into grand and dynamic poses. The finish of patinas can make that metal turn a hundred chemical colors, make cold hard metal into supple flesh with fresh bruises and stained blood, make the static statue appear to shift and move with animal grace. A perfect material to shape and tribute the gods.

But the cults are gone, the idols desecrated, totems toppled. Very few of the most beautiful of the ancient bronzes survive. The body of the god boiled into weapons and money. So go all religions. Many a bronze crucifix has melted into the belly of a cannon, the pocket of a priest. But the metal of many uses persists and is used again, bending to each new need.

Bronze endures. The burnished brown hue whispers ancient origins we've since forgotten, but that survives in this third

place alloy, less than other metals but so much more because of that. History into legend into myth and away, only a few artifacts and the color remain to teach us the tales of our ancestors. Bronze beckons us to try and follow the mysterious trajectory that brought us from there to here, and maybe further yet.

Cinnamon

Sweet wood. A breeze off the Malabar Coast could carry the dusty spice eight leagues across the ocean to greedy sea captains hankering for a hold full of the stiff curl of this precious commodity, soft brown in color. Rolled and sold across the world, cinnamon carries the tropics in its mellowed hue. Telephoned through Arab traders and Mediterranean dealers, the word we speak as cinnamon began some say in Phoenician, but came to English through Greek. This mellow seasoning peeled into tubes from aromatic barks, ground and sugared, mixes with sweet chocolate and hot bread, spiced cider and iced tea, hard liquor and scented candles, an offering to the gods, a treasure almost destroyed by Cleopatra along with gold and ivory according to Plutarch to protect her fortunes from falling into Roman hands. For the last of the Ptolomies, her plans failed and the Egyptians have always since been the vassals of imperial potentates and foreign religions. Cinnamon is a spice, with wars wrought and humans enslaved to control its power, the preservation of its powder and the taste of its tropical origin. Columbus claimed to find it in the new world, but as with almost everything else, he was wrong.

Neil Young could live out the rest of his life with a cinnamon girl. In Proverbs 7, the Bible offers some advice:

> *In the twilight, in the evening, in the middle of the night and in the darkness. Behold, a woman comes to meet him, dressed as a harlot and cunning of heart.*
> *Boisterous and rebellious, wanderlusting, She is now*

in the streets, now in the squares, And lurks by every corner... So she seizes and kisses him, And with a brazen face says... "I have come out to meet you, to seek your presence earnestly, and I have found you. I have spread my couch with coverings, with colored linens of Egypt. I have sprinkled my bed with myrrh, aloes and cinnamon. Come, let us drink our fill of love until morning; Let us delight ourselves with caresses. For my husband is not at home...."

Do not let your heart turn aside to her ways. Do not stray into her paths. For many are the victims she has cast down, and numerous are all her slain. Her house is the way to Sheol, descending to the chambers of death.

All desires lead to death, but this prophet might mean otherwise. It is true that betrayals of all kinds should be wisely avoided, but women throughout history, so often enslaved by husbands, had few agencies. Taking other men or women into their bed was one way (potentially pleasurable) to rebel against the tyranny of marriage. The first action of manumission is to reclaim a body. A patriarchal document, the Bible warns against girls but there are surely cinnamon lovers of all genders out there too. Just as lusty, just as oppressed. Those tempters who find freedom in a hot embrace, the sweet and spice of sex a little muskier than cinnamon, but one thing can lead to another.

I find force in women wanderlusting and rebellious, the warrior queens and shield maidens that refuse to become like Rilke's panther whose "vision, from the constantly passing bars, / has grown so weary that it cannot hold / anything else...." Though the aroma of cinnamon taints its carriers with the exotic, the smell's so wholesomely regarded from Christmas cookies to breakfast cereals that it's sold to young girls for their pre-teen perfumes, a safe alternative to the funky miasma of erotic adults.

To Langston Hughes in 1921, cinnamon was just one of the "rainbow-sweet thrills" of Harlem girls waiting on Sugar Hill: "Rich cream-colored / To plum-tinted black, / Feminine sweetness / In Harlem's no lack. / Glow of the quince / To blush of the rose. / Persimmon bronze / To cinnamon toes." Hughes knows that these shades and hues worn by humans are a powerful beauty.

In the depths of its rich yellow brown, cinnamon dreams of long journeys ending, no matter how hard, with sugar on your tongue.

Green

Jungle
Seafoam
Mint
Turquoise
Teal
Grass
Avocado
Chartreuse
Emerald
Poison
Sage
Jade

Jungle

Jungle green sops with the hungry fantasies of a child enclosed in a perilous primary school. Inside, the predators are prim nuns with strapping rulers; outside, cruel bullies prowl the chain link shadows. Somewhere faraway, feckless parents in all ways flounder.

My favorite crayon. Wielded recklessly in a first grade classroom, the paper sheath peeling away in an upward spiral as I smeared the paraffin cylinder's pigment over rough paper. The clutched crayon colored tropical rainforests and dense jungles, a wilderness choked with dripping vines and snaking foliage, waxy leaves veined with firing red and flowers like ornate Assyrian daggers crafted for arcane rituals. Other colors streak and stain: the saturated primaries flickering from the wings of *rara avis*, the wetly leaping hues skinning poison dart frogs, the silent gold of a panther's eye as she skulks and stalks the thickets, concluding in a flash of white teeth and red splatter.

A hue of drenched dreams and disoriented heat, viscous movements and untrackable paths. Inmates kept in jungle prison colonies don't necessarily need walls, escape into the lush forest is often its own death sentence. As Henri Charriere wrote of his time in the penal colonies of French Guiana in *Papillion* (1969): "We have two guardians: the jungle and the sea. If you don't get eaten by sharks or your bones picked clean by ants, you will soon beg to return."

Living in isolation, the people who make the jungle their

home grow wise and shy with its secrets. Outsiders are only infiltrators, another predator. As Nemonte Nenquimo, leader of the Waorani people of the Amazon, wrote in the Guardian in October 2020: "In each of our many hundreds of different languages across the Amazon, we have a word for you – the outsider, the stranger....It took us thousands of years to get to know the Amazon rainforest. To understand her ways, her secrets, to learn how to survive and thrive with her. And for my people, the Waorani, we have only known you for 70 years (we were 'contacted' in the 1950s by American evangelical missionaries), but we are fast learners, and you are not as complex as the rainforest."

Jungle green colors the berets of elite soldiers, minds and muscles taut, guns cocked and loaded, camouflaged in pooling patterns of varicolored viridescence. They do not hesitate to kill their quarries. The green beret developed for mountain warfare and weather never really survived the jungle, a steel helmet appropriately camouflaged better served the skulls of infantrymen. But the name persists. Many of the last half century's wars were not fought on open plains in dugout trenches and rarely on mountain passes, but deep in jungles, the last refuge for freedom fighters and guerrillas, banditos and terrorists, rebels and insurgents, their name dependent on its utterer.

This blunt color finds a painterly home far from colonial armies and native resisters in the leafy forests of Henri Rousseau. Smoothed and creamed, his greens become theatrical backdrops for wide-eyed primates and creeping tigers, burning bright. Each articulated leaf distinct and distinguished, the green almost cools so we can see this jungle with a clarity often lacking in the damp torpor of equatorial climates. The simplicity and clarity becomes almost childlike, those dense real places of difficulty and disease, riotous and vivid biomass transform through Rousseau into

flattened pictorial tableau, making that place of peril, one of possibility.

A dream without parents, their softly patronizing authority overthrown. Jungle green is where the wild things are. Rousseau inspires the illustrations of the illustrious Maurice Sendak. In the hallway down which Max the Wild Thing creeps, a house plant swells with wild tropical color, however contained. In the homes of wandering hearts, one will always spot a potted exotic. Barks crested and knobbly, fronds sharp as spite or softly heart-shaped into wide clean planes, delicately veined. Ferns and philodendrons, elephant ears and bromeliads, flaming sansevierias and fleshy orchids. Behind each of these jungle plants rooted far from their native rainforests hides a secret wild thing, ready to swallow up all they love with a single, wet gulp.

Seafoam

Sunlight skims the churn of foam on the ocean's hazy frontier, the end of vision. That slim infinity where the sky kisses the sea can only really be seen in that single elusive burst of green light at sunset, the ocean burping color after it's finally slurped down that solar yolk for the day.

An unseen forever. The unreachable, distant horizon. Hidden within that burst of seafoam green is a place.

Horizon is just old Greek for a boundary, a limit, whilst the Old English just called it something like an "eye-mark." But the horizon isn't a limit, it's a place. Tolkien wrote of the Undying Lands, where the world makers and their supranatural children lived beyond the reach of the mortality they wrought upon the world.

On the floating island of Tír na nÓg, under the soft shadow of the Big Rock Candy Mountain and past the Fields of Elysian and Aaru, in the center of the Garden of Eden sits a Seafoam Palace. Made of air's coupling with water and lit with rosy dawn and smoldering dusk, the light mingles as it dances through the palace walls into a perfectly faded and frothy green, deeper than aqua and brighter than ether. The hallways of always lead to great feasts where the warriors toast over and again, the grog poured by polar bears drips down their beards and between their breasts, to bathing chambers made of marbled clouds where in pink bubbles frolic nymphs and naiads drunk on champagne singing a sweet psalm of hardship and forgiveness, to sprawling bedrooms dripping

with silk and voile, angora and needle lace, batik and brocade, cashmere and chiffon, gauze and damask, merino and muslin, organza and qiviut, taffeta and tulle around piles of pillows on beds and chaises where bodies laze and fuck and dream and laugh and talk and smoke under a soft hazy light. The hallways lead to rooms of fire and rooms of ice, chambers for weeping and laughter, memory and forgetfulness, stairwells lead into arcades and rooms behind rooms.

Here in the Seafoam Palace, dreams are wetly born and softly sated. Here hide all the gods and phantasms, exquisite monsters and rarest beasts. Here your grandmother curls her fingers in Neptune's beard and your grandfather smooches a mermaid. Here, jinns play poker with saints and Nirvana opens for Moksha. Indra plays the drums and the devatas sing backup and the Ghost Dancers twirl and stomp. Here, beyond the limits of what we can see, the invisible live freely: illuminated just so, ghosts take form, spirit finds flesh, and they drink dew stiffer than hundred proof whiskey and ambrosia so fresh it still wriggles. Peyote buttons and fruit from the Tree of Knowledge are only the appetizers.

The unreachable reached, there is no beyond, this is the beyond, and even here there is further still, hallways beyond hallways, as deep as imagination can go, not onward but inward, spiralling like a seashell heartward, forever. The horizon is an illusion of perspective, a trick of gravity, and where we stand is always timeless infinity in all directions.

The beyond is both everywhere and here.

Mint

They were serving mojitos again. She ran her finger on the edge of the glass, dipping the nail of her silver-polished pinkie into the icy rum. Her ring clinked on the lip. Taking a sip, her tongue washed in lime and muddled mint and she felt like she always felt at parties, fashionable cocktail in hand. Unsheltered with only her drink to protect her. Her body today felt something that had to be lugged around. One too many limbs, one too many bodies.

The kiss of her lipsticked mouth stayed on the edge of the glass, a pale green.

The partygoers chatted around her about foundation repairs and mutual funds, diaper brands and rapid restructuring, a softer patter interspersed about bars and restaurants, recipes and farmers' markets, everyone checking their cell phones at polite intervals. A complacent air of entitled success seemed to settle over the party, a smug residue. Was this networking? Were these friends?

She wanted to be liked, but maybe only for the right reasons. Networking didn't have to be that gently banal evil of self-interested hustling but maybe a way to connect with others that she would like to work with, whose visions and styles matched her own. Was she happy at her job? Were there other jobs she hadn't considered? She clued into the conversation at her right. A man with an unbroken smile in his twenties was listing some recent accomplishments to a woman in an elegant dress in her thirties. A soft brag, he

complimented all his colleagues, how very *professional* they all were. She could smell the woman's perfume, crisp and light like autumn apples. Did she sound like *that* when she talked about work? She hated that she was thinking about work, again. Life was more than just labor on labor, right?

And she drank more, gulping it a little too quickly and she ran her right hand nervously over the bracelets on her left wrist, metal and plastic and wood. She felt her clothes against the sweat of her skin, the tug of her bra over a wet back, the cotton of her panties riding up a bit, the shift and flow of her organdy skirt over bare legs. She wished she hadn't come, but stayed anyway.

She did wish she had more friends, or new friends, or perhaps connections of any kind are so rare it's worth making the effort. She surveilled the party and couldn't concentrate on any face for too long. How easy it was to just walk up to strangers and compliment them on their outfits, that perfume maybe. Three women with accents on the other side of her were planning a girls' trip with shopping and a beach day and a tour of art museums. It sounded really okay. She'd never done anything like that, at least not yet.

And the alcohol smoothed out her anxiety from a hard crumple to a soft crease and she went to the bar and ordered another drink. And she could taste the cool crush of the mint leaves as the bartender ground them in the bottom of the glass and she did not feel clean but when she drank her first sip, she knew what clean at least tasted like. A cool mist spraying off a waterfall, a breeze whispering across grassy fields after the rain, and she thought of the heave of her body and when it had last felt light, awash in salty waves, as they surged and retreated, frothed and wetly slapped with chilled waters.

She looked at all the faces of the party, was there anyone here

she could love? Was anyone here her heartbreaker? Which might be her best friend? Which face could she kiss? She chose one from across the crowd, a mischievous smile, kind eyes behind bright green glasses and dreamed of a life with them, of lazy Sundays and shared silences, of hard desire softening into companionship, trust and betrayal and trust again, of a dance that would be dangerous even at its safest. Another drink, and a shred of leaf loosed from under the ice swam into her mouth and settled on her tongue. Sticking it out, she plucked the errant mint leaf from the tip.

Would she be good enough? Pretty enough? Smart enough? Would they earn her affections, talents, magic? Would she tire of their life? Could she hide her flaws or would she appear naked under those kind eyes? Would she be hated because of great qualities, loved despite great faults? Would her shape fit snugly into theirs, limbs around limbs, life around life? Would she feel a blush of embarrassment at their manners? Growing tired of their caresses, would she go to another party, kiss another face?

At home, she knew what would happen. She was not afraid of solitude, but the lure of possibility, life-changing magic could be here somewhere.

The doubt surged and retreated, desire defeated doubt. The ice cool of the glass felt good, and her body with all its moist folds felt loose, and the talk of the party felt less like anxious striving and more like wet leaves to be passed through and peer behind.

And her heavy body felt light, or remembered its lightness. She set down her empty glass and pounced in.

Turquoise

I discovered why the Navajos considered turquoise to be sacred—everything is sacred in this life.
—Lee Yazzie in *Smithsonian Magazine*,
November 24, 2014

A milky sky not far from still swimming pools. The cream of clouds in an otherworldly cocktail, an ancient churn of ancient stone. Water percolates through copper and aluminum making not a faceted gem, but a semi-precious cryptocrystal. Water made stone, its bends and scars and impurities finding their force from ancient flows.

Carved out of bloody sandstone, banded with silver, sold in boutiques and roadside stands, legacies of the Zuni, Navajo/Diné, Pueblo, and Hopi of the American Southwest. Diné children are given their first piece of turquoise hours after being born. A protection from want, from need, from ill fortune, turquoise is a hope, a yearning, a wish. The Southwestern native words are many but most mean "sky stone." Its name in English comes from a whispery French take on a stone of perceived Turkish origin (though it came from ancient Persian mines where the locals called it in their ancient tongue something like *victory*). Aztec kings and Egyptian pharaohs wore a bit of this mineral in their death masks, a color that protects the beyond. "Turquoise" spoken is a poem filled with cool wetness, both exotic and familiar, a summer sky over hard deserts, where water is life. A shard of sky you can wear on your wrist, but softer, softer. A color

for palaces and holy domes clad in the color of the heavens.

A sacred stone. Tossing turquoise into the river is a prayer for rain. To wear this shade is to try to embody a flow made permanent, an evolution never-ending, awash in forever.

Teal

Hang on to a moment too long and you will suffer.

The color teal is a threshold, a passage in-between. Linger in this shade and you risk becoming a specter, neither living nor dead, but a haunted memory of what once was and cannot yet be.

Death is not the end of course, but just a change of state. In corporeal death, whether your beliefs return you back to stardust or pass you onto paradise (or inferno for that matter), you merely go from one plane of existence to another. Hermann Hesse's itinerant artist Goldmund puts this change most beautifully to his friend, the monk Narcissus, in *Narcissus and Goldmund* (1930):

> *I hope death will be a great happiness, a happiness as great as that of love, fulfilled love. I cannot give up the thought that, instead of death with his scythe, it will be my mother who will come to take me back to her, who will lead me back to nonbeing and innocence.*

The thought of returning to nonbeing and innocence gives me wondrous comfort, the promise of a love that can only be fulfilled with my death.

Though I have not yet of course died, I have unwisely resisted the death of things and eras, of connections and relationships. I have lingered in this vestibule, this room between rooms, this teal hallway and been cursed for grasping onto the moment in its passing.

Teal captures both the beauty of the ephemeral and the horror of resisting a moment's brevity so well because of its very nature as an in-between pigment, a bright little compromise between green and blue, the earth and the sky. And when stained beyond the momentary, this compromise achieves the grandeur of neither. When clenched too hard, the transitory moment becomes a terrible illusion, a dark bardo for hungry ghosts.

Stuck in teal, you somehow know its intention was to soothe, but you are not soothed. A faded plastic sunned for too long, peeking from a trash heap. A country pond poisoned with toilet cleaner.

With rare exception, most teal flowers have usually been dyed and when dyed, teal stinks like a synthetic trying to hide its falseness. Neons never hide their fakery, and you can easily exalt in their electricity. Teal colorant, soft in its saturation, covers up the crime and comes off as phony.

Cheerful maybe, but never authentically so: it lacks the hope one looks for in truly bright colors. Though certainly not as hard, teal lacks emerald's fire. A darker shade of blue-green, an offspring of cyan, not far from turquoise but turquoise's ancient powers make teal look callow and uncommitted.

The color teal originally derives from the duck whose feathered eyes gave its name to the color. But in the beginning, teal only ever meant "flock." Teal is for flocks, a color that comes from a scatter.

Teal is not a color found easily in nature, but it does peek out from the wilderness here and there: flashing from the feathers of some ducks and kingfishers, on the wings of certain butterflies, moths, and dragonflies, in the fruits of *Ampelopsis sinica* and on the seeds of *Avenala madagascarisnsis*. Teal peeks from the eyes on some Moraea flowers, the petals

of Puyas. Truly rare, but some eyes twinkle teal as does the mineral teal apatite, along with the skins of some fungi and the toxic bloom of blue-green algae.

When teal has beauty, it is momentary, a transient confluence of colors whose nobilities are compromised only for an instant. A sweet coupling, a glancing flirtation, a deep if impermanent unity.

Teal is a color best caught off the coast of an unspecified island at dawn, the night drunk out of the sky and all that luscious black smearing into burnished lavender and muddy pink as the dawn perches on the horizon. And in that instance, the last ghouls of night blaze off bleary eyes, the sun assassinates darkness with a sharp ray through a crashing wave. Sky shot through a curving ocean. Leaping, angled, arced, the slippery water forced against gravity, catching the morning light. The current tremors and halves, folds forward, surrendered and shattered, sending its heart to the bottom of the sea.

Teal's truest beauty lasts only in that briefest moment. To stain it with permanence is a sin you will suffer until you let it go.

Grass

To hear the grass grow…

I can't always love the kiss of grass. The cool brush of a thousand blades, the scent of your weight crushing each spear, the freshest feel of it growing, pressing, lively, beneath a prone body as time languors on. The sun sashays and dapples, a shifting patch of shade in the unruly grass beneath the jacarandas.

I can't regularly lend myself to that lackadaisical pleasure. I think too much of all the people—their mouthy couplings and angry hungers, fading skins and hollow prizes, all the money owed, plans and provisions, fears upon fears of buying in and missing out. I worry over parades and parliaments, exhibitions and uprisings, wars and cocktail parties, the time to pick up a child from school, to feed the meter, to weep. I'm afraid of the police killing another innocent. All the right-wing demagogues and leftist ideologues electioneering. The cost of gasoline, skyrocketing rent. All the heartbreak sadness of poverty, scratching at my chamber door. How many people have liked this photo? I glance at my phone and my phone tells me how many others have glanced at theirs, nervous and longing like me.

And the grass is always there, wet with dew, soggy with rain, hiding under snowdrifts. It grows, wild or cropped, fertilized or gone to seed, worn thin with walking by all the Richard Longs of the world. And its color is all of that. Even crisped and dead, brown lawns still sigh green. I can look at a grass

green dress and hear the buzz of a cicada, the wavelets of boats upon the lake, the muted chuff of traffic idling at the lights, blinkering at every turn, honking at snoozers and texters and hotrodders and grannies cruising rushless in sedans, all just a blur on the edge of perception, present enough to remind how velvety is that distance. I can feel a bundled sweater lift my head just so, or the feel of hair folding over thighs.

Wheat and fescue, barley and rye, lemon and crab, Kentucky blue and common reed, vetiver and stipa, sorghum and scutch, the leonine tufts of cortaderia and the whiskers of pampas. I remember deep in the cane field, the elephant grass sharp and thick licking the edges of Sandy's rusty Ford, how it peeked into the car doors as we held hands in the front seat saying goodbye, the planes rising and falling above us before she dropped me at the island airport.

But its green is an amalgam, the brightest St. Augustine of a suburban connoisseur. Just an abstraction, a dyer's trick, but it works.

The rush is all just rush. There are worse lives spent than those spent lying in the grass.

I do not know if lying in the grass produces happiness in me or I am at my happiest when I have time and company to lie in it. Reading to another, laughing at picnics, watching a child, my child once, toddle and softly fall with a laugh into that forgiving green.

But I know the grass is a poem that never gets any older or younger, that grows on and it doesn't care where I lay my head. It doesn't care how many Whitmans sing its songs, how many splendors Coleridge lost, how many Holdens play catcher in its rye. The green, green grass of home and all the snakes that slither there.

I do not like it, but I need it and I let it take me. I am my most in the cool crush of its green.

Avocado

A buttery green peeled from rough skin. Sliced and slivered down, the knife sticks in a hard-heart, a plump seed the size of a baby's fist. Exposed, that slick flesh darkens from pale green to brown to black, the color turning, though the slippery meat stays soft on the tongue.

Changed from *ahuacate* to avocado in 1915 by a gang of farmers at the Hotel Alexandria in Los Angeles, they alerted the dictionaries of their decision and renamed a species. Like much of everyone in California, the fruit originally comes from Mexico. The Aztecs gobbled them as aphrodisiacs, naming this lux fruit of kings in Nahuatl, *ahuacatl*, which by some accounts translates to "testicle."

The avocado is most precisely a berry according to botanists, a fleshy fruit surrounding a single ovary. Both male and female, the avocado swings both ways and the tree can partially self-pollinate. Avocados have a unique flowering behavior called "protogynous dichogamy." The tree has both functional male and female organs in each flower. Over a two-day period, the bloom opens first as a female and on the following day as a male

Avocado's color, cut from California trees, found its way into Golden State homes in the 1970s with appliances coming in goldenrod and tequila sunrise, harvest gold and baby shit brown, poppy orange and coppertone, burnt umber and the mellowest of avocado green paneling easily available on a matching Sears Roebuck stove and refrigerator combo.

Earthtones and pastels were just a sedative after all those bad trips and worse wars, a gradual chromatic transition. Avocado as kitchen trim only ever faked a laid-back vibe, turning selfish as that nervous decade sunsetted.

Though far from the revolutions of that time, the bruised green of avocado beams its own optimism, a sigh of joy amidst necessary revolutions. The liberated free to dance through thronging discos and parade in brazen beauty on the streets, celebrating hard-won rights with sweat-glistened skin went home to kitchens colored with avocado. But then the 80s kicked in and the colors changed, AIDS and crack cocaine crashcoursed all the ravers, Ronald Reagan and the Christian Coalition and the Silent Majority embroiled those left in exhausting skirmishes. Capitalism rang triumphant and welfare crumbled in its clarion call. All those Silicon Valley geeks turned on by Purple Haze and Buckminster Fuller and Carl Sagan tumbled out of 60s Utopianism only to IPO into the 1980s and 90s as technolibertarians, petty dictators in black turtlenecks. All the lovely color disappeared into lifeless green screens and their oatmeal terminals, into office furnishing so neutral as to be neutered, settling finally into the antiseptic purity of the white plastic laptop: a thing unmarked by a human hand, composed of nothing that grows.

But the fruit and its color remain. Shredded into guacamole for Super Bowlers dipping their idle hands with salted chips, sliced into salads for vegetarians still holding strong in the Golden State, coloring a sweatshop-free t-shirt off the rack on Sunset Blvd., avocado is now richly spread wherever the climate can keep a tree from Israel to Indonesia.

That bigbottomed alligator pear, that hard teardrop, so tough when plucked, so soft when left to sit and mellow freely, its

gender as beautifully fluid as it should be for all. And once ripened, with pleasure peel away that thick skin and joyfully taste the soft nourishing succulence within.

Chartreuse

They say chartreuse is halfway between green and yellow, but only on some faraway planet. Otherworldly to be sure, the green of chartreuse is more than modern, the shine of a distant star, ancient in its gleam but exponentially more advanced than our primitive modernity.

When the little green men leap from their saucers, their skin will shimmer from the flickering camera bulbs a rich, wet chartreuse.

Ectoplasm is of course chartreuse when it leaks from the ears, nose and throats of that gang of Victorian spiritualists caught here and there in scattered pictures. A proven fakery, we want nothing more than weird and visceral evidence of afterlife, the slimier the better. The Ghostbusters' first captured spectre is the decidedly gross and ectoplasmic Slimer: "Sir, what you had there was what we refer to as a focused non-terminal repeating phantasm, or a Class 5 Full Roaming Vapor. A real nasty one too." Maybe chartreuse is the color we want of all things and creatures unearthly.

The color radiates toxicity. All the nuclear waste of a hundred cartoons glow chartreuse, as if only a double corruption of the natural order could produce such a strange color. Fire we see in a range from orange to red to yellow and maybe blue, but perhaps Promethean fire, those first flames to warm the hands of the first humans, burned with a glow that could only be called chartreuse.

This color name has all the pretensions in English of certain

French words. The more romantic Americans especially enjoy the deployment of French to flout their education, cultured and worldly in an old-fashioned kind of way. Industrialists learn Mandarin and anime fans Japanese, German for philosophers and Swedish for anyone buying cheap furniture, but French, last century's lingua franca, is best for reading Baudelaire and Stendhal by candlelight. *La Chartreuse de Parme* (1839), never for some reason clad in the appropriate color, is a novel that makes the spiritual life look downright drinkable. Chartreuse is after all an alcoholic cordial, a high-proof infusion of herbs in wine, the shade of which lent the name of the liquor to this particular pale and radioactive green.

The recipe for chartreuse was passed to the Carthusian monks by the Marshal François-Annibal d'Estrées in 1620 and crafted by his ancestor, an alchemist and expert herbalist attempting to make aqua vitae: the legendary elixir that could restore youth to the aged, endow animation to the dead, and create the philosopher's stone.

The monks took a century to interpret the manuscript before they began making the liqueur that sadly fell short of its alchemical promise. They first sold it as medicine rather than as straight booze, before the French revolution forced them out of the country and their recipe of 130 herbs fell into unsympathetic hands. Napoleon called for all secret formulas to be sent to the Ministry of the Interior: unimpressed they stamped chartreuse "refused" and sent it back. Periodically booted out of France by anti-clericalism, the Carthusians have been moonshining their elixir uninterrupted since the dispensation of another Marshall of France, this one Philippe Pétain, who let them back in during Vichy to curry favor with the pope for his conservative authoritarian regime.

Saint Bruno used "Chartreuse" to name his order of monks,

taken from the mountains near Chambery and Grenoble in France where the first monastery was established in 1084, a gift from Saint Hugh. The English bastardized it into Charterhouse, and that's where the novel hits English-speaking hands. The liquor is not universally beloved, but goths, black-clad and romantic to a fault, can be found sipping it in New Orleans bars with names like the Whirling Dervish and Dracula's Daughter. Maybe because Poppy Z. Brite mentions it eight times alone in the prologue to her sultry vampire novel, *Lost Souls* (1992) a kind of bible for a certain kind of goth. Writers are rarely to be trusted.

Though if Stendhal is to be believed, then Chartreuse is where we finally retire, all intrigues exhausted, apart from the world but connected to all in spirit, doubtlessly infused with a dram or two of aqua vitae.

Emerald

The ballet had nothing to do with jewels. The dancers are just dressed like jewels.
—George Balanchine on his ballet *Jewels*, quoted in Nancy Reynolds, *Repertory in Review* (New York: Dial Press, 1977), p. 247.

Let the emeralds be the eyes of my betrayer.

Let the emeralds be the mist that carries away the world.

Let the emeralds melt from stone and into wine. We swim in their oceans drunk on their color.

Let the emeralds become the photograph you snap of yourself the day your father died, the day you fell in love, the day you broke your heart, the day you tasted snow, the day you knew you were going to die, the day you knew you were going to live. Vividly bright in their shine. Sharp in how they cut your life.

Let the emeralds grow from the trees like fruit, their juice sloshing over our hands as we squeeze them.

Let the emeralds bubble from the earth and carry the sinners to the promised land.

Let the emeralds drape and drip from naked breasts.

Let the emeralds whisper to the wretched in the long night.

Let the emeralds become spiders, jewel-throated birds, naked reptiles with long thin tongues that tickle your skin before they bite you.

Let the emeralds ride wild over the hills through prairie grasses taller than men and disappear over the horizon.

In *The Wonderful Wizard of Oz* (1900), Dorothy and the gang are going to see the wizard in the Emerald City. In two editorials in the *Aberdeen Saturday Pioneer* in December 1890, the author L. Frank Baum advocated for the complete extermination of indigenous Americans. If you imagined the Emerald City was a way home, it's hard to regard Oz the same way after knowing that.

The basis of all alchemy was found on an emerald tablet in a seated corpse on a golden throne beneath a statue of Hermes. *As above, so below.* Or that's what somebody said.

A hard green stone. Light and bright. A tincture of blue, but so very green. A fantasy.

Is emerald the green of hatred? The green of envy? Of subtle knowledge?

Suppressed desire hardened into a jewel in your chest, a color like a cavity.

Poison

Sugar on your tongue, a shiver of whiskey, a few puffs from a thin cigarette.

A toxic pill, hemlock punch, the sinking needle of a lethal injection.

A gulpful of smog, a bite of pesticided produce, the kiss of acid rain.

Any brute can execute, but poison is a subtler art. Many a royal taster went green with a bite from a tainted tart intended for his regent. Not a few inconvenient patricians and emperors lost their lives to the wrong swallow. Poison is power and power is poisonous. The toxic soak of too much authority, the ease of murder with a monopoly on violence. Every whim met, every fantasy exercised, the envy of others, the weight of its pressure, such power will wither a body and break a mind as well as the best potion in a poisoner's apothecary.

But even with all the hierarchies stripped away, all of us still have the power to hurt ourselves, eat a little poison to ease a spiritual ache or blot away the pain. Even the weakest, lacking all other power, can throw their body on the machine, let the taunts internalize, light their robes on fire. When all the rest is taken away we still have these bodies to destroy, out of politics or self-loathing, desperation or joy. Poison can help us stave off death with a smallest dose of its infinite darkness. Samuel Johnson "...he who makes a beast of himself gets rid of the pain of being a man." Take another drag, another shot, one more snort. L. Cohen: "And everybody knows that

you live forever, / Ah when you've done a line or two." The great Renaissance physician Paracelsus penned, "Everything is poison, there is poison in everything. Only the dose makes a thing not a poison."

> *A poet makes himself a visionary through a long, boundless, and systematized derangement of all the senses. All forms of love, of suffering, of madness; he searches himself, he exhausts within himself all poisons, and preserves their quintessences.*
>
> —Arthur Rimbaud, Letter to Paul Demeny, May 15, 1871

In his 1994 book about ethnobotany and psychopharmacology *Pharmako / Poeia*, Dale Pendell follows the way of the shaman, which he describes as "the poison path," going deeply into the chemical and mythological properties of traditional plant medicines/poisons. The Ancient Greek word for medicine is the same for poison, *pharmakon*, and further bears in that language the connotation and sparkle of sorcery. Poison is the heart of intoxication, and the derangement of the senses that artists sought from before and after Rimbaud to reach beyond the thin surface of perceivable reality.

Just a little drop of poison.

The numerous forms of poison come in a spectrum of pretty colors. Cyanide makes a bitter blue and quick death for an unmasked spy; in Asian videogames, purple marks the poison; but in the West, cartoon enchantresses all know that poison is green.

Called many things, poisonous green is best named by its primary toxin: arsenic. The snaky brilliance of its special emerald is only brought out when bonded to other elements but its green glows with arsenic's powerful poison. And most murderous poisonings still use arsenic (tasteless

thallium is more *moderne* and subtle, but arsenic is sold on every corner for the socially acceptable murder of rodents and roaches). In 1775, Carl Wilhelm Scheele invented a copper-arsenite pigment that replaced all previous hues and itself was improved upon a green of greater brilliance and chemical complexity. Called a poetic Paris Green from its use as rat poison in that city's sewers, the toxic dye went into wallpaper and paint, clothes and cakes, candies and toys. Easily killing scores of Victorian children susceptible in their tender youths to brisk deaths, this Impressionist pigment likely made Monet blind and Cézanne diabetic (who knows how it rattled poor Van Gogh). The defeated Napoleon's stomach cancer is said to have been helped along by the brilliant green paint of his room in St. Helena (incidentally his favorite color). When used on apple trees as an insecticide, Paris Green burned the trees and killed all the grass around it, as well as one imagines many of the eaters of those poisoned apples, a scattered flock of unsaved Snow Whites each consumed alive by the deadly shade. Turing and his poisoned apple. Though apocryphal, some say Steve Jobs called his computer company Apple in honor of Turing (Jobs said he wished he had been that clever). When your laptop lights up a glowing apple, an urban legend beams through a little drop of poison.

Pick your poison.

The skull and crossbones makes your heart thirsty, your tongue licking canines with a strange hunger. Lists of poisons read like the names of old lovers, but none of my exes could surpass the hallucinatory end of the beautiful nightshade, belladonna. (Though strychnine isn't as poisonous as cyanide or arsenic, it makes a most gruesome death. Every muscle in your body contracts till you die of exhaustion, taking two or three hours. There is no antidote.) Plant poisons are so numerous, an exhaustive list to be made by another poet or

a botanist (or, like Pendell, both).

So many ways to die in the forest. How many humans keeled over before we built immunities or learned our lessons from poison plants? Not all lessons are learned, when the fallen fruit ferments under the trees, all the mammals gather to get deliciously, riotously drunk. The hangover, poison's lasting gift, feels worth the fun, at least most of the time.

Booze makes for our most common poison, celebratory pints and poured sacred amphorae, the rattle of bottles like dancing bones and the stink of stale beer and staler drunk's piss on the pub steps. The tempting jewels line the barkeep's walls like toxic fruits in a savage garden. Belly to the bar, we sip it, ounce by ounce, from rum to whiskey, a gin fizz and a screwdriver, neat and on the rocks. The poisons come and their sickness gives relief. The razor of a bad memory dulls, the clear sight of a ragged face softens and glows, every twisted scar and weary sinew washes away with a bottle or two of mercy. Vision blurs but truth does not: you're drinking poison.

The range of delicious poisons ranges from booze to heroin, inebriants and psychedelics, the thanatos of tobacco to the cool huff of nitrous. Many poisons bend reality. Charles Baudelaire, after listing the soft joys of liquor and opium, names his lover's eyes and spit as the most poisonous drugs of all:

> *All that is not equal to the poison which flows*
> *From your eyes, from your green eyes,*
> *Lakes where my soul trembles and sees its evil side...*
> *My dreams come in multitude*
> *To slake their thirst in those bitter gulfs.*
>
> *All that is not equal to the awful wonder*
> *Of your biting saliva,*
> *Charged with madness, that plunges my remorseless soul*

Into oblivion
And rolls it in a swoon to the shores of death.
—"The Poison" (1857/1861)

Of course his paramour's eyes are green.

Love is a powerful poison.

There are no numbers of those killed by conventional poisoning versus those killed by love. Outside of strychnine perhaps, love is the worst poison in the world. It is not a gentle death. Love's labor won can make a valentine delirious and swerve into obsession and madness. Love's labor lost: the deleterious effects can be found with any broken heart, and we've all had one. The first symptoms look soft enough, a dull glare passes over the eyes, the face grows heated, lips plumped, often tears. But then a chill paleness of shock sets in. This is the point where love lost cannot be returned, even forgiven, these aching scars do not relent and the distrust of the abused colonizes consciousness. The damage is done and the poison seeps into the flesh, wrapping wraithy fingers around bones and squeezing until the hard architecture of one's body feels as delicate as crystals, splintering with the particular pain of cut glass on soft tissues. Every joint and cell, every ounce of spirit and crisscrossing thought is loss. Energy becomes a heavy stone dropped into an infinite, watery abyss, falling down, down, down.

The sufferer doesn't eat and the sleep is so wracked that it offers no shelter. Some find solace in other poisons, alcohol sapping the force of the more punishing intoxication of love. Most survive luckily, but many do not. Like a special parasite that brings on madness without actually killing, the poison of love suppresses survival instincts, causes reckless behavior, and an insanity wont to bold symbolic deaths. In conservative societies, the social ruination that follows a failed affair,

particularly for women in patriarchal regimes but also men, leaves a wronged lover to a fallen fate. The click-clack of the train, the cool clean breeze of a river bridge, the ease of a convenient window in a high place. The arsenic under the sink, the heroin from the corner dealer, the pills in the cabinet washed down with a draught of vodka, so clear...all seem a mercy.

Love lost poisons the mind and spirit. Recovery, if it comes, is long and hard. The anguish so lasting that survivors never fully trust again the soft lips and softer words of a would-be lover. They can slip their tongues into your mouth, but the heart is locked tight. Only the brave, the blithe, the foolish suffer such risks readily after recovery. But like all the most delicious poisons, those that survive are likely to fall in love again. Even if the fall follows another, a deadly poison.

The list of poisoned lovers is long indeed. Fiction is ripe with them. Romeo's apothecary's brew. Emma Bovary's jar of arsenic and mistaken expectations: "'Ah! it is but a little thing, death!' she thought. 'I shall fall asleep and all will be over.'" Lily Bart's overdose in Wharton's *House of Mirth* (1905) as her lover, unknown, rushes to ask for her hand in marriage. There's also the sweet kiss of Cleopatra's asp. On the internet if you care to search, you'll find many videos of double suicides from star-crossed lovers and numerous notes citing love as the reason that many slough off this mortal coil, numbered beyond the count of grief.

Be careful of intoxicating power and saccharine promises, pretty green eyes and potions. The deadliest poisons are the most deliciously addictive. The desire for power, the power of love, both can easily poison. But like Paracelsus says, the dose makes the poison.

Sage

Alas, my love, you do me wrong,
To cast me off discourteously.
For I have loved you well and long,
Delighting in your company.

The ceremony begins. Sage smolders a lingering skyward trail of heavy smoke, the air thickens and each breath heaves its perfume. A soul cleanser, a call to the spiritual higher-ups, a huff or two clears the mind. Thanksgiving chefs use sage to sex up the taste of turkey, native medicine men in the Americas as smoldering wands for important rituals, and Oaxacan seers chew on the *S. divinorum* variety to have the Mother Mary grant them her subdued visions. Sage relaxes and dries a sopping brow, but its power is to witness poisons more than cure them. The clarity that comes with sage can be its own drug, a medicine abused we know is a poison (as poison employed properly can heal). The sting of unrequited love lends a narcotic sharpness to vision, all things witnessed but only in service to our lover.

If you intend thus to disdain,
It does the more enrapture me,
And even so, I still remain,
A lover in captivity.

Growing from the end of Asia to the California coast, sage hugs the coast of my homeland though thoroughly bulldozed. Bracing, ocean breezes shiver through and over

the lowland chaparral of coastal sage, carrying a hint of salt along with the herb's spectral scent. Easily employed as an incense, working sage so is like scratching your nose with a reliquary. In a jam, it'll do the trick…but hardly its best use. I keep a branch in my car as I pass to and fro over the asphalt, a reminder of a place before and beyond humans.

Salvia in Latin, the lady savior. A mint by family, sage cools like its much mintier cousins but hardly with the other's clean cheer. A poultice and medicine for thousands of years, sage has been called to save humans from all manners of ailments. Whatever its proven or unproven properties, the scent does something to us to be sure. Both spicy and gentle, sage's soft aroma whispers both the exotic and familiar, far from ordinary but never strange, the slow roll of a cymbal, a kitten's tongue. Hardly a revelatory awareness, sage is a dim light that softens a hard darkness.

> *I sang my songs, I told my lies,*
> *To lie between your matchless thighs.*
> *And ain't it fine, ain't it wild*
> *To finally end our exercise?*

The green of sage isn't the horny dangerous fecundity of the jungle. Clean like the mints, it relaxes too much for that other herb's cool, clean brightness. Slathered across a countryside, sage almost disappears as dusty foliage, a general backdrop for flowers and hard blue skies. Sage is an invitation, but without urgency.

> *Greensleeves was all my joy,*
> *Greensleeves was my delight,*
> *Greensleeves was my heart of gold,*
> *And who but my Lady Greensleeves.*

The shade worn by Leonard Cohen's Lady in "Leaving Greensleeves" (1974) in the singer's version of the ancient

song here was surely sage. But sage, she does no wrong, unless you call her to do what she cannot. And five hundred years later, the pastoral lament plays on to a lady that will never come again.

Jade

That strange lump of stone with its faintly muddy light, like the crystallized air of the centuries, melting dimly, dully back, deeper and deeper—are not we Easterners the only ones who know its charms? We cannot say ourselves what it is that we find in the stone. It quite lacks the brightness of a ruby or an emerald or the glitter of a diamond. But this much we can say: when we see that shadowy surface, we think how Chinese it is, we seem to find in its cloudiness the accumulation of the long Chinese past, we think how appropriate it is that the Chinese should admire that surface in that shadow.

—Jun'ichirō Tanizaki, *In Praise of Shadows* (1933)

Wet neons of a thousand Chinatowns. Carved wood in angular patterns, the snap of children's cheap fireworks, noodles and vegetables and soy and a hundred animals dipped whole into snickering oil. Snapshotting tourists, sandalled and khaki-shorted, mix with the blush and drugstore cologne of pranking teenagers, coins tinkle in good luck fountains. The shelves of the curio shops heave with possibility. Enduring heirlooms rub against plastic tchotchkes. Silken gowns needled with branching trees shimmer in the shopworn halflight over herbal remedies with mystical poetry and freshly dipped incense sticks. A candle flickers over fruitful offerings to the spirits. Within locked vitrines and behind glass-top counters, the shimmer of a green stone softly beckons, shaped by an ancient civilization since the dawn of recorded time.

Jade. A fleshy, green milk stone carved with knives and polished into undulating sculptures and talismans, scepters and pipes, the delicate petals of a peony and the fierce teeth of a dancing dragon. Each is made with millennia of charm and lore, craft and knowledge, force and spirit more complex than can ever be deciphered. Ancient already when the first of the ancient historians whose work survives attempted to decode the carvings of a lost world. They could only guess. The six ritual jades: heaven and earth, plus the four cardinal directions: North and West, South and East.

Chase the rising sun to its cradle and you'll find an endless ocean fringed with billions who in their great gathering of wisdom, mastered arcana in the labyrinths of meanings and came back with a menagerie of fortune, each to a year, a million monks and robed priests unraveling the stars and splitting time for chieftains and emperors, wise councils and corrupt viziers, all marking their passing and power with cuts and curves of jade.

Is this just another Westerner with visions of exoticism and chinoiserie? Maybe, but here these sights are met with reverence, my ignorance acknowledged. I have freed myself to love these shadowbright complexities, dragging with it all the awkward intimacies and inevitable fuck-ups.

I asked my friend Zandie about this milky green, and to her Chinese family, jade is the weight of family, an heirloom passed along from generation to generation with each adding the heft of their lives to its gravity.

In his dictionary the *Shuowen Jiezi* (translation adapted from Zheng Dekun) finished in 100 CE, the first lexicographer of China, Xu Shen described jade thus:

> *A stone that is beautiful, it has five virtues. There is warmth in its luster and brilliance; this is its quality of*

> *kindness; its soft interior may be viewed from the outside revealing [the goodness] within; this is its quality of rectitude; its tone is tranquil and high and carries far and wide; this is its quality of wisdom; it may be broken but cannot be twisted; this is its quality of bravery; its sharp edges are not intended for violence; this is its quality of purity.*

The stone is not stone, but pure color. A gemmy possibility soft enough to statue.

In a forest thick with the lumbering majesty of ancient trees, there lies hidden an enchanted cave, its entrance only summoned with a spell. With this whispered prayer, a glowering gate opens into the earth leading into a carved passageway filled with dancers and kings, concubines and warrior-princesses, leopards and griffins, larger than life, united in a dance too complex, too alive in its still turns to reckon a glancing purpose, a beginning or end.

Narrowing to the mouth of a doorway you duck to enter and arrive at an underground garden, the trees laden not with fruit but succulent gems, heavy emeralds and plump rubies, pearls the size of pomelos and melons shimmering with the iridescence of diamonds, alive and glistening with a luminous glow. In the center lies a pool made of milky, liquid jade. Stripping your clothes you first dip a toe and feel something beyond pleasure, a warmth and comfort. Slipping your whole body into its viscous beauty, the green coats your skin. You remember not only all your life, but all the lives, time without time back through the origin of life, the warmth of the womb and deeper, back to the electric soup that birthed the first life. You remember not as if you were looking back, but as if you were standing at the beginning and could see forward, all the possibility of time. This warm pool bubbles with raw creation, not yet settled, the dreams

of triumphs yet won and desires amorphous, mysterious, infinite. Your body warms, loosens, feels with each moment less and less separate from the color and you feel all qualities of jade become you: kindness, wisdom, purity, suffused with memories yet to come.

You leave the pool, saturated with its magic. You slip back into your clothes and leave the cave in a trance, the gate sighs shut behind you and disappears into the earth. You witness the trunks and branches of the trees reaching into a starlit sky, the love song of a nightingale, and the rustle of leaves as if they were all carved from precious stones, a softer, gentler glow than the garden of gems. And you feel the enchantment of the pool crystallize within you, and as it hardens into settled forms, you know that you have the bravery of jade within you. You might break, but you will never twist. Your sharp edges are not intended for violence.

You step without fear into the soft darkness of the night.

Acknowledgments

This book has been a long, perilous journey filled with many changes of fortune, and I've had more help than any human has a right to deserve from more people than I could ever hope to befriend and love.

A number of publications and editors have given space and nurturing to this writer surely, and helped publish versions of many parts of this book—the fierce Sky Gooden at Momus, the many wondrous editors at Mousse including Edoardo Bonaspetti, Stefano Cernuschi, Antonio Scoccimaro, Francesco Tenaglia, Clarissa Tempestini, Giovanna Manzoti, Isabella Zamboni, Chiara Moioli, and really all the humans I've worked with there over the years, my editors these past two decades at Artforum, including Chloe Wyma, Allese Thomson, Mira Dayal, Alex Jovanovich, Kate Sutton, Samara Davis, Brian Sholis, Paige K. Bradley, and for the last 16 years the magnificent David Velasco, my fearless editors Jonathan TD Neil, Mark Rappolt, and David Terrien at Art Review, the brilliant Dorothée Dupuis at Terremoto, the artist Natalie Czech for the first gleam of ruby, the encouragement of Kathi Schendel from LambdaLambdaLambda and the support of Flaka Haliti for giving air for cloud white to first form, the poetic editors and editorial poets Suzanne Stein and Kara Q. Smith at SFMOMA's Open Space for giving support to the earliest stain of cyan; the utterly amazing Peta Rake, Jesse McKee, Katarina Veljovic, and Jacquelyn Bell at the Banff Centre for the waterbirth of seafoam green and all the incredible support that they gave me, Hedi El Kholti a tender genius

who gave a cozy place in his Animal Shelter to puce, Ed Schad who invited me to relay a haunting in the pages of the Brooklyn Rail, and the late, beloved Georgia Fee at Artslant who kept me going, time and again.

Deepest thanks to Daniel, Charlotte and all the humans at Not a Cult for believing in this and Lauren Mackler for years of friendship, giving some of the first support for this fever dream, and most especially here for her editorial guidance. I thank Shaun Roberts for this stunning cover and Rhiannon McGavin for cleaning up a messy manuscript. Profound gratitude goes to Chris Kraus who has kindly supported this project in many ways. And to all my family… my late mother and father, Michael and Sharon; siblings Martin, Becky, Matthew, and Angela; friend and co-parent, Sandy; and, of course, our daughter Stella.

And to the many friends, colleagues, and loved ones who read copies and drafts as well as supported me in these long years, you know who you are and how much I love you. To them and all, my gratitude is depthless.